PAUL KLEE

Selected by Genius 1917–1933

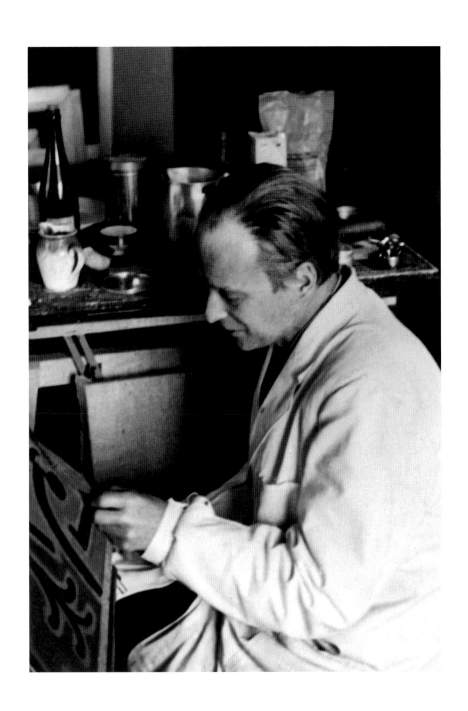

PAUL KLEE

Selected by Genius 1917–1933

Edited by Roland Doschka

With essays by

Roland Doschka,

Ernst-Gerhard Güse,

Christian Rümelin

and Victoria Salley

Prestel

Munich · London · New York

This book has been published in conjunction with the exhibition of the same name held
at the Stadthalle, Balingen, Germany, from 28 July until 30 September 2001.

Front cover: *Queen of Heats*, 1922, 63 (plate 20)
Back cover: *Northern Village*, 1923, 140 (plate 27)
Frontispiece: Paul Klee in his studio in Kistlerweg, Bern, summer 1938 (cf. p. 214)

The Publisher would like to thank all lenders, institutions and musuems
for kindly providing pictorial material for this volume.

© Prestel Verlag
Munich · London · New York, 2001

© for works illustrated by Paul Klee, by the Klee Stiftung, Bern / VG Bild-Kunst, Bonn, 2001

© for works illustrated by Pablo Picasso, by Succession Picasso / VG Bild-Kunst, Bonn, 2001

Die Deutsche Bibliothek – CIP Einheitsaufnahme
and Library of Congress Cataloguing-in-Publication data is available

Prestel Verlag
Mandlstrasse 26, 80802 Munich
Tel. +49 (89) 38 17 09-0
Fax +49 (89) 38 17 09-35

4 Bloomsbury Place, London WC1A 2QA
Tel. +44 (020) 7323-5004
Fax +44 (020) 7636-8004

175 Fifth Avenue, Suite 402,
New York, NY 10010
Tel. +1 (212) 995-2720
Fax +1 (212) 995-2733

www.prestel.com

All texts translated from the German by Elizabeth Schwaiger, Toronto,
except for the foreword, translated by Michael Robinson, London

Edited by Christopher Wynne
Designed by Cilly Klotz and Gunta Lauck
Lithography by Trevicolor, Dosson di Casier
Printed by Gerstmayer, Weingarten
Bound by Conzella, Pfarrkirchen

Printed in Germany on acid-free paper

ISBN 3-7913-2495-0

CONTENTS

For Angela Rosengart

FOREWORD

"Uns traegt kein Volk." Paul Klee ended a famous lecture on his painting to the members of the 'Kunstverein' in Jena, Germany, in 1924 with these pessimistic words, which mean as much as "No people [of this world] supports us." He did not think that the art he and his fellow Bauhaus Master, Wassily Kandinsky, were working on so doggedly would ever reach a wider public. But Klee was wrong. Even as late as 1953, Georg Schmidt, the director of the Basler Museum, maintained: "Paul Klee's language was still an unintelligible, secret language a few years ago; most people needed a handbook before they could begin to grasp it, but it is now well on the way to being spontaneously intelligible to all, without any such aid." (Quoted from: Georg Schmidt, *Engel bringt das Gewuenschte*, Baden Baden 1953)

And now Klee has become a classic whose pictures are reproduced in their thousands. They have established themselves so firmly in the collective memory that seeing the original can be an experience in its own right, a discovery. The fact is that no reproduction—however perfect it may seem—can be a substitute for an original or capture the refinement of Klee's virtuoso, poetic compositions, drenched in light. They are precious things, full of immediate lightness and invention. Often they convey scarcely any sense of the energy and the struggle, the disappointments and the hopes it cost their painter to create them.

Although Klee's œuvre includes approximately 10,000 works—only Picasso exceeded him in diligence and obsessiveness—every sheet seems like a rare treasure. Each one is evidence of a fight to create a pictorial language that became a stimulus and a source of inspiration for many artists of the Modern period such as Wols and Baumeister as well as de Stael, Miro and Bissier, to say nothing of the debt the Ecole de Paris and American Abstract Expressionism owe him. As well as this, Klee has since become the guiding light of modern art education. His analysis of creative resources and methods still provides a basis for seeing things aesthetically. He makes our view of nature and art lastingly sharper—Paul Klee teaches us how to look in a new way. He was not interested in making his personal style into a dogma: for him all art was an allegory. Tolerance remained the key to his nature: he once finished a term at the Weimar Bauhaus by saying: "I have shown you one way here—I took a different one myself."

Artists are extraordinary people, by profession and by vocation. This is particularly true of Paul Klee, for whom life and work were insolubly joined. It is rare in the history of art to be able to follow an artist's development as precisely as can be done in the case of Klee, who gave a written explanation of every step, however small. This provided a great deal of material for art-historical research, making it possible to examine detail and to mount exhibitions that investigate the individual aspects of his work down to the most subtle of ramifications.

This volume and the exhibition are intended to provide a general survey and present as many facets of Klee's work as possible. The title *Selected by Genius: 1917–1933* extends from the period when Klee was employed first as 'Form Meister' at the Bauhaus, up until his summary dismissal by the National Socialists as professor of painting at the Düsseldorf Academy. Klee developed a veritable cosmos of pictorial forms during this period, presenting a wealth of creative beauty that has remained unique.

Klee was a gardener in a little piece of paradise. Under his direction his charges blossomed beautifully, full of harmony and grace. His motifs seem to develop with consummate ease, almost—it would seem—of their own accord, and whatever basic note he strikes, his colours contrast in such a way that their sound blends in inevitable harmony. Even when he compresses his pictorial resources to the utmost, he never slips into anything uncontrolled or random. Klee formulates subtly sensitive offerings for the viewer's eye, offerings so cautious and gentle that they readily elude consumption in this day and age. Paul Klee's art demands undivided attention—and it is also capable of opening one's eyes to something that lies beyond the image itself. *Roland Doschka*

THE MASTER YEARS 1917–1933

Ladies and Gentlemen,

Speaking now in the presence of my work, which is actually supposed to speak its own autonomous language, I find myself at first rather uneasy about whether enough reasons have been assembled and whether I'll be able to do it properly. (…) However, I reassure myself that my talk as such is not addressed to you as something in isolation but that, merely supplementing impressions received from my pictures, it may add a certain character that is perhaps still missing.

Paul Klee, Jena 1924[1]

Paul Klee (1879–1940) was one of the most important German-speaking artists active in the first half of the 20th century. The œuvre of this prolific and versatile artist, which comprised roughly 9,000 works by the time he died, is certainly multifaceted, revealing Klee's unceasing efforts to find new outlets of expression for his teeming creative energy.

The exhibition 'The Master Years. 1917–1933' presents works which the public at large, art historians and critics as well as Klee himself concur in regarding as attesting most impressively to his development as an artist. This period saw recognition of his work and, concomitantly, financial success. After participating in group shows, Paul Klee finally achieved his breakthrough at the age of 38 with two one-man shows mounted by Herwarth Walden in his Berlin Gallery, 'Der Sturm', in March 1916 and February 1917. The upturn in Klee's career is documented not only in sales figures; from then on his work continued to receive positive notices in the press. Now a factor to reckon with on the art market, Klee concluded a three-year contract with the Munich art dealer Hans Goltz in 1919, which assured him a steady, if modest, annual income.[2]

The year 1920 represented a high point in Klee's career with publication of the illustrations he did in 1911 for Voltaire's *Candide* (published by Kurt Wolff) as well as the edition of Curt Corinth's *Potsdamer Platz* (published by Georg Müller)

he had been illustrating since 1918. Moreover, an essay Klee wrote on the graphic arts was published in an anthology entitled *Schöpferische Konfession* ('Tribüne der Kunst und Zeit'), which was edited by Kasimir Edschmid. This Klee essay is still drawn on as an invaluable source for interpretation. A comprehensive retrospective of Klee's work comprising 326 exhibits was mounted in Hans Goltz's 'Neue Kunst' gallery. The exhibition was accompanied by a catalogue which was a special number of the periodical 'Der Ararat' and included a biographical outline based on data provided by the artist. Appreciation of Klee as an artist in the period discussed here rests primarily on two monographs published in 1920, one of them by Hermann von Wedderkop in the 'Junge Kunst' series and the other by Leopold Zahn: *Paul Klee. Leben, Werk, Geist.* The latter draws mainly on material Klee placed at the author's disposal. The monographs were followed in 1921 by Wilhelm Hausenstein's *Kairuan oder Die Geschichte vom Maler Klee.*[3]

The final proof that Klee had indeed arrived as an artist is furnished by an invitation extended to Klee in October 1920 to teach at the Staatliches Bauhaus in Weimar, which Walter Gropius had founded the year before: "Most honoured Herr Klee, today we have had the great pleasure of unanimously sending a telegram to you. At the moment we are, after approval of our budget, in the fortunate position of being able to summon another master to us and there was no question of whom we would invite. (…) Our pupils are beaming with delight at the thought that you might come to us; in fact, everyone here is fondly looking forward to your arrival. Therefore, we are hoping for a quick yes! … It would be splendid if you came."[4] The post as Bauhaus instructor which Klee took up in January 1921 assured him a sufficient income and, moreover, afforded the opportunity for lively intellectual exchanges with such other Bauhaus 'Masters of Form' as Lyonel Feininger, Johannes Itten and Gerhard Marcks. Klee was able to devote himself to intensive theoretical study of the creative process and to focus his thoughts on where he

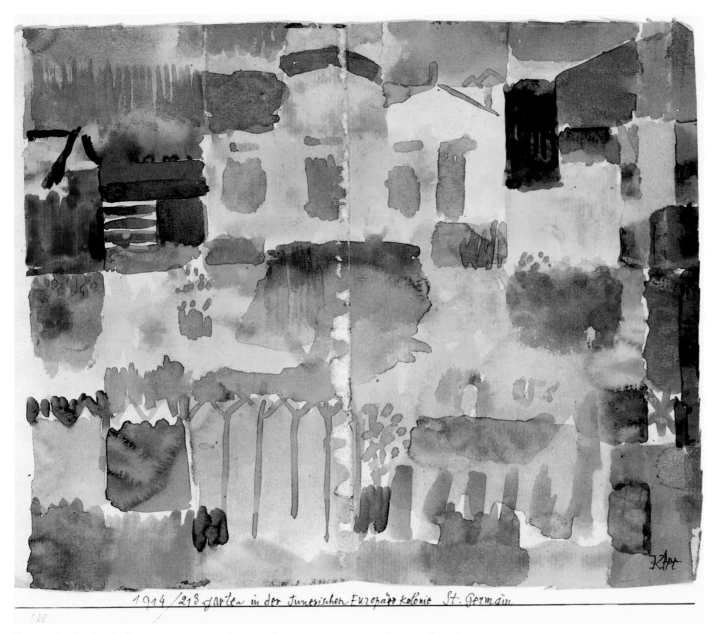

fig. 1 *A Garden for Orpheus*, 1926, 3, pen and watercolour on paper, mounted on cardboard, 47 × 32 /32.5 cm. Paul Klee Foundation, Kunstmusem Bern. Inv. no. Z 586, Ref. no. 3,949

personally was headed. He put it as follows: "When I went to teach there, I was forced to be absolutely clear about what I had for the most part been doing unconsciously."[5] Personnel changes at the Bauhaus, which moved to Dessau in 1925, brought about changes in the curriculum and the approach to instruction. Training was tautened and focussed more strongly on architecture.[6] Klee, who with Wassily Kandinsky had been in charge of the glass and mural workshops from 1922, became increasingly torn between the demands made on him by teaching and his work as an artist. Since, by the close of the 1920s, he was no longer comfortable with what he

was doing at the Bauhaus, he started to look for another teaching position. In 1930 he was invited to teach at the Düsseldorf Art Academy and took up the post of instructor there in October 1931. However, even before he had settled in Düsseldorf, he was overtaken by political developments in Germany. Subjected to racist defamation, Klee was classified as a 'degenerate artist' in September 1933 and immediately suspended from instructing. Meanwhile Klee's work was being exhibited to increasing acclaim in both the US (first one-man show at the New York Société Anonyme in 1924) and France (first one-man show in 1925 at the Vavin-Raspil Gallery

in Paris). And in 1933, before Paul Klee emigrated to Switzerland, the Paris art dealer Daniel-Henry Kahnweiler concluded a general contract with him. In December 1933 Klee and his wife Lily moved to Bern. The last seven years of Klee's life were marred by great personal difficulties. The authorities at first denied Klee, who had been born in Switzerland, Swiss nationality. An uninterrupted five-year stay in the country was necessary for naturalization, but even after he had met this requirement, Switzerland was too conservative to appreciate Klee as an artist despite large-scale exhibitions of his work in Bern and Basle. The official German line in art propaganda seems to have carried the day even in neutral Switzerland. Moreover, symptoms of scleroderma, the disease which would eventually kill Paul Klee, appeared in 1935. The hardships he experienced in those years are reflected in a stagnation of creativity. Not until 1936 does the catalogue of his works show evidence of renewed activity, which by 1939 — the year before Klee died — had increased to 1,253 works.

The roll of exhibitions and academic publications devoted to Paul Klee's life and work is long. So wide-ranging are his œuvre and his theoretical writings that together they represent an inexhaustible resource for both popular commentators and critical scholarship. Until the 1980s art historians tended to place Klee on a stylized pedestal, idealizing him as an artist who, in their view, matured both personally and, therefore, artistically without benefit of external influences. Consequently, as an artist Paul Klee personified the modern ideal of aesthetic autonomy. This view of an intuitively creative intellect feeding solely on its own inner resources was primarily grounded on what Klee had to say about himself and his work in his diaries, letters and theoretical writings. With the onset of the 1980s, however, specialist publications increasingly began to approach his work critically and to interpret it analytically.[7] The hackneyed picture of the unregenerate loner was corrected. Klee in fact carefully cultivated such close ties and even friendships with other artists that they exerted a considerable influence on his work. Through Alfred Kubin, with whom he corresponded for many years, and the Swiss painter Louis Moilliet, who had been a friend since childhood, Klee came into contact with Wassily Kandinsky, Franz Marc and August Macke and their circle. Klee was a member of the 'Blauer Reiter' and was a life-long friend of Kandinsky's, who had been a

neighbour in Schwabing.[8] In 1924 at Galka Scheyer's suggestion, Lyonel Feininger, Alexei von Jawlensky, Wassily Kandinsky and Paul Klee founded the 'Blaue Vier' as a forum for publicizing their work, most particularly in the US. The four painters, who were all friends, exchanged works constantly. Josef Helfenstein has shown that their communi-

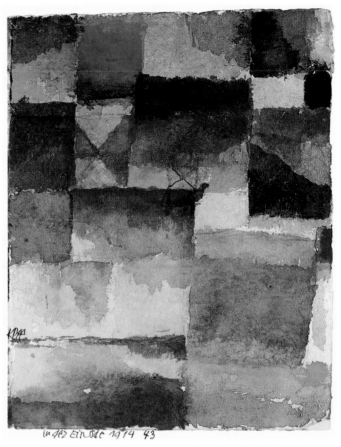

fig. 2 *Garden in the European Colony of St. Germain in Tunis*, 1914, 213, watercolour on paper, pen on reverse, mounted on cardboard, 22 × 27 cm. The Metropolitan Mueseum of Art, New York, The Berggruen Klee Collection. Inv. no. 1984.315.3

cation assumed a symbolic character which is reflected in their work.[9]

Apart from the close personal ties Klee maintained with artists, a further formative influence on him was his intensive study of the work of other Moderns, notably such French painters as Picasso, Delaunay, Rousseau and Matisse.[10] Robert Delaunay especially, whose essay 'La Lumière' Klee translated for the magazine 'Der Sturm' in 1913, has been repeatedly cited as having exerted a major influence on Klee.[11]

He studied Vincent van Gogh's work, recognising that he was a painter of genius and attesting to the power of his line "which profits from Impressionism while overcoming it", because, as Klee put it, it caused "[his] swirl of little bows to be reconciled with the control [exerted by] firmly linear boundaries."[12] Then again he viewed Paul Cézanne as "the instructor par excellence, much more of a teacher than van Gogh."[13]

fig. 3 *Blossoming*, 1934, 199 (t 19), oil on black priming on canvas, oil on priming on reverse, mounted on stretcher, 81 × 80 cm. Kunstmuseum Winterthur, Legacy of Clara and Emil Friedrich-Jezler. Inv. no. 1184

What is difficult is attempting to determine the extent to which his contemporaries' work influenced Klee's development simply from his diaries, since he edited them himself in later years with a view to publication.[14] Similarly, the catalogue of his œuvre, which was drawn up in advance for the purposes of facilitating the execution of his will, should also be subjected to critical analysis (cf. the article on 'Klee's Interaction with his own Œuvre' by Christian Rümelin).

Klee, whose career began to take shape at a time when attendance at art academies was no longer regarded as indispensable for success, was nonetheless not entirely opposed to academic training.[15] Hence his joining Franz von Stuck's class in October 1900, "although one could not learn painting there because colour was never mentioned."[16] Klee decided to teach himself because what he was most interested in was coming to grips with colour. According to his own, often cited statement, the moment of truth came for Klee as a painter in April 1914 during a trip to Tunis with his friends, the painters Macke and Moilliet: "Colour has me in its grip. I no longer need to strain for it. It has me forever in its clutch, I know it has. (…) colour and I are one. I am a painter."[17] Klee struggled long and hard before he could handle colour. Mastery was preceded by a series of black-and-white watercolours (1908–10); the greys already reveal enormous tonal subtlety. Now that line and tone had been achieved, all he needed to claim mastery of painting was the third element, colour.[18] Regula Suter-Raeber has traced the stages through which he passed in 1914 to reach this breakthrough with colour and, through it, abstraction.[19] Before Tunis, Klee was trying to create something with colour which was primarily governed by formal laws instead of capturing impressions gained from the observation of nature. In Tunis, however, the impact made on him by the intense colours and the entirely different light in this exotic southern country pointed him in a different direction so that he succeeded in capturing what he saw in nature in translated form on the picture-surface; his relationship to what he was seeing and how he dealt with it in aesthetic terms changed in the course of the trip. Although the sheet *Garden in the European Colony of St. Germain in Tunis* (1914/213: fig. 2) is resolved entirely on the surface and primarily built up of coloured rectangles, reflecting the light and warmth of Tunis, it is, especially where colour is concerned, not yet free of the representational. *In the Desert* (1914/43: fig. 4), while retaining the geometric composition which is built up of surfaces throughout, reveals a much higher degree of abstraction. The atmospheric quality of an empty landscape is evoked without any direct representational reference. Klee has achieved his goal — mastery of colour.

His preoccupation with colour was accompanied by a keen interest in formal, phenomenological study. Marianne L. Teuber has shown that he came into contact early on with Ernst Mach's *Analyse der Empfindungen und das Verhältnis*

des Physischen zum Psychischen 'Analysis of the Feelings and the Relationship of the Physical to the Psychic'), published in 1886, and Friedrich Schumann's phenomenological studies, which were widely read in early 20th-century intellectual circles, and that Klee's handling of form came to be based on these works.[20] They took on a particular significance for him that was both theoretical and aesthetic while he was instructing at the Bauhaus. Under their influence, Klee experimented with parallel lines in a series of pictures executed between 1925 and 1927. In the drawing *A Garden for Orpheus* (1926/3: fig. 1), he has represented his mythical landscape entirely with vertical, horizontal and diagonal parallel lines which seem to converge into surfaces and form various spatial planes. His interest in phenomenology is expressed chiefly in his repeated return to the chessboard on varying planes of abstraction in work that is at first still recognisably representational, as in *City with Three Domes*, which he executed in 1914/2, and the Tunis watercolours. From 1923 he produced entirely square pictures such as *Harmony in Blue = Orange* (1923/58: cat. 24), which, albeit devoid of representational allusion, evoke movement, object and atmospheric quality solely according to the visual principles governing the theory of form and colour. On into the late Bern years, Klee was to remain true to this principle of composition and form as revealed in the squares emerging from, and receding back into, the picture ground which Will Grohmann would term 'magic squares' in 1954 (*Blossoming*, 1934/199: fig. 3).

Viewed separately, Klee's works can seem simple, easy for the spectator to grasp — even without any knowledge of their art historical, phenomenological and philosophical background. This is certainly the explanation for his enormous popularity. Its complexity surfaces when his œuvre is studied collectively in its entirety. Klee, who delighted in experimenting, was capable of working on several innovations at once. Thus *A Garden for Orpheus* (1926/3: fig. 1), *Clearing in the Forest* (1926/118: cat. 42) and *Monuments in the Plain of N.* (1926/7) were all executed in 1926. In each of them Klee has expressed his aesthetic intention by drawing on a great variety of artistic devices. Consequently, although the dream of achieving "a very broad-ranging" œuvre encompassing "the entire elemental, representational, content and stylistic field,"[21] as Klee described it in Jena in 1924, may not have come to fruition in individual works, he did attain his objective in his œuvre as a whole.

fig. 4 *In the Desert*, 1914, 43, watercolour on paper, 17.4 × 13.9 cm. Franz Meyer, Zurich

The poetic, fairy-tale narrative character of Klee's pictures often makes it impossible to subject them to simple iconographic analysis. Instead, Klee arouses associative impressions in the viewer. Invariably emphasizing this quality inherent in all artistic creation, Klee nevertheless also sees it as the "source of vehement misunderstanding between artists and laymen."[22] The equally odd yet poetic titles he gave his pictures, such as *Small Rhythmic Landscape* (1920/216: cat. 13), *Rose Wind* (1922/39: cat. 19), *Affected Place* (1922/109: cat. 21) and *Monument on the Border of the Fertile Country* (1929/40: cat. 49) represent linguistically what he has rendered in visual terms. The titles supplement the works and help viewers to read them. Nonetheless, the titles are not mere aids to interpretation which simply explain visible form. Klee uses visual devices just as he does language to spark off psychological effects which release inner images and generate associations. This makes it impossible for a picture to be given a single, valid interpretation since every viewer who responds to it translates it into his or her own percepts on the basis of his or her biography and experiential repertoire. The doubts expressed by Alberto Manguel about "whether there can even be a coherent system for decoding pictures as we have for reading script"[23] apply particularly to Klee's work.

Just as his works often elude iconographic classification on an individual basis, Klee's œuvre, taken as a whole, defies unequivocal attribution to any one of the numerous conceptions of art and style prevalent in the first half of the 20th century. His drawings and paintings are varied in the extreme in every respect. Individual qualities of his work seem to recall Symbolism, Fauvism and Expressionism, Cubism and Lyrical Abstractionism as well as geometric Constructivism, Surrealism and even Dadaism. However, one is ultimately forced to concede that his work cannot be subsumed under any of these terms. All one can do, therefore, is to join Goethe in claiming for Klee what the universal genius of the German Enlightenment did for the Pompeiian Alexander Mosaics, i.e. that "our contemporaries and posterity (…) [will] not be sufficiently capable of commenting appropriately on such a marvel of art and we [are] forced over and over again, after enlightened observation and study, to return to pure and simple admiration."[24] *Victoria Salley*

ENDNOTES

1 Talk given by Paul Klee at an exhibition of his work in the Jena Kunstver ein on 26 January 1924. First published as: Paul KLEE, *Über die moderne Kunst*, Bern 1945; recently again: *Paul Klee in Jena 1924. Der Vortrag*, ed. Thomas KAIN/Mona MEISTER/Franz-Joachim VERSPOHL, exhib. cat. [Minerva. Jenaer Schriften zur Kunstgeschichte, Vol. 10] Jena 1999, pp. 49–69.

2 Cf. Christine HOPFENGART, *Klee. Vom Sonderfall zum Publikumsliebling. Stationen seiner öffentlichen Resonanz in Deutschland 1905–1960*, Mainz 1989, pp. 26–39.

3 Cf. HOPFENGART, as in n. 2, pp. 41–47.

4 Susanna PARTSCH, *Paul Klee, 1879–1940*, Cologne 1990, p. 47.

5 Quoted in Carola GIEDON-WELCKER, *Paul Klee*, 1995, p. 69.

6 Cf. Magdalena DROSTE, *Bauhaus 1919–1933*, Cologne 1990; Jeannine FIEDLER/Peter FEIERABEND, eds., *Bauhaus*, Cologne 1999.

7 Starting with Otto Karl WERCKMEISTER, *Versuche über Paul Klee*, Frankfurt am Main 1981 and *Paul Klee. Das Frühwerk 1833–1922*, exhib. cat. Städtische Galerie im Lenbachhaus, Munich 1979.

8 Cf. *Ein Gespräch mit Felix Klee*, in: *Paul Klee. Die Sammlung Berggruen*, exhib. cat. Kunsthalle Tübingen 1989, Stuttgart 1989, pp. 19–48; *Paul Klee und seine Weggefährten*, exhib. cat. Schlossmuseum Murnau 1999, ed. Brigitte SALMEN, Murnau 1999.

9 Josef HELFENSTEIN, *'Die kostbarsten und persönlichsten Geschenke' – Der Bildertausch zwischen Feininger, Jawlensky, Kandinsky und Klee*, in: *Die Blaue Vier. Feininger, Jawlensky, Kandinsky und Klee in der neuen Welt*, exhib. cat. Kunstmuseum Bern and other vennes, Cologne 1997, pp. 79–136.

10 *Paul Klee. Eine biographische Skizze nach eigenen Angaben des Künstlers*, in: 'Der Ararat', 2nd Sonderheft, Paul Klee. Catalogue of the 60th exhibition of the Galerie Neue Kunst Hans Goltz, vol. 1, Munich 1920, reprinted in: Paul KLEE. *Schriften, Rezensionen und Aufsätze*, ed. Christian Geelhaar, Cologne 1976, p. 137.

11 On Delaunay's importance for Klee see Christian LENZ, *Klee und Delaunay*, in: *Delaunay und Deutschland*, exhib. cat. Staatsgalerie moderner Kunst im Haus der Kunst München 1986, ed. Peter-Klaus Schuster, Munich 1986, pp. 227–242.

12 Paul KLEE, *Tagebücher [Diaries] 1898–1918*, new critical revised edition, publ. by the Paul Klee-Stiftung. Kunstmuseum Bern, compiled by Wolfgang Kersten, Stuttgart 1988, nos. 816 and 899.

13 Paul KLEE, *Tagebücher 1898–1918*, as in n. 12, no. 857.

14 Christian GEELHAAR, *Journal intime oder Autobiographie?*, in: *Paul Klee. Das Frühwerk 1833–1922*, exhib. cat. Städtische Galerie im Lenbachhaus, Munich 1979, pp. 246–260.

15 Gregor WEDEKIND, *Paul Klee: Inventionen*, Berlin 1996, pp. 16–18.

16 Paul KLEE, *Tagebücher 1898–1918*, as in n. 12, (Hausenstein I) p. 484.

17 Paul KLEE, *Tagebücher 1898–1918*, as in n. 12, no. 9260.

18 For his use and mastery of the three artistic devices line, tone and colour see his talk in Jena in 1924, cf. n. 1.

19 Regula SUTER-RAEBER, *Paul Klee: Der Durchbruch zur Farbe und zum abstrakten Bild*, in: *Paul Klee. Das Frühwerk 1833–1922*, exhib. cat. Städtische Galerie im Lenbachhaus, Munich 1979, pp. 131–165; cf. also: *Aufbewahren, Umarbeiten, Zerwirken. Tunesische Aquarelle, 1914–1923*, in: Wolfgang KERSTEN/Osamu OKUDA: *Paul Klee. Im Zeichen der Teilung*, exhib. cat. Kunstsammlung Nordrhein-Westfalen Düsseldorf and Staatsgalerie Stuttgart 1995, Stuttgart 1995, pp. 45–54; Otto Karl WERCKMEISTER, *Klee vor den Toren Kairouan*, in: *Paul Klee. Reisen in den Süden. 'Reisefieber praecisiert'*, exhib. cat. Gustav-Lübcke-Museum Hamm and Museum der bildenden Kunst Leipzig 1997, eds. Uta Gerlach-Laxner/Ellen Schwinzer, Stuttgart 1997, pp. 32–50.

20 Marianne L. TEUBNER, *Zwei frühe Quellen zu Paul Klees Theorie der Form*, in: *Paul Klee. Das Frühwerk 1833–1922*, exhib. cat. Städtische Galerie im Lenbachhaus, Munich 1979, pp. 261–296; cf. also Monika GOEDL, *Diesseits nicht fassbar?*, in: *Paul Klee. Die Zeit der Reife*, exhib. cat. Kunsthalle Mannheim 1996, ed. Manfred Fath, Munich 1996, pp. 13–25.

21 *Talk given by Paul Klee in Jena in 1924*, see n. 1, p. 69.

22 *Talk given by Paul Klee in Jena in 1924*, see n. 1, p. 58.

23 Alberto MANGUEL, *Bilder lesen*, Berlin 2001, p. 24.

24 Johann Wolfgang von GOETHE, in a letter to W.J.C. Zahn, 10 March 1832, in: *Sämtliche Werke. Briefe, Tagebücher und Gespräche*, Frankfurt am Main 1993: "Mitwelt und Nachwelt (…) nicht hinreichen […], solches Wunder der Kunst würdig zu kommentieren, und wir genötigt […], nach aufklärender Betrachtung und Untersuchung immer wieder zur einfachen reinen Bewunderung zurückzukehren."

A LYRIC POET IN PARADISE AND A DRAMATIST IN ARCADIA

Reflections on the creative process in the work of Paul Klee and Pablo Picasso

Rarely has the work of an artist been interpreted with such variety — in such a short period — as that of Paul Klee. With his small volume *Paul Klee, Drawings* (1951), Klee's early biographer and friend Will Grohmann shaped a popular image of Klee as an artist that endures to this day. Published in what was then a record edition of 80,000, Grohmann's book

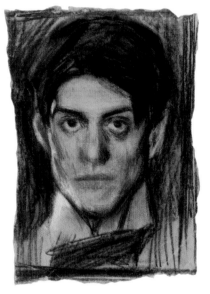

Paul Klee, *Self-Portrait*, 1898, pencil on paper, mounted on cardboard, 13.7 × 11.3 cm. Gift of LK, Klee Museum, Bern. Inv. no. 297

Pablo Picasso, *Self-Portrait*, 1899–1900, charcoal on paper, 22.5 × 16.5 cm. Museum Picasso, Barcelona

portrayed the artist as a dreamer and playful creator of whimsical inventions. French critic René Crevels, on the other hand, described Klee as the "virtual creator of Surrealism" as early as 1928 in a text entitled 'Merci, Paul Klee' published in a catalogue for the Flechtheim gallery. A misapprehension Klee was quick to repudiate. More recently Otto Karl Werckmeister, an art historian in the United States, has tried to debunk the 'Klee Myth'. Turning to Marxist theory for additional ammunition, Werckmeister sets out to prove how the

artist engineered the reception of his work and employed clever marketing strategies to foster the romantic perception that followed. Every generation, it would seem, forms its own image of Klee.

In the context of this impressive history of public and critical reception, Klee's famous statement "Diesseitig bin ich nicht fassbar" — (which translates roughly into "I cannot be understood in this world") — takes on new meaning. This essay is not intended as yet another exegesis of Paul Klee's universe of images and ideas; an abundance of literature already exists on that topic and the bibliography for this catalogue contains over 400 titles. Instead, I would like to reflect on Klee's creative legacy in relation to that of another master of classic Modernism, equally renowned and admired: Pablo Picasso. What connects and what separates these great masters of classic Modernism?

Klee and Picasso were undoubtedly aware of each other, but they only met once and briefly at that. The encounter took place in 1937 when Picasso accompanied is ailing son Paolo to a hospital in Bern. Encouraged by his art dealer Daniel Henry Kahnweiler, Picasso went to see Klee, who was already severely weakened by his illness, in his studio. It does not seem to have been a memorable event. Neither Picasso nor Klee ever commented on the brief encounter.

At first glance the two artists seem fundamentally different, almost antithetical in character. On the one side is Klee, a Swiss/German whom Jean-Paul Sartre called an "angel, who recreates the miracles of the world," a sensitive,

Pablo Picasso, *Quatre études de guitare*, pen and ink,
illustration for Balzac's work *Le chef d'œuvre inconnu*

lyrical, inward-looking artist, who stays completely in the background behind the screen of his work. And on the other side the extroverted Spaniard Picasso, a Mediterranean 'Prometheus', the archetypal bohemian, whose studio was a stage and whose affairs have become a cliché of the anarchism and egotism that define the classic image of an artist's life.

What links these two, however, is that they both expanded the potential of expression by pictorial means like no other artists before them. Klee and Picasso are the undisputed masters of image invention of the twentieth century. The inspiration they provided for subsequent generations of artists made them pacemakers of Modernism. Both had a will to totality: "Sometimes I dream of a work of really great breadth, ranging through the whole region of element, object meaning and style", Paul Klee declared in his famous treatise at the Museum in Jena in 1924. And Pablo Picasso once remarked in conversation with his art dealer Daniel Henry Kahnweiler, that the accuracy of dates on his work was so important because he wished to leave as complete a documentation as possible for the generations to come as a contribution to the "study of creative man". Both, Picasso

and Klee were aware of their own importance early in their respective careers.

To document and explain his artistic development in his early years, Picasso bequeathed a huge inventory of works from his youth to the city of Barcelona. Today, they fill an entire museum, the Museo Picasso in Barcelona, and offer insight into the mastery and skill of a precocious genius. Picasso, whose ambitious father had forced him to draw from nature with great precision at the tender age of five, once commented when visiting an exhibition of children's drawings: "When I was the same age as these children, I could draw like Raphael. It took many years before I could draw like these children." This naturalism, which he absorbed at such a young age, gave Picasso a facility of observation and a precision and quickness of execution that were the envy of generations of artists.

However, at the latest during his Blue Period, Picasso himself grew to understand the limitations of the pictorial grammar that had determined composition in painting ever since the Renaissance. Deliberately and provocatively, he set out to explode the boundaries of the Western tradition. "Nothing of note has been painted since the cave paintingsat Altamira," Picasso is said to have opined and from 1905 onwards he began to question the traditional structure of images with increasing radicalism. By studying the paintings of Rousseau, the *Douanier*, he saw how uniformity of style could be overcome by assembling pieces of different styles in the manner of a collage. From 1905 onwards, he also explored traditional Iberian sculpture, and soon after began to study the additive formal principle at work in African masks and sculptures. His *Demoiselles d'Avignon* (1908) was a veritable exorcism by which Picasso cast off the tyranny of academic teaching, traditional stylistic principles, Euclidean geometry and the beauty ideal of traditional painting. He dissected the act of painting into its basic elements, destroying objects to reconstruct a new pictorial world out of the broken pieces like so many building blocks. But — and this distinguishes him from Klee — Picasso always departed from the object and always returned to the object, no matter how deformed. Pure abstraction, Picasso explained, had too little drama. The representational in nature offered him inspiration for mutations and metamorphoses through which pictorial means took on a life of their own in the hands of the painter.

Rebellion, protest, destruction and reconstruction are key expressions in Picasso's creative vocabulary. This is nowhere more evident than in Clouzot's 1954 film *Le Mystère Picasso* shot at the Grimaldi estate in Antibes. A semi-transparent screen allows the film-goer to observe Picasso in the process

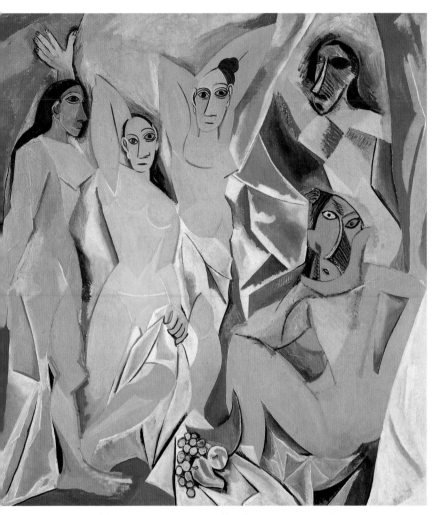

Pablo Picasso, *Les Demoiselles d'Avignon*, 1907, oil on canvas, 243.9 × 233.7 cm. The Museum of Modern Art, New York

of creating an image. No sooner does it appear to be completed, however, than the artist begins to paint over some areas, destroying, dissecting or reconstructing shapes, so that not one, but — in analogy to the process of film-making itself — a multitude of images take shape in front of the viewer's eye. The image becomes a stage for actions that can only be described as dramatic. The means of pictorial composition — line, shape, colour, and structure — are the actors in this drama. In a quarrelsome dialogue, they join forces, engage in

battle, expire and rise again. A finished painting held no interest for Picasso, who was captivated by the creative process of making, the stream-of-consciousness flow of ideas in the never-ending line. This is evident in the countless variations on the 'femme fleur' and perhaps even more so in series of *Bull* lithographs, where Picasso plays with the motif from primitive linear rendering to full-blown naturalism.

Picasso was even more emphatic about the importance of his early images than Paul Klee. "How many things an artist must be: poet, naturalist / explorer, and philosopher. And now, I've even become a bureaucrat by compiling a large and precise inventory of my entire artistic output since childhood," he wrote in his diary in 1911. At this point he began to systematically enter all of his drawings and paintings, classified as to their importance, in a hand-written catalogue raisonné (cf. essay by Christian Rümelin). He was especially interested in documenting a detailed chronology of his artistic invention. The result is a genesis of his creative intellect. It may astonish that the catalogue begins with works from 1883, when the artist was only four years old. However, this is further proof of how much Picasso identified with his own perception as a child, which he understood as a fundamental component in his artistic development.

"There are," he wrote in 1912, "still primeval sources of art, such as we find them in an ethnographic museum or at home in the room of our childhood (don't laugh, reader). Children know how to do it and this should not be interpreted as an indictment of the most recent development [in art]. Instead, this coincidence contains a core of real wisdom. The more helpless these children are, the more instructive is their art, for even at this stage there is corruption: when children begin to observe fully developed works of art or even try to emulate them … That's how far we have to go back if we wish to avoid archaizing." (*Reviews and Essays*, Cologne 1976, p. 97ff).

While Picasso always started with a given form (regardless of whether he was painting an object, a figure or a nude), which he treated as subordinate to his subjective sensibility (his fantasies, wishes, desires and fears) and then dissected, deformed and recreated in the spirit of visual creation, Paul Klee always set out literally from ground zero in his drawings.

An analytical thinker and *pictor doctus* par excellence, Klee gave a fascinating account of the process of creating an image in his *Confessions of Visual Creation* from 1920 as "a small journey into the land of superior knowledge." His

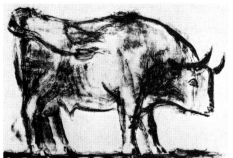

5 December 1945

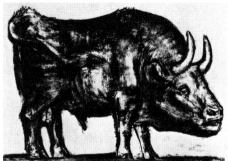

12 December 1945

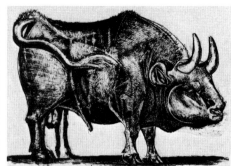

18 December 1945

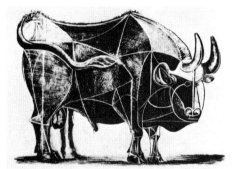

22 December 1945

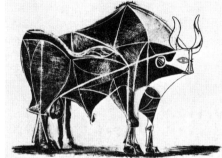

24 December 1945

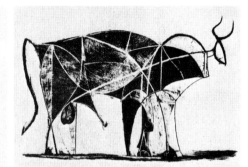

26 December 1945

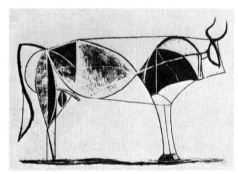

28 December 1945

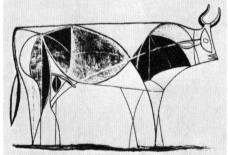

2 January 1946

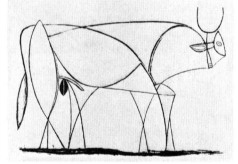

5 January 1946

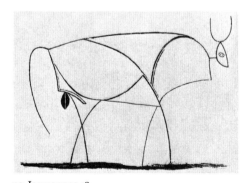

10 January 1946

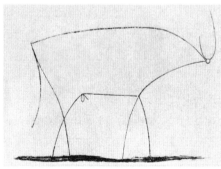

17 January 1946

Pablo Picasso, *Le Taureau* (The Bull), 5 Dec. 1945 – 17 Jan. 1946, lithographs, each 28.9 × 41 cm.
Mourlot 17, states I–XI. Collection of Bernard Picasso, Paris

description of the polyphony of pictorial elements, their creation in time and space and their merging into a whole, can serve as a practical guide to reading and looking at his pictures:

"Let's chart [...] a topographical map to embark on a short journey into the land of superior knowledge. Taking a leap past the dead point [of inertia], here is the first act of movement. (Line). After a brief pause to catch our breath ... (interrupted [line] or line broken at several points) ... we look back to see how far we have already travelled. (Counter movement). We picture following the path hither and thither. (Bundle of lines). A river obstructs the path, we use a boat. (Wave movement). Upstream, there would have been a bridge. (Row of arches). On the other side we meet a like-minded spirit, who also wants to go where greater knowledge can be found. United in joy at first, (convergence), differences gradually set in (independent execution of two lines). Some excitement on both sides. (Expression, energy and psyche of the line). We cross a fallow field (surface, crossed by lines), then a dense forest. He [the other traveller] loses his way, seeks and once even describes the classic motion of a running dog. I, too, have lost some of my composure: fog lies over a new river landscape (spatial element). Soon the atmosphere clears again. Basket weavers return home with their wagon (the wheel). Among them a child with cheerful locks (the corkscrew movement). Later, it turns humid and nocturnal (spatial element). Lightning on the horizon (the zigzag line). But the stars are still above us (a scattering of dots). Soon we reach our quarters. Before falling asleep, some things will return as memories, for a small journey of this kind leaves a powerful impression. The different lines. Dots. Smooth surfaces. Dotted, criss-crossed surfaces. Movement of waves. Restrained, structured movement. Counter movement. Weave, web. Wall structures, scaled structure. Unity. Diversity. A vanishing, then strengthening line (energy). The happy equilibrium of the first stretch, then inhibitions, [loss of] nerves! Suppressed trembling, gentle stirring of a hope-inspiring breeze. Before the storm, horseflies attack! Rage, murder. The 'good thing' as a guiding thread, even in the thicket and in twilight. The lightning reminds one of the temperature chart ... of a sick child ... long ago."

This account clearly explains what Klee means when he speaks of art as a creative allegory. To him, the surface, the canvas or paper is a little garden of paradise from which pictorial elements grow like plants, exploring their potential in the transitional spheres between figure and abstraction, form and idea. With his creative intuition Klee joins in the creative process like a gardener who coaxes the plants into full bloom. His titles are full of garden and plant metaphors.

Christ Child with Yellow Wings, 1885, 2, pencil and chalk on writing paper, mounted on cardboard, 9 × 6.3 cm. Paul Klee foundation, Bern. Inv. no.: Z II

The Romanticism of the nineteenth century shines through in Klee's œuvre, in which the genesis of art, the path, is reborn Klee had no interest in what he sometimes referred to as the 'formal end', but in the forces that give rise to pictorial in modern form — natura naturans instead of natura naturata.

Klee had no interest in what he sometimes referred to as 'formal end', but in the forces that give rise to pictorial form: nature as genesis. With the artist himself a part of it. Klee's introspective, self-exploratory art, which was constantly in search of new solutions to achieve the deepest level of meaning, is a living example of art as seeking. His experiments with pictorial form have the sole purpose of searching for the most profound degree of expression, of which this exhibition is eloquent testimony. To Klee, the final step was to give — as he called it — his 'objective consent' to the shape, still undefined, still floating between abstraction and representation. In other words, he invented a title. In so doing, he took care to point out that the title need not be binding, that it shouldn't be

taken literally: "The signatures (titles) only point in a direction I feel. Do not equate the signature with intent."

Klee's titles are poetic, full of subtle humour, which is light but also melancholic. In the graphic works especially, the titles in Klee's precise clerk's handwriting stand in deliberately naive contrast to the complexity of the composition. Each of Klee's images is directed at the individual viewer, inviting him or her to meditate. In contrast to Picasso, of whom few aphorisms on art and his own work are documented — Picasso presents a vivid series of pictorial experiments, instead of a theory — Klee has left an impressive legacy of theoretical and personal writing. His diaries alone, which he kept from 1889 onward, are an exceptional document of an artist's development. They reveal the discipline and persistence with which Klee pursued pictorial perfection. Picasso, the child prodigy, seems to have been born with it. But the main concern in Klee's writing was to create a compendium of his theories on art and the creative methods, which he diligently developed with rigorous logic between 1921 and 1931 for his teaching at the Bauhaus in Weimar and Dessau and at the Düsseldorf Academy. There are some 4,000 manuscript pages of notes and sketches from that period, which Klee planned to publish in a collection under the title *Bildnerische Gestaltungslehre* (or 'Theory of Creative Design'), a project that was never realized. Klee, who came from a family of musicians, also wrote poetry. Felix Klee, the artist's son, has published a collection of his father's poems. The following is a free translation into English:

End of June
Night leaves with speed
Wide-eyed is the day.
■
Just one thing
Is near
Inside Me, a weight
A pebble
■
One eye that sees — a strange gaze —
The other that feels

Thou, quiet, alone,
You, monster,
My heart is yours,
My heart is thine!
■
Only unheaded steps, the plea
■

Klee's poetry falls within the tradition of German Expressionism. If proof were needed that it far surpasses amateurish rhyming, one need only note the title of literary scholar Roman Jakobson's book, published in 1976 as: *Hölderlin, Klee, Brecht. On Word Art in Three Poems.*

Pablo Picasso, who counted Guillaume Apollinaire, Max Jakob, Paul Iluard and Jean Cocteau among his friends and who frequently and exuberantly surrounded himself with writers, also tried his hand at writing. But lyric poetry did not suit his nature. In writing, as in his paintings, Picasso was in search of the dramatic. One of the best known examples is 'Le désir attrapé par la queue' (or 'How to catch desire by its tail'). Premiered as a recital in the home of Louise and Michel Leiris on March 19, 1944, the work drew obvious inspiration from Alfred Jarry's *Ubu Roi*. The surrealist farce — a protest against Fascism — was presented by an illustrious cast: Jean Paul Sartre, Simone de Beauvoir and Jacques Lacan were some of the readers, who performed the piece under the direction of Albert Camus.

Klee is the lyric poet, the gardener in his own enchanted garden, a paradise of Modernism. Picasso takes on the dramatic lead, he is Zeus in a heathen Arcadia. Alfred H. Barr, the former director of the Museum of Modern Art in New York, emphasized the lyrical qualities in Klee's œuvre in the foreword to the 1941 Paul Klee exhibition at the museum: "Not even Picasso can match his sheer power of invention. And his powers of imagination are easily equal to Picasso's; naturally, Picasso is much more forceful. Picasso's paintings scream or stamp or kick; Klee's paintings are engaged in whispered soliloquy — lyrically intimate, unfathomably sensitive."

Roland Doschka

KLEE'S INTERACTION WITH HIS OWN ŒUVRE

Public reception of Paul Klee's work occurred predominantly in the period beginning with his early successful exhibitions in Herwarth Walden's gallery Der Sturm in the fall of 1917 and ending with his final move back to Bern in the fall of 1933. Numerous exhibitions, reviews,[1] early biographies,[2] and acquisitions by museums and private collectors[3] document this period, in which Klee intensified his contacts to the art market,[4] made his mark as a teacher and master at the Bauhaus first in Weimar, then in Dessau, and at the Academy in Düsseldorf. This was also the period during which he wrote and published the bulk of his theoretical and pedagogical writings.[5] It seems to have been a time of stability and security in his private life; yet it was also a time of upheavals that affected not only his material position but above all his attitude towards his own œuvre. Klee began to influence the reception of his work with great deliberation, while presenting himself — and allowing others to present him — as a withdrawn and introspective artist.

Although he never explicitly admitted it, many of his works were in fact very much inspired by his immediate surroundings, the growing demand for his works, his experiences as a teacher and member of the Bauhaus, and the development of his own art theory. The close link between the works and their basis in theory was therefore justly emphasized, drawing attention to the reciprocal and complex interaction between theory and practice as a characteristic of Klee's œuvre.[6] This is evident not only in individual works, but also in Klee's interaction with his entire body of work. While no specific statements on the part of Klee are documented, his analytical approach — the compilation of an œuvre catalogue, the attention to mounting and presentation, frequent revisions, renewed exploration or even "recycling" of older works or themes, and especially the concept of forming an estate collection during his lifetime — reveal complexity that is largely still unexplored. What follows is an attempt to illustrate Klee's interaction with his own work between 1917 and 1933 in five steps.

1. Klee's Handwritten Œuvre Catalogue

In 1911 Paul Klee began to enter all the works he had created up until then in a notebook which he described as an œuvre catalogue.[7] The basic included the date, running number, title and a brief note on technique and/or materials.[8] From time to time he would add information on sales, change of ownership or exhibition history.[9] The most obvious reason for compiling this list was probably Klee's first solo exhibition in Switzerland, for which he was required to provide a list of exhibited works.[10] In a diary entry, which he subsequently revised, he described himself deprecatingly as a bureaucrat for undertaking this task; still, the fact that he compiled such a detailed index in the first place is a reflection of his particular interest in exploring and analyzing his own œuvre. In contrast to another list, begun while still in high school and abandoned in 1897, the œuvre catalogue contains only works which the artist himself now deemed as complete. Retrospectively, he struck all the drawings from his youth, various efforts dating back to his time in school and others whose artistic integrity he judged as not fully developed, such as the early landscape drawings and sketchbooks.[11] Klee continued to catalogue his work until shortly before his death, by which time it filled several cloth-bound notebooks and loose-leaf binders. The structure and function of the catalogue underwent several changes. Initially intended as an overview of his production to date to organize his first retrospective, the catalogue later became an important tool that helped the artist to administer his body of work, exhibitions, loans to prospective collectors and sales.

The œuvre catalogue as such has become a focus of discussion only recently. The main problem is that it was never questioned; instead, it has always been accepted as an infallible source. The process by which it was compiled and the relative character of the chronology it established were completely ignored. Klee's numbering seemed to provide a precise dating of the works, often adopted even during the

artist's lifetime, whose accuracy continues to be assumed to this day.[12] It is true that the catalogue corresponds to the artist's own understanding of his work and development, which is readily traced, and that the artist himself insisted that it remain unchallenged by art historians, critics and the public. For a long time, however, this uncritical acceptance of the dates and entries in the catalogue prevented any critical investigation of Klee's self-perception. Even if the chronological convergence or divergence between œuvre catalogue and working process can be solved for individual pieces, the principal dilemma remains: the strategy of the artist, his own perception and interpretation of the work is still unexplained. In the case of Klee, this is nowhere more evident than in the hand-written œuvre catalogue. The fact that this list represents a process in which not only works prior to 1911 but also those created at a later time were subjected to a deliberate selection expressed by the existence of an entry and its position, was ignored for a long time. This did little to address the problem of locating the titles of individual works, nor did it answer how the artist reviewed his body of work. The reworking of numerous pieces in the early 1920s and the re-evaluation that went hand in hand with this process was reflected in the catalogue. This development was founded, at least up until 1916, in a process that was by no means linear. Klee's assessment was especially critical with regard to the drawings and paintings prior to 1911. In the end, he included only eighteen of his works from childhood and youth.[13]

It is important to note that Klee didn't immediately include all relevant works, listing them in part only after 1916, and also omitted numerous works to which he either no longer had access or of which he had created two versions. Aside from his childhood drawings, he also abstained from including many other early works. *Only Self* (1899, 1), *Adventurous Fish* (1901, 1) and *Floating Grace (in the style of Pompeii)* (1901, 2) from the period before and during his journey to Rome were at least retrospectively recognized by the artist as worthy of inclusion.[14] As Okuda has shown, the chronology in the registration of these early works was fairly chaotic, perhaps an indicator of Klee's attitude towards his work at that time. By the end of the First World War it had changed, however, and he began to add works created after his return to Bern in 1902 and the move back to Munich in 1906, thereby recognizing these early pieces as finished works of art.[15]

During the First World War, specifically from 1916 onwards, Klee had the catalogue duplicated and from that point forward he continued to keep two copies. The same is true for the period from 1930 to 1933, when he made entries into his "main book" and into a copy. In this manner there was always an up-to-date list in both studios, in Dessau and in Düsseldorf. The early catalogue duplicates, listing works prior to 1921, are particularly helpful in establishing an understanding of the indexing, chronology and the grouping into creative periods of the early entries.[16] This is important with regard to the process involved in establishing titles and subsequent overpainting. The discrepancies between catalogue original and duplicate also provide insight into how Klee developed his cataloguing system, which he began to apply, from the early 1920s on, in other areas as well. The easiest approach is to focus on the accompanying notes, assuming that entries with identical script and writing tools were made in the same period. Although this is not sufficient to establish precise dates, one can differentiate individual cataloguing phases, at least until 1920.[17] From 1918 to 1920 Klee used not only different pens and inks, he also made entries in indelible pencil and India ink.[18] After 1920, he always used a fine-tipped fountain pen and black ink and the notebooks become less distinctive in appearance from that point forward, making any deductions as to grouping etc. more difficult.

It is reasonable to assume, however, that Klee did in fact continue to group works, often retrospectively. The date of creation was not the primary criterion for establishing sequence, as is evident in his notes during the 1920s. Klee grouped paintings, followed by watercolours or coloured works on paper, and then drawings, even if they were sketches for paintings listed higher up,[19] thus providing insight only into each phase of cataloguing, but not into the chronological relationship between the works themselves.

The revisions to titles are a different matter altogether: while they do not decrease overall in the early twenties, they are fairly manageable in scope and there does not seem to be a particular system at work.[20] The titles often reveal the provisional character of the original catalogue entries. In general one can differentiate two approaches, easily spotted in a comparison of original and duplicate. The latter often lists only the original title, without notation of any subsequent changes. The œuvre catalogue, on the other hand, clearly documents Klee's process to establishing titles of works: in

some instances Klee would note a preliminary title in pencil, which he subsequently confirmed in ink; in other cases he revised existing entries. Both approaches demonstrate that Klee reviewed his early work several times and each review was reflected in corresponding revisions.[21] There seems to have been no particular system, for even within individual groupings, catalogued at the same time, or similar works, there is no evident pattern as to why some titles were changed, while others remained the same. The fact that not all pieces in a group or works otherwise related in form and style were subject to such revisions, suggests that Klee regularly revised individual entries in pencil whenever he felt it necessary to do so.[22]

Other characteristics of the handwritten œuvre catalogue also confirm that it should not be interpreted as definitive. Two aspects in particular support this position: firstly, the rare so-called subsequent entries and secondly Klee's own cross-references to other works. Klee indexed numerous works once he started his catalogue and although works prior to 1911 were theoretically included, it is evident that some were added only at a later date. Okuda cites many examples of subsequent entries in the years 1910 to 1920, concerning 46 pieces in total.[23] Even after the cataloguing system had been consolidated and the artist began to update it fairly regularly, one can still trace omissions, subsequent entries (thus in 1919) or even queries as to the date of individual works. Numbers 251 through 265, for example, are crowded into less space, written with a finer pen tip and in some cases noted on a loose sheet that has been inserted into the notebook pages. Although not explicitly identified as subsequent entries, the style would suggest that that is exactly what they were. In the following year (1920), Klee added an asterisk to some of these entries, marking them down for 1920 instead of 1919, adding the footnote: "Nachbuchung" (or "subsequent entry"). Again in 1920, work No. 26 of the same year is not registered in the catalogue, nor is there any reference to it. In the following year, the entry *Landscape near E. in Bavaria*, 1921, 182, is accompanied by the note: "perhaps 1920?" His own doubts notwithstanding, Klee never changed the entry although he may well have realized that the style of the piece placed it in a different year. Until the mid-1920s the question of precise or approximate dating was obviously of secondary importance to Klee, whose main focus was clearly the working process itself and the relationship between individual works.

2. Klee's Cross-Reference System

Klee tried to create a system of references by choosing his titles accordingly and also by noting relationships between works in his œuvre catalogue.[24] In some cases, the two methods overlapped. 89 drawings bear titles that clearly identify them as precursors to another work or as originals later reprised in a print. In other words, the titles for these drawings were established at a time when titles for the related works already existed or catalogue entries where the running number is included in the title. The titles to a small number of prints, all lithographs based directly on a previous drawing, include information on the original sketches, which clearly predate the lithographs, that is they had already been registered in the catalogue at the time when the lithographs were added to the list.[25] These lithographs are all based on pen and ink drawings, with the exception of two pencil drawings. As was his practice with watercolours, the artist often returned to works created several years earlier. While some early prints were still based on drawings created more or less during the same period, this soon changed and all subsequent graphic works were based on drawings and sketches from 1915/16, illustrating how Klee used printmaking to analyze and study his own work. The titles of etchings never made reference to the drawings they were based on; instead they were listed in a separate category in the œuvre catalogue.[26] While the early etchings were original in design — in keeping with Adam von Bartsch's postulate that graphic works which are not based on other works have a higher intrinsic artistic value[27] — the lithographs were almost exclusively on just such a practice of reprising images from works executed in other media.[28]

By contrast, drawings whose titles indicate subsequent watercolours and paintings or reference other, earlier drawings are far more frequent. As is the case with the lithographs, the artist's personal view on these works is evident in how rarely they were exhibited. They do, however, provide a record of Klee's efforts at documenting the working process itself, keeping track of the source on which the relevant other works (e.g. paintings) were based. Obviously this record was not intended for public perusal. Klee stopped selling drawings from the mid-1920s onwards[29] and he refused to release them to his art dealers[30] — although he had been praised as an extraordinary draughtsman.[31] This was an attitude, which he also emphasized to his wife.[32]

Altogether, this approach has resulted in some confusion. The drawings created prior to 1921 and after 1930 were neither mentioned in critiques and other publications nor exhibited; the result being that Klee's contemporaries were largely ignorant of these works. Avid followers could only gain access to this area of Klee's work through the reproductions published in Herwarth Walden's periodical "Der Sturm" and in the "Sturmbilderbuch." The latter were used by Will Grohmann as illustrations for his essay[33] and published in his catalogue of drawings compiled in 1934.[34] Grohmann tried to diminish or even counteract[35] the private nature of the drawings.[36] Although he declared that the drawings were an "equal component in the entire body of work" next to the watercolours and paintings, he overlooked the fact that Klee himself had already applied a traditional hierarchy to his works through the form in which they were entered into his own catalogue. In 1919, Klee had begun to index paintings, followed by watercolours, and thirdly, the corresponding drawings, apparently as the least 'valuable' medium.[37] While this system does little to establish chronological order, it is an expression of Klee's own academic, museological valuation at the beginning of his career. It simplified the task of indexing, since Klee was able to avoid having to repeatedly enter identical information. From this point forward, Klee viewed drawing in a completely different light: what he had previously regarded a medium worthy of exhibition, became an intensely private activity whose main function seemed to be one of preparation. Grohmann was faced with a conflict, and he found himself in the position of having to declare the drawings as a body of work whose usefulness lay in the fact that it served to explain Klee's creative mind and his intentions. For this reason alone, they should be ranked as highly as the paintings and watercolours. On the opening pages of his book, Grohmann was therefore careful to emphasize that the drawings express everything that is implied in the paintings and watercolours, for "all that Klee has to say is fully contained within them, inasmuch as it can be expressed by graphic means."[38] Accordingly, Grohmann was able to "fully define the character of Klee's art [...] on the basis of the drawings."[39] Naturally he was only able to do so by representing Klee as a metaphysical artist — very much in keeping with Klee's own self-mythologization — capable of imaging fundamental human values and themes by plumbing the depths of his own inner self.[40] The unconscious, which played an important role in this process and could only find spontaneous expression — in analogy to *écriture automatique*[41] — is the central idea in Grohmann's interpretation, thus transforming the private nature of the drawings into an inherent quality of the creative personality.

While this evaluation by Grohmann corresponded to Klee's basic attitude, it seemed to invest the drawings with far greater importance than their exhibition history — or lack thereof — seemed to suggest. Few drawings were exhibited in the 1920s and early 1930s, and the inclusion of drawings in the three major retrospectives — 1920 in Munich, 1923 in Berlin and 1935 in Bern — varied widely. In 1920, Klee's main intention was to present himself as a painter, and the drawing component of the show was relatively small with 103 exponents. The Berlin retrospective, on the other hand, aimed at offering a more comprehensive overview of his graphic work, focusing especially on the second half of the 1910s and the years immediately after the end of the First World War.[42] By contrast the Bern retrospective treated drawings in an almost marginal manner.[43]

While several drawings were included in the two major exhibitions of collections — the Ralf collection in Berlin in 1930 and the Hannah Bürgi collection in 1937 — this was largely due to the composition of these private collections. The presentation of these exponents was hardly sufficient to provide the public with an overview of Klee's body of graphic work. It is fair to say that Klee withheld this area of his art, so explicitly valued by Grohmann, from the public eye in all these major exhibitions, especially the three retrospectives. Very few people could therefore gain first-hand knowledge of Klee's graphic work, and the bulk of these works, especially those that served as studies for other works, remained largely unknown. This allowed Klee and his biographers to promote the impression that the watercolours and paintings were entirely spontaneous and original visions, even though Klee had an enormous inventory of drawings, which had clearly served as preliminary studies, and which he carefully documented and utilized through his own system of cross-references.

As mentioned at the beginning of this section, Klee's other method of establishing a reference system was to annotate relationships between works in his œuvre catalogue. Klee developed both methods discussed here more or less concurrently: the annotations begin to appear in the catalogue

around the same time as the cross-references appear in the titles of drawings. More examples have been found for this second method, 285 altogether encompassing works from 1904 to the early 1930s.

The notes not only served to highlight a close relationship between individual works, but also to point to other, much earlier, principles and ideas that may have taken on importance in a new context or served as an inspiration many years later.[44] Seen in this light, one can readily understand why the annotations are the most voluminous of all the catalogue entries, nearly four times as much as the notes on later works or notes made when a work was first catalogued.[45] The retrospective addition of these references clearly demonstrates that Klee not only re-evaluated his drawings throughout the 1920s, but also applied the method to much earlier drawings. He even revisited drawings from his journey in 1914 to Tunisia, and the drawings from the early war years.[46] This process of self-referencing — both with regard to earlier drawings and newer works in colour and with regard to drawings and paintings created during the same period — seems to contradict Klee's self-mythologization and the image that was in part promoted by biographers and art critics.[47] Like Grohmann and Einstein, they postulated the spontaneous and extraordinary subjectivity in the artist's work. This impression could only be maintained, however, for as long as the watercolours and paintings were studied in isolation from the drawings that had preceded them.

There exists an entire group of works, where this separation was vitally important from a marketing perspective: the oil transfer drawings, which Klee also described as original transfer drawings or oil drawings. Derived from sketches and drawings, technically speaking, they are in truth a hybrid between original and reproduction, being both unique works in the manner of a monoprint but at the same time the product of a printmaking process. Although varying in colour, they are distinct above all in their quality of line, which clearly echoes the original drawing, without, however, displaying any of the characteristics of printmaking.[48]

Klee viewed these oil transfer drawings very differently from the lithographs. In both cases he tended to simply vary or directly copy an existing drawing. Ever since his contribution to the SEMA portfolio, he tended to regard lithography as a relatively minor art form. Conversely, his dedication to oil transfer was considerable. The number alone — 340 altogether — is proof of Klee's strong interest in this medium. Based on his drawings on transfer paper from 1911, Klee didn't continue his experiments with the transfer process until 1919 and it was then that he discovered oil transfer or oil drawings. No doubt the greater remuneration for coloured works on paper (two to three times the price of drawings) was a contributing factor in his attempts to achieve a more efficient approach to his watercolour production, but this can hardly have been the main inspiration. While Klee usually copied the composition, lines and hatching from the drawings, the difference in scale between drawing and transfer sheet, the placement of the drawing on the sheet, the colouring and other modifications demonstrate that he was not pursuing a form of mechanical colouration or quasi-industrial production of watercolours. Rather, he applied this technique as a rigorous translation of his ideas on composition and colour onto paper. Klee's penchant for experimentation with materials — discussed by Haxthausen[49] — is rarely evident in the more conventional prints, pencil or pen and ink drawings. It is, however, very much in evidence in the oil transfer drawings, especially in those that served as models for subsequent paintings.[50] In 49 pieces, some of which are paintings, Klee developed original ideas previously sketched in one or two drawings, which he then transferred. In each case, however, he incorporated additional colours and experimented with a variety of primers and backgrounds to expand the expressive impact of the drawing. These basic differences between paintings based on an oil transfer drawing or a watercolour and the drawings that had preceded them are immediately apparent in a direct comparison of such works.[51]

The original model for the drawing *Fire Wind*, (1922, 190) (fig. 1) on which Klee based a painting of the same title in the following year (registered in early 1923 as entry number 43), was a painting on paper, which Klee had entered into his catalogue at the beginning of 1922 under the number 17 (pl. 18).[52] In the original he had used a variety of motifs, some dating back to earlier works, and adhered to a nearly monochromatic, dark tonality enlivened with a few light red and beige accents. In the following, he reprised the window motif with the S-shaped forms and lines that were linked in perspective to the edges and corners of the principal figure. Rather than setting the composition into a horizontal format, as in the first painting, he enhanced it dynamically with

patterns of movement set along the left margin and accentuated the placement with a narrow house added on the right side. Still, Klee took care not to over-emphasize the vertical or portrait format. Thus the surface of the paper, textile in appearance and enhanced with the hatched lines,

fig. 1 *Fire Wind*, 1922, 190, pencil on paper, mounted on cardboard, 28 × 22.3 cm, Öffentliche Kunstsammlung Basle, Kupferstichkabinett, Bequest of Dr. Richard Doetsch-Benzinger, Inv. no. 1960, Ref. no. 3015

which is an important visual component in the work, stands in marked contrast to the apparent movement of the motif.

The painting based on this drawing has a completely different effect. The lines —— in pencil in the drawing, oil transfer in the painting — have lost their original lightness and characteristic variation. They are superimposed on the animated, modulated oil underpainting as wide, solid black lines. The differentiation in the drawing — expressed in a darker line for the principal S-shape, finer lines leading the eye towards the figure, and as horizontal hatched lines — has been abandoned in favour of an emphasis on contour. The lines no longer serve to stress movement or fine gradations, but serve as boundaries between different colour fields in the image. This new sense of weight and solidity and the completely changed appearance of the image is emphasized by the vertical format, although the entire composition is less constrained in the image frame than it is in the drawing.

Similar observations can be made of the *Fish Image*, 1925, 5, (fig. 2), although here two drawings were placed one above the other to create the composition for the painting. Klee would sometimes focus on a detail in a drawing as a model for an oil transfer, at other times he would combine two or more drawings into a new composition. The advantage of this technique was that it offered great freedom in modifying existing compositions. In doing so, Klee would never simply transfer every aspect he had developed in the drawings. In *Fire Wind*, 1923, 43 (pl. 23), Klee also transferred all the hatched lines, albeit somewhat coarsened in texture. In the case of the two drawings, subsequently combined into the aforementioned painting *Fish Image*, 1925, 5, he omitted some of the hatched lines in the upper section, while reproducing others more forcefully. The most remarkable aspect, however, is the effect of the two drawings in combination. The first drawing for *Fish Image* (1925, 5), catalogued in 1924 as drawing number 279 (fig. 3), is very self-contained and solidly grounded along the lower edge of the sheet; the second drawing for *Fish Image* (1925, 5), listed in 1924 as drawing number 280 (fig. 4), on the other hand, is a vertical arrangement of fish images; in combination, the two drawings achieve a compositional whole. One has to be very familiar with Klee's specific oil transfer technique to realize that the linear component is based on drawings and that the work is in principle a transfer of previous pieces. The visual and tactile quality of the mounting surface is of little importance in terms of material aesthetic. The opposite was obviously intended; in other words, the artist did not wish to create the impression that the oil transfer itself was an original drawing. It is remarkable to note that there are 99 cases of oil transfers where no related drawing has been located or identified, all the more surprising as the process by definition requires an original. It is possible that Klee preserved and registered only some of the drawings used for oil transfers, or that some were destroyed in the process itself. Chronologically, however, the oil transfers must have been realized prior to mounting the relevant drawings on cardboard, as was Klee's practice, and titling and entering the work into the œuvre catalogue.

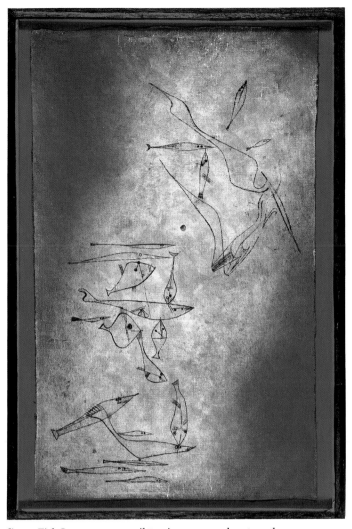

fig. 2 *Fish Image*, 1925, 5, oil tracing, pen and watercolour on plaster priming on gauze, mounted on blue primed cardboard, original frame, 60.5 × 40 cm, Rosengart Collection, Lucerne, Ref. no. 3686

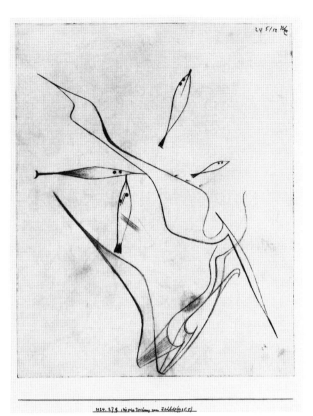

fig. 3 A drawing for *Fish Image* (1925.5), 1924, 279, 28.6 × 22.9 cm, pencil on paper, location unknown

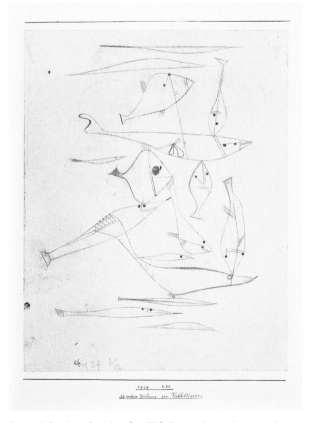

fig. 4 A further drawing for *Fish Image* (1925.5), 1924, 280, pencil on paper, mounted on cardboard, 28.8 × 22.7 cm, private collection, Ref. no. 3653

Another means of 'referencing,' although rarely employed by Klee, was to copy his own work in order to document invented images, especially in drawings, effectively creating a personal image archive. Contrary to other artists, who produced copies or variations of their own originals either for sale or for creative development, Klee excluded his copies from his body of work by clearly identifying them as such, thereby limiting their use for his own private and artistic goals.[53] All copies were made in 1926 and neither sold nor exhibited, with two exceptions: the earliest, a drawing from 1913, was repeatedly shown and sold to the Otto Ralfs collection; and the last copy was presented by Klee to his friend Hans Bloesch as a gift in 1938. The precise function of these copies, and the reasons why some were executed on paper and others on tracing paper remains unclear.

3. Mounting and Presentation as Visual Means

Klee's third approach to revisiting his works after completion was to address the issue of presentation. This was so vitally important to Klee, that he not only did most of his own framing, in some instances even painting the frames, but also mounted all his own drawings on cardboard, sometimes with a coloured border. Klee had begun early on to mount works on paper on cardboard, on which he noted at least the date, and later also the full catalogue number, usually the title, and sometimes even a dedication.[54] The mounting and registration process is rarely identical. Some early works were obviously mounted at a later date, as is documented in the style of identification[55] or the identifying information is executed in two different media (e.g. pencil or ink) pointing to different dates for mounting and catalogue registration. As we have shown in the section on catalogue registration, this process was rarely completed by simply mounting the work on cardboard, at least in the period preceding the early 1920s.[56] The variety in writing tools prior to 1911 suggests that these may have been mounted at an earlier date and re-evaluated after he began the œuvre catalogue, a process that led to revisions and additions in some cases. There is little consistency, however, evident in the fact that the style and method of identification for some early works matches that used at the beginning of the 1920s. As Okuda has shown, this may indicate that changes were made to some works at a later time.

fig. 5 Paul Klee's studio, Burgkühnaueralle 6–7, Dessau, 1932, Bequest of the Klee family, Paul Klee Foundation, Kunstmuseum Bern (F 853 / 12)

These different styles of identification can serve as a rough guide to establishing the period in which pieces were mounted or titled. While most early works were simply marked by year and corresponding œuvre number, later drawings bear the title on a separate line on the cardboard, usually with title on one side and work number on the other side. Klee applied both styles throughout the 1910s without any apparent system. Only after 1918 did the horizontal ink line appear, the so-called border mark. Sometimes it underlined the title and the work number, but often it served as a dividing line between the drawing and the entry. From 1919 onwards, we see the emergence of two such lines, one above and one below the drawing, as a kind of linear frame. Generally speaking, Klee applied this system mostly to drawings in the beginning; cardboard-mounted watercolours or small canvasses were similarly identified only at a later date.[57] At around the same time, circa 1919, Klee began to move the identification, i.e. title and work number, from the left or right corner of the sheet to the bottom margin and to underline it. This structured the space beneath the drawing and also influenced the appearance of the mount. It also provided Klee with ample room in which to annotate a particular title and work number.

Klee rarely signed drawings directly on the paper itself.[58] It was his habit to mount all works on paper onto cardboard, a practice from which he deviated only once. An acquaintance had offered to transport several pieces to art dealer Kahnweiler in Paris without going through the usual customs procedures.[59] In this case, Klee marked the title and work number on the reverse.[60]

Watercolours, on the other hand, were often accompanied not only by the aforementioned margin lines, but also by full

borders or even other coloured strips of paper, which gradually became important means of accentuating the effect of the mount.[61] Klee began using the strip of [coloured] paper only shortly after the First World War.[62] Again, these borders were often added at a later time when Klee was (re-)mounting an earlier work, in a process similar to his revisions of titles and notes. It was a means to further develop the marginal strips, for these were delineated with an ink line. The single or dual lines that had previously formed a horizontal border had changed into a wider strip that clearly separated the work from its presentation surface. Generally speaking, both the borders and the frames were harmonized with the watercolour, creating a clear visual separation but also enhancing the unifying quality. The result is an ambivalent relationship between mount and work. While the border is clearly part of the mount by virtue of its material, its colouring acts as a mediator between the work and the mount: the relationship is closer than in other pieces that are separated only by a margin line or not at all. The border blurs, but does not eliminate, the boundary between image and mounting.

This phenomenon is more pronounced in works surrounded by a border on all sides. The border isolates the work from the cardboard in the manner of a painting frame. As a result, the work appears more centered on the cardboard. Whether the work was executed on paper or on fabric such as canvas[63] or gauze[64] has little bearing, since the latter were often supplied with a paper backing.[65] Another method, independent of the immediate image surface, was to mount the original sheet, etc., onto a second sheet of paper[66] or to attach strips of paper along the sides[67], which were in turn either painted or simply monochrome papers. For purposes of accentuation, Klee preferred coloured[68] or metallic paper, usually gold or silver.[69] All works mounted in this manner, most created up until the early 1920s, and especially small works, are visually enhanced in this manner and achieve an effect that is almost like a painting.

But Klee's vivid interest in presentation is not only expressed in his attention to selecting mounting materials and styles.[70] In a letter to his future wife Lily he notes how a small painting[71] had gained much from being set into a traditional frame, although the frame profile was not entirely satisfying and Klee mentions that he may replace it with plain strips at some later date. The advantage of beveled frames

was their strong, albeit understated cross-section, which "provides a delightful contrast to the flat style of my works and is an external aid to elevate the compositions onto a pictorial plane."[72] This excerpt shows that the frame was evaluated with regard to its contribution to the overall visual effect and with view to making a work suitable for exhibition. In this case, the artist worked with an existing frame, whose measurements fit the work.[73] A suitable frame was finally selected through a process of experimenting with different solutions.

fig. 6 Paul Klee's studio, Palais Suresnes, Werneckstrasse 1, Munich, 1920, photo: Paul Klee, Bequest of the Klee Family, Paul Klee Foundation, Kunstmuseum Bern (F 1/9)

Studio shots from Munich (fig. 6) and Weimar (fig. 7) document this approach: some works are simply placed inside a frame, without attaching them, to test the effect. At the same time, these photographs reveal that Klee always studied the effect of a painting first, before moving on to the next step of finding an appropriate frame. Important or much-admired pieces were only hung on the studio wall once they were framed, sometimes to the point where the studio took on an atmosphere of an exhibition, such as in the Weimar studio or in the master's house in Dessau. All the works in this area of the studio were framed and hung as they would be in a gallery setting. The artist's preference for individual works is clearly evident. In Weimar and in Dessau, Klee found a prominent spot for the painting *Monastery Garden*, 1926, 116 (B 6), less by setting it apart from others, than by ensuring that it dominated the wall.[74]

The photographs also show that Klee used a variety of types of frames with differing characteristics. Aside from the traditional frames, which he used from the very beginning, we notice the emergence, from circa 1919 onwards, of plain strips attached to the stretchers to form a narrow edge frame. While this marked the boundary between image and surrounding surface, the separation is less accentuated. Even the beveled frames, which Klee continued to use, illustrate

fig. 7 Paul Klee's studio, Weimar 1926 or later, photo: Paul Klee, Bequest of the Klee family, Paul Klee Foundation, Kunstmuseum Bern (F 19 / 24)

that in all cases the overall effect took precedence, with the frame clearly subordinate to the (aesthetic) demands of the image field. Klee tended to favour a plain profile especially for paintings that were particularly strong either in colour or in motif, to add depth to the image. Despite his focus on the importance of framing and presentation, he would agree to change a particular frame if the existing one proved unsatisfactory to a collector, for example. In 1936, Othmar Huber bought the painting *Dwarf Fairy Tale*, 1925, 255 (Z 5).[75] Huber seemed irritated by the narrow frame, for he asked for permission to attach a second frame around the original framing strips (fig. 8). Klee asked his wife to respond that he agreed "that you can arrange to have a second silver strip, approx. 4 cm wide, attached to the frame. This would undoubtedly enhance the effect of the image on the wall. Another, albeit more elaborate, solution would be [to cover the walls] in a neutral wallpaper."[76]

The original image surface was a vertical oval cardboard, later mounted onto another cardboard, which was nailed to a wood frame and surrounded by narrow framing strips. It is unclear why Klee did not preserve the original oval shape, for there are many cases where the same approach to framing did not cause him to change the orientation of the image at the centre. Here, however, he emphasized the oval within the tall rectangular frame by drawing the eye to it through a light-brown edge. The material properties of this edge identify it as belonging to the second, markedly recessed cardboard, i.e. the same plaster priming and structure. At the same time it creates a visual link between image and mount. But since the edge doesn't simple follow the curve of the oval, widening to the left and the right sides, it diminishes the vertical orientation of the oval. The edge of the latter is not covered by the plaster priming; on the contrary, the internal image field appears as an embossed surface and thus as the primary component of the painting.

Only the secondary component of the painting, that is the rectangular cardboard covered in plaster primer, is enclosed by brown framing strips. Thus the double frame has not only functional meaning for the presentation of the work, as it does in other instances, but the frame and the manner of surround combine into a unique three-dimensional structure that separates the work even more from its surroundings.[77]

Klee also took care to preserve his work behind glass.[78] What is surprising, is the intensity with which he investigated a wide variety of presentation options. The setting into customized frames, the experimentation with a variety of borders and the process of mounting the works became important factors through which the artist could determine the effect his works would have.

4. The Creative Process

The mounting on cardboard, Klee's desire to re-evaluate paintings and modify details, the cross-referencing, the relationship between drawing and oil transfer, or drawing, oil transfer with watercolour wash and painting, on the other hand, all demonstrate that the artist's involvement with any given piece wasn't necessarily completed upon entering it into the catalogue. As we have shown, many motifs were

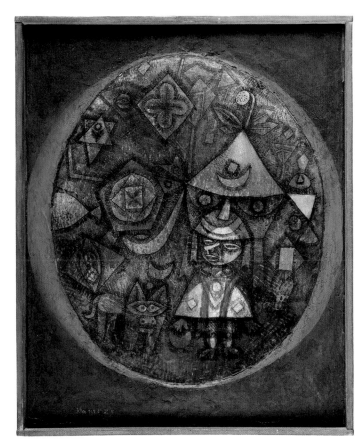

fig. 8 *Dwarf Fairy Tale*, 1925, 255 (Z 5), watercolour on cardboard, mounted on cardboard with watercolour on plaster priming, nailed onto wooden frame, original frame, 43.4 × 35.4 cm. Private Collection, Switzerland, Ref. no. 3937

repeatedly explored, existing works fragmented and such details elaborated in a number of ways. These are all standard creative processes on the path to the final realization of a work of art. It is therefore not unusual that Klee, too, frequently explored similar or even identical motifs again and again.[79] What is unusual is the timeframe and the intensity with which he did so, but not the fact in and of itself.[80] In this context, the fragmentation of existing compositions offers a more specific and interesting line of inquiry. Kersten and Okuda have conclusively explained how the cutting up or dividing into parts of works represented a highly conscious method that was integral to the entire process.[81] Here one must differentiate between dissected and reconfigured works[82] and those that derive from details taken out of a larger original composition, whereby the new sections were treated as individual pieces of work.

Both approaches spring from the same source, namely Klee's own dissatisfaction with a particular piece or his

view that a work was somehow unfinished. The attitude towards his œuvre, however, is fundamentally different in each case. In the case of recombining existing parts, a composition is first cut into pieces, which are then re-assembled on the same cardboard into a new composition.[83] Far from being a purely destructive process, this method subscribes to an inherently constructive principle.[84] Thus far, studies have shown that the parts were newly assembled and then reworked in detail, or that the new assemblage of otherwise unchanged pieces constituted a new piece in itself.[85] This is the categorical difference between these and other works, which Klee also cut into pieces, but where he treated each individual piece as a new work on its own, to be mounted separately and modified if he deemed it necessary. The latter approach erased any concrete link to the original image.

The reverse sides or images, which were used as surfaces on which to mount other works, are a different matter altogether and come to light only in the course of conservation efforts. In some drawings the presence of additional drawings on the reverse side is obvious, because the medium has bled through. It is much more difficult to determine similar instances in paintings. Nevertheless, 38 paintings have thus far been discovered, which were completely covered over by another layer.[86] These are efforts, which Klee rejected out of hand, that is he did not select them for further work. Instead of destroying them, he simply reused the surface.

A typical example is the painting *Jumper*, 1930, 183 (C 3) split 1 (pl. 59), executed in watercolour and pen and ink on cotton, and originally mounted onto a plywood. This board in turn was covered in a composition, probably an oil painting from 1929 (fig. 9), which Klee later chose to reject. More frequently, however, Klee followed the practice of many artists, by simply turning the surface over and painting onto the other side.[87]

Naturally Klee never entered cast-offs into his œuvre catalogue. Nor did he note the cutting up, over-painting or restoration of damaged sections. And here scholarly investigations of Klee and his art encounter a very specific problem. Naturally Klee never included cast-off pieces, be it that they were on the reverse side or used as a mounting surface for another work, into his oeuvre catalogue. Nor did he note the cutting up, painting over or restoration of dam-

aged sections. This is precisely the point where scholarly studies of Klee and his art encounter a very specific problem. The work *Botanical Theatre*, 1934, 219 (U 19) (fig. 10) perfectly illustrates this problem. Klee probably began to work on this painting in 1923. In 1924, he entered a painting into the catalogue that might be identical to the *Botanical Theatre* from a technical perspective.[88] The fact that the first version of the painting bore a different title, listed in the catalogue as *Tropical Landscape*, is certainly interesting but not unusual. What is unusual, however, is that we have precise information of the period during which Klee focused on this painting. He finished it on July 10, 1934,[89] entered it into the catalogue under that year and with the work number and title by which it is still known today. Surprisingly, both dates are inscribed in the top left corner of the painting, directly beneath the signature, for the numbers "24, 34" can hardly constitute a catalogue number. Firstly, Klee always indicated years by all four digits, and secondly he had already registered a drawing under this work number, a fact he would not have overlooked.[90]

He eradicated the process that ultimately led to this painting. The prerequisites and the duration of the working process, and thus the cross-referential context and the stylistic evolution, are erased, surviving only as an outcome in the finished piece, but no longer as an active, creative exploration. Since Klee rarely chose the time of completion as a date for the catalogue entry, instead citing the time when a work was begun, thereby negating the fact that he had reworked the same piece, the numbers and dates given to any particular piece can at best communicate when Klee worked on it, and not when it was completed. Klee's numbering process adds to the confusion. Early biographers of Klee's work simply accepted these numbers as accurate, without any further critical investigation, thus building a body of research and reference literature that negates the procedural character of the genesis,[91] and reinforces the myth of spontaneous, unstudied creation. *Botanical Theatre*, 1934, 219 (U 19) (fig. 10) is by no means an isolated case. Closer analysis of this painting clearly reveals the individual phases.[92] A comparison with Klee's entries into the œuvre cata-

logue in 1923 shows that he must have begun with this piece at around the same time. Some of the figures and the central composition are characterized by the hatched lines that defined the principal form, a stylistic element which he only developed during that year.[93] In contrast to the subsequent development, which should be placed circa 1924, these

fig. 9 *Untitled*, 1930, 183 (C 3), split 2, oil on plywood, originally together with *Jumper*, 1930, 183, cat. no. 5299, 51 × 53 cm. Gift of LK, Klee Museum Bern, Ref. no. 5300

hatched lines maintain an inherent transparency of background. Only in the following year are the lines combined into a dense structure—visible in the areas along the left and right edge of the painting—that results in a medium-light, rather colourless monochromatic appearance.[94] The flower motifs were added in a third phase, circa 1925 or 1926; these are strongly reminiscent of the floral figures, called 'radiolars,' and positioning of plants in deliberately discontinuous space and lack of perspectival depth. This addition alone creates an internal tension, since different, mutually exclusive intentions collide in the same image. The style thus far, corresponding at least to some degree to conventional ideas on space and perspective, is largely overthrown. In contrast to the cubist dissection of space, which Klee practised prior to and

at the beginning of the First World War, individual elements are now shifted into a frontal perspective and placed side by side on the same plane. The next step, which brings us forward to 1930,[95] continued the exploration of plant motifs and the problem of perspective, but focused above all on a different structure of colour, which Klee developed around 1925,[96] but had not applied in a similarly expansive and dominant manner before 1930. Using a wide brush, he applied colour in a manner that produced a secondary structure with a unique effect that was independent of the composition. The final steps — and here we can no longer differentiate between individual areas, at least stylistically — aimed at integrating the different preceding phases to give the piece a more homogeneous appearance.

This entire process is negated by the apparent precision of the number and date entry. As a result, we are denied access to this individual piece as a manifestation of the artist's creative development or his reflection on his own work. Instead, the artist postulates a non-genetic finality in surprising contradiction of his own art theory. This entire process is negated by the apparent precision of the number and date entry. As a result, we are denied access to this individual piece as a manifestation of the artist's creative development or his reflective investigation of his own work. Instead, the artist postulates a non-genetic finality, surprisingly in stark contrast to Klee's own utterances on the theory of art.

5. Gifts, Dedications and the Estate Collection

The last aspect of Klee's approach to his own body of work was largely concerned with its economic value by defining prices, reserving works as not for sale or presenting pieces as gifts to family members, friends and collectors. Klee exchanged works with some of his artist friends, always ensuring that such exchanges answered not only to the purpose or preferences of his colleague, but also represented a comparable value for what he received in turn.[97]

Similar principles were applied to gifts made to family members or collectors. The dedications generally include not only the name of the recipient, but also the occasion. Most collectors who received a gift from Klee, had lent their support to the Klee society, an association formed to provide financial assistance to Klee[98] and which furnished the artist

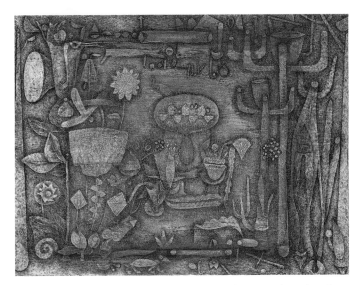

fig. 10 *Botanical Theatre V*, 1934, 219 (U 19) oil, watercolour, brush and pen on paper, mounted on cardboard, 50 × 67 cm, Städtische Galerie im Lenbachhaus, Munich, Gabriele Münter and Johannes Eichner Foundation

with a fixed monthly income. In turn, the artist agreed to put together a portfolio from which members of the association could purchase works at preferred prices.[99] The pieces included in these portfolios are generally not marked with personal dedications. Klee simply made a selection of works and ensured that they were circulated to the members. At Christmas 1927, however, four sheets received individual dedications: one each for Rudolf Ibach, Heinrich Stinnes, Werner Vowinckel and Hannah Bürgi. Only Ibach received a watercolour, moreover one from the preceding year, the others all received one drawing from 1927 each.[100] By choosing the watercolour, Klee complemented a selection of other pieces which Ibach had acquired, rounding out the collection with this present.[101] Just as his gift to Ibach was a gesture to acknowledge his patron's previous purchases and his efforts in the context of the Art Association in Barm, the gift of the drawings was also a means to recognize the efforts of the other collectors. As mentioned earlier on, Klee did not sell drawings, but he would present them as gifts from time to time.[102] This decision was not solely based on financial considerations. It allowed him to offer something to his collectors which was otherwise not available. Moreover, the selection was always made in areful consideration of the other pieces already in each collector's ownership.[103]

The same is true of the gifts presented to Will Grohmann, Alois Schardt and Georg Schmidt, the three art historians

whose influence on his career had been considerable in the 1920s and 1930s. It was rare for Klee to make such gifts — aside from exchanges with other artists or gifts to his wife Lily. But he made an exception in the case of these three art historians.[104] In return for financing the journey to Tunisia, Klee had given several works to Charles Bornand[105] and duly noted so in his œuvre catalogue; in yet another instance, Klee had expressed his thanks for receiving a cat with a drawing of a cat.[106] Thus the gifts to the art historians should be seen in a similar light. As was the case with collectors, these were hardly unconditional gifts; rather, each piece was presented in recognition of an act of support, of which Klee was only too aware, no matter how 'private' the gesture may have been.[107] The rare occasions on which Klee presented a gift to gallery owners and art dealers were slightly different in nature. They generally responded to some concrete event, although rarely a direct material value. It would be wrong to say that all art dealers, with whom Klee maintained lively contact, were the beneficiaries of such donations. Obviously, the decision to donate a work was primarily based on whether he viewed the dealer first and foremost as a person in charge of an institution that was of vital economic importance to him, or as a friend. Dealers with whom he had only professional contact were not included in the circle of gift recipients, with the exception of Alfred Flechtheim, to whose fiftieth anniversary portfolio Klee contributed a piece. Galka Scheyer, on the other hand, who was not only a collector but also tried to promote his work in the United States, received several pieces.[108]

The third instance, finally, refers to gifts and dedications to friends and family members. Friends, such as all Hans Bloesch[109] or the Galston family, received gifts on various occasions. Some marked specific events, such as a birthday. The gifts to the Galston family generally commemorate experiences that had obviously made a profound impression on Klee, who was especially close to their young daughter Florina Irene to whom he presented several gifts in an effort to distract her from her illness.[110]

Klee was much more likely to give works to family members than to friends. Already in his youth, Klee had presented several works to his aunts without marking a particular occasion.[111] Some works presented to family members, his wife Lily or a small circle of friends, carry specific dedications, but most of the pieces given to his parents or his sister are without dedications. The volume of these gifts is considerable,

even if most are early pieces, although those given to Mathilde were entered into the œuvre catalogue in contrast to the gifts his parents received.[112] Most are drawings, although the gifts include a few watercolours and one *Hinterglas* or 'behind-glass' painting. Later works and especially paintings were never presented as gifts.

The artist's gifts to his wife Lily are a different matter. With the exception of an early etching and two drawings, both especially selected — one through the title and the other through inclusion in their guest book — Lily received almost exclusively watercolours and paintings.[113] The etching aside, Lily's presents did not include examples of his early work or of his mature work after 1934. Lily received predominantly works created in the 1920s and early 1930s, probably at her own wish. It seems that she felt especially drawn to the pieces created in 1923, for she received three from that year alone, one in her guest book and two watercolours, given over the course of the years and retrospectively dedicated to her.[114] Surprisingly Klee chose original works as Christmas and birthday presents only twice.[115] Invariably his selections for Lily focused on restrained and gentle pieces.

The Estate Collection

Even prior to entering into his contract with Hans Goltz, Klee had identified several works as 'not for sale' although they were included in commercial exhibitions.[116] In other words, he began to differentiate early in his career between works that were intended for sale, drawings for gifts and donations with appropriate dedications, and a third category, works that would eventually form an estate collection.[117] With regard to the body of work released for sale after 1925, especially works on paper, Klee developed a system of pricing by classifying the individual pieces into categories.[118] This applies to all works, including his early œuvre, in as much as they were brought onto the market after 1925. Naturally the price is a reflection of Klee's of own valuation of a particular piece. It is still unclear how Klee arrived at this system and what his criteria were in defining categories. In the following, an attempt is made to reconstruct his approach at least with regard to the estate collection.

It is important to distinguish between the works chosen explicitly for the estate collection — i.e. pieces that were

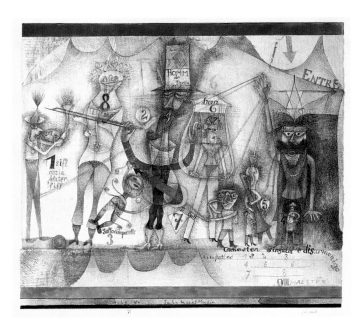

fig. 11 *Music at the fair*, 1924, 164, watercolour on paper, cut and recombined, strips of watercolour and pen on the top and bottom, on the bottom two more strips of watercolour and pen, mounted on cardboard, 26.5 × 30.5 cm. Private Collection, Switzerland, Ref. no. 3536

exhibited but from the outset reserved for the artist's private collection — and those, which were excluded from the body of work for sale because the artist had given them a special price category. The importance of this differentiation lies less in any conclusions one might draw with regard to the artist's own evaluation, but as an indication of the fluctuations in the intensity with which Klee analysed his own œuvre over the course of time. And it is especially instructive to consider which pieces Klee selected from his impressive and extensive body of work as being so significant that he wanted to reserve them for himself or as part of his estate. Moreover, it is important to distinguish between the motivation behind the selection and the time when it was made: the reservation of works for his own collection served Klee's interests at the time; the concept of an estate collection, on the other hand, reflects a desire to direct the reception of his artistic legacy.

Dedication of a work by an artist to himself is perhaps the most spontaneous form of evaluating his own work, and astonishing as it may seem, Klee did so in two cases. Both must have occurred after his return to Bern in the fall of 1933, for both had previously been left for sale with Rudolf Probst. But when Probst returned his inventory to the artist in November 1933, the shipment included these two pieces. *Music at the Fair*, 1924, 164 (fig. 11) and *A Garden for Orpheus*,

1926, 3 (fig. 12), were by then nearly ten years old. Evidently, receiving these works once again into his own possession prompted a re-valuation and the artist reserved them for his private collection. While both works are representative of Klee's work in the 1920s both in technique and in style, they are unique in terms of theme and artistic vision. After inclusion in various shows prior to his emigration, these pieces were not included in any of the major exhibitions Klee mounted in the 1930s.

Klee showed similar restraint in the selection of works reserved for his private collection. While two pieces were marked as 'private collection', it is unclear what Klee's vision of such a collection was.[119] And the few examples of works chosen from the studio in Bern do little to cast a light on this issue. However, three major exhibitions no doubt helped to establish a more concrete idea in the artist's mind. These were the exhibitions in Bern,[120] Basle[121] and Lucerne,[122] conceived not as museum retrospectives but as sales exhibitions. The exhibition catalogues include Klee's price recommendations as well as his thoughts on the unsuitability for sale of individual works, which he expressed only with regard to two works in the three exhibitions.[123] Clearly, there was no established terminology. Works listed as 'not for sale' in one catalogue, were listed as 'private collection' in another. For all three exhibitions Klee chose exclusively works created after 1919. Earlier pieces and even works from his journey to Tunisia, which had helped to establish his career, were not included in these exhibitions, which focused on the 1920s. Very few loans were included, with the exception of a few pieces from Hannah Bürgi's collection for the Basle exhibition. The number of exponents aside, the exhibitions differed in terms of emphasis and layout. The first in the series, the exhibition in Bern, presented Klee's work with over one hundred paintings and some 150 watercolours, offering a comprehensive overview of his work since 1919 and ending with the recently finished painting *Botanical Theatre*, 1934, 219 (U 19) (fig. 10). The watercolours were selected from a much later date onward, that is after 1925, while his selection of drawings was even more radical, showing only pieces from the year prior to the exhibition. The exhibition in Basle followed a similar approach, paintings and watercolours were listed separately in the catalogue and cover the same periods as those shown in Bern. The selection was smaller in scope, however. Notable, too, was the exclusion of drawings,

which were only shown again in the following year in Lucerne. There, the exhibition was structured in a radically different way. Paintings and watercolours were no longer presented as separate categories, and only a few drawings were reserved as not for sale, as they had been in Bern, or without price recommendation, as in Basle. Several works, both paintings and watercolours, were identified as 'not for sale' or as 'private collection' in at least two of the three exhibitions.

The selection for these exhibitions is a reflection of Klee's own evaluation of the works during each period: not all pieces were included in each exhibition and he changed his mind with regard to which pieces were marked as 'not for sale.' By contrast, the selection for the planned estate collection was more definitive, albeit more limited. In addition to one print each from the lithograph editions of *Vulgar Comedy*, 1922, 100, and *Witch with Comb*, 1922, 101, this preliminary estate selection included only one behind-glass painting and one painting on canvas from 1919.[124]

Still, these three areas represented only a small portion of the estate collection of works in colour. Most of the approximately two hundred and fifty were 'selected' by virtue of elevating them into a certain price category. In these cases he did not adhere to his own system of eight price categories, but gathered these works into a category of their own, which he labelled 'Sonderklasse.' This category included works that were not for sale, either to private collectors or to museums, but which could be shown in exhibitions. Retrospectively nearly half the works shown were included in this special category. Klee had begun to classify his works in accordance with a fixed pattern of prices only after his contract of exclusivity with Goltz was cancelled. Thus all price categories as well as the application of the special category to works created prior to 1926 were retrospective evaluations. There is no evidence of fixed criteria, although an investigation of some pieces, which Klee cut into pieces and subsequently included in the 'Sonderklasse' sheds some light on the issue.[125] It was rare that an entire grouping of new pieces created in this manner (see the paragraphs on Klee's approach to 'recycling' works and reassembling them into new pieces) were included in the special category. Most of the time, Klee reserved only one fragment for the special category, assigning the other fragments to one of the standard price categories. While the criteria for selection are difficult to reconstruct, we

fig. 12 *A Garden for Orpheus*, 1926, 3, pen and ink and watercolour on paper, mounted on cardboard, 47 × 32 / 32.5 cm, Paul Klee Foundation, Kunstmuseum Bern, Inv. no. Z 586

have more insight into the organization Klee envisioned for his estate collection. It is worth noting that Klee introduced this area of his œuvre with a colour drawing, which dates back to his stay in Italy, while including few other early pieces in the estate. With a mere five works up to 1910, this phase in the artist's career is clearly underrepresented, especially when one considers that he rarely sold any of the paintings behind glass.[126] This seemed to confirm the impression that he no longer valued the early work, which had consisted mostly of drawings, after 1920. They were rarely included in exhibitions and very few were added to the special category reserved for the estate collection. His treatment of subsequent decades was quite different. Following his years in the Blue Rider, he took care to include a representative selection from that period in the special category, even though this

selection was once again made retrospectively and only after he had experienced his first successes with these works. It is therefore hardly surprising that most of the works which Klee included in this 'Sonderklasse' fall into the period between his journey to Tunis and his teaching activities at the Academy in Düsseldorf. Klee included few of his works created after his return to Bern in the 1930s in the special category — a contrast to his active exhibition history during that time and his shipments to Kahnweiler, confirmation that this was a tremendously productive period. There is no doubt that Klee's selections from his own body of work for a special cat-egory reflect the artist's personal evaluation of his own works against the background of their reception at the time, offering us a unique insight into the artist's view of his own early and late work.

Christian Rümelin

This contribution is the first exhaustive attempt at constructing an overview of Paul Klee's management of his own artistic output on the basis of the catalogue raisonné. My thanks are due first and foremost to the Paul Klee Foundation, the Kunstmuseum Bern and the colleagues who helped to compile the Catalogue Raisonné Paul Klee, especially Danièle Héritier and Isabella Jungo for their assistance in gathering the data and providing critical help.

Plates

1 mit dem Regenbogen

1917, 56
Aquarell auf Kreidegrundierung auf Papier,
mit Aquarell eingefasst, auf Karton
17,4 × 20,8 cm
Privatbesitz, Schweiz

1 With the Rainbow

1917, 56
Watercolour on chalk priming on paper,
watercolour border, mounted on cardboard
17.4 × 20.8 cm
Private Collection, Switzerland

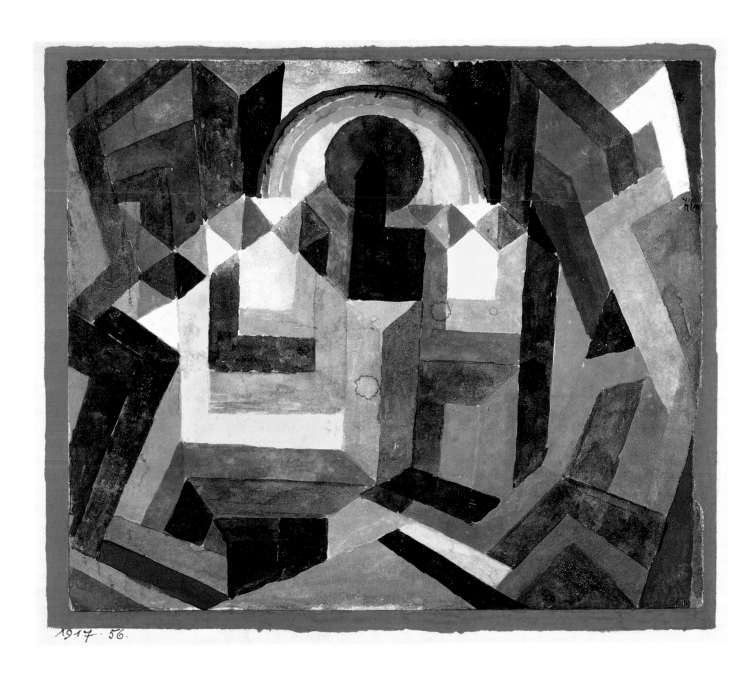

1917. 56.

2 Spiel der Kräfte einer Lechlandschaft

1917, 102

Aquarell auf Kreidegrundierung auf Leinwand

und Zeitungspapier, auf Karton

16,4 × 24,3 cm

Privatsammlung

2 Interplay of Forces in a Lech River Landscape

1917, 102

Watercolour on chalk priming on canvas

and newspaper, mounted on cardboard

16.4 × 24.3 cm

Private Collection

Klee

3 Berglandschaft

1918, 46
Aquarell und Gouache auf Leinen,
zerschnitten und neu kombiniert,
links und rechts Glanzpapierstreifen angesetzt,
auf Karton
12,8 × 22,9 cm
Privatbesitz

3 Mountain Landscape

1918, 46
Watercolour and gouache on linen,
cut and re-combined,
glazed paper strips added to the right and left,
mounted on cardboard
12.8 × 22.9 cm
Private Collection

1918 · 46

4 Burg mit untergehender Sonne

1918, 127
Aquarell und Feder auf Gipsgrundierung auf Leinen auf Papier,
mit Aquarell und Feder eingefasst, auf Karton
18,5 × 27,8 cm
Die Sammlung Berggruen in den Staatlichen Museen zu Berlin

4 Castle with Setting Sun

1918, 127
Watercolour and pen on plaster priming on linen on paper,
bordered with watercolour and pen, mounted on cardboard
18.5 × 27.8 cm
The Berggruen Collection, Staatliche Museen zu Berlin

5 E

1918, 199
Aquarell und Bleistift auf Kreidegrundierung
auf Papier auf Karton
22 × 18 cm
Privatbesitz, Schweiz

5 E

1918, 199
Watercolour and pencil on chalk priming on paper,
mounted on cardboard
22 × 18 cm
Private Collection, Switzerland

1919, 1919 (21 E)

6 kleine Landschaft

1919, 108
Öl- und Lackfarbe auf Leinen auf Karton
20,5 × 16,2 / 16,5 cm
Privatbesitz, Schweiz

6 Small Landscape

1919, 108
Oil and enamel paint on canvas,
mounted on cardboard
20.5 × 16.2 / 16.5 cm
Private Collection, Switzerland

7 Junger Proletarier

1919, 111

Ölfarbe auf Karton

24,4 × 22,7 cm

Schenkung LK, Klee-Museum, Bern

7 Young Proletarian

1919, 111

Oil on cardboard

24.4 × 22.7 cm

Gift of LK, Klee-Museum, Bern

8 Kosmische Architectur

1919, 162

Ölfarbe auf Karton

50 × 30 cm

Bayerische Staatsgemäldesammlungen,

Kunsthalle Augsburg

8 Cosmic Architecture

1919, 162

Oil on cardboard

50 × 30 cm

Bayerische Staatsgemäldesammlungen,

Kunsthalle Augsburg

9 Moribundus

1919, 203
Ölpause, Aquarell und Feder auf Papier auf Karton
21,7 × 28 cm
Sammlung Rosengart, Luzern

9 Moribundus

1919, 203
Oil transfer drawing, watercolour and pen,
mounted on cardboard
21.7 × 28 cm
Rosengart Collection, Lucerne

1919 203. Moribundus

10 Bild mit dem Hahn und dem Grenadier

1919, 235
Ölfarbe und Pinsel auf Karton,
rückseitig Ölgrundierung;
47 × 40,5 cm
Sammlung Rosengart, Luzern

10 Picture with the Cock and Grenadier

1919, 235
Oil and brush on cardboard,
oil priming on reverse,
47 × 40.5 cm
Rosengart Collection, Lucerne

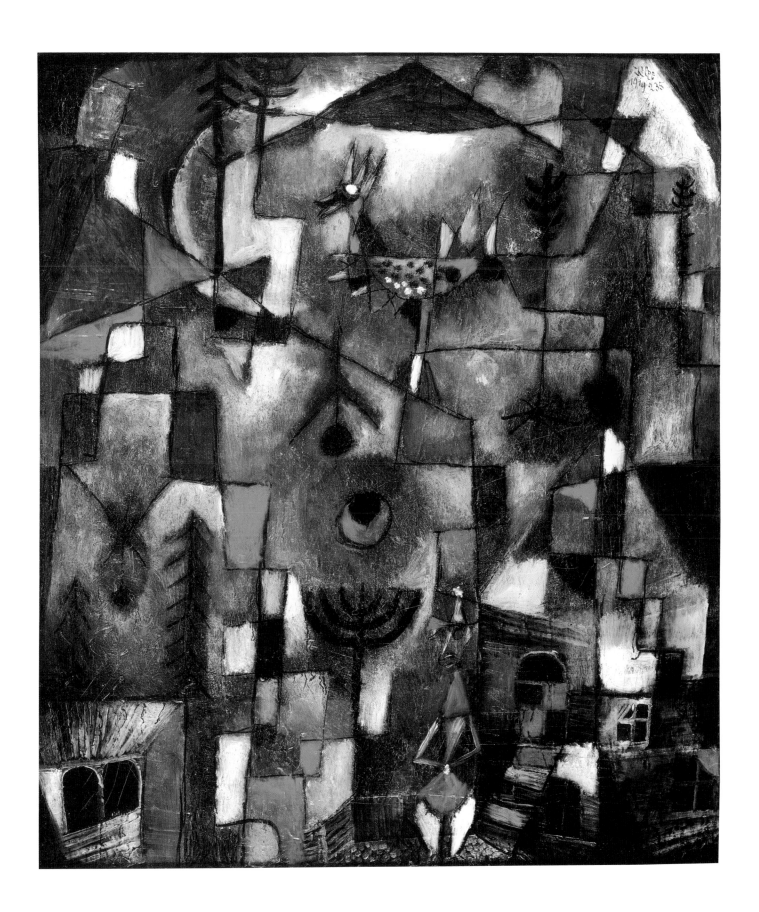

11 Erwachende

1920, 49
Aquarell auf Kreidegrundierung
auf Papier auf Karton
22,5 × 28 cm
Die Sammlung Berggruen in
den Staatlichen Museen zu Berlin

11 Woman Awakening

1920, 49
Watercolour on chalk priming on paper,
mounted on cardboard
22.5 × 28 cm
The Berggruen Collection,
Staatliche Museen zu Berlin

1920. 49. Erwachende

12 Drei Blumen

1920, 183

Ölfarbe auf Grundierung auf Karton,

rückseitig ganzflächig Ölfarbe

19,5 × 15 cm

Schenkung LK, Klee-Museum, Bern

12 Three Flowers

1920, 183

Oil on priming on cardboard,

oil on whole reverse surface

19.5 × 15 cm

Gift of LK, Klee-Museum, Bern

13　kleine rhythmische Landschaft

1920, 216
Ölfarbe und Bleistift auf Leinwand, mit Papierklebestreifen
mit Federskizzen eingefasst, auf Karton
27,8 × 21,7 cm
Privatbesitz, Schweiz

13　Small Rhythmic Landscape

1920, 216
Oil and pencil on canvas, bordered with adhesive paper
strips and pen sketches, mounted on cardboard
27.8 × 21.7 cm
Private Collection, Switzerland

14 Transparent-perspectivisch

1921, 55
Aquarell und Feder auf Papier
auf zweitem Papier auf Karton
23,4 × 25,9 cm
Privatbesitz, Schweiz

14 Transparent-Perspectively

1921, 55
Watercolour and pen on paper,
on second paper mount and on cardboard
23.4 × 25.9 cm
Private Collection, Switzerland

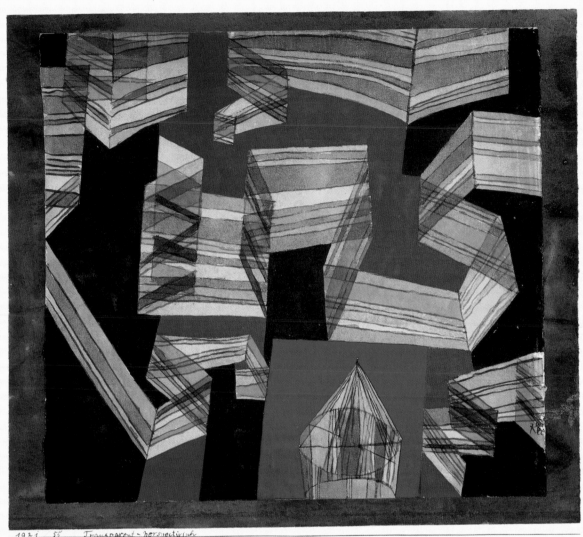

1921 55 Transparent-perspectivisch
s.k.

15 Kristall-Stufung

1921, 88

Aquarell auf Papier, mit Pinsel und Feder eingefasst, auf Karton

24 × 31,3 cm

Öffentliche Kunstsammlung Basel, Kupferstichkabinett,

Schenkung Marguerite Arp-Hagenbach,

Inv. Nr. 1968.407

15 Crystal Gradation

1921, 88

Watercolour on paper, bordered in brush and pen,

mounted on cardboard

24 × 31.3 cm

Öffentliche Kunstsammlung Basel, Kupferstichkabinett

Gift of Marguerite Arp-Hagenbach

Inv. No. 1968.607

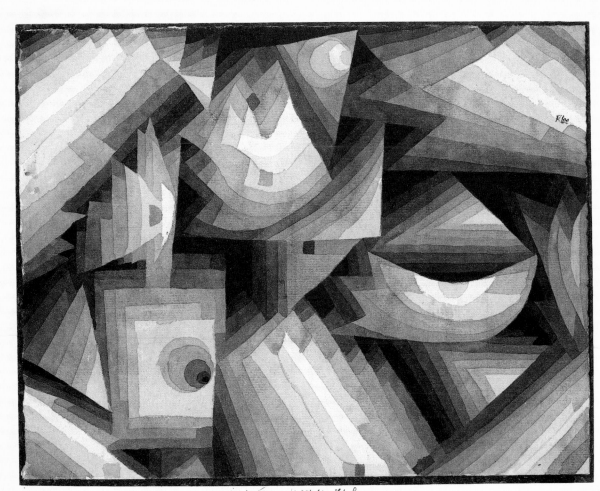

1921/88 Kristall-Stufung

16 Kopf eines berühmten Räubers

1921, 124
Ölfarbe auf Papier auf zweitem Papier auf Karton
24,8 × 19,7 cm
Privatbesitz, Schweiz

16 Head of a Famous Robber

1921, 124
Oil on paper, on second paper
mount and on cardboard
24.8 × 19.7 cm
Private Collection, Switzerland

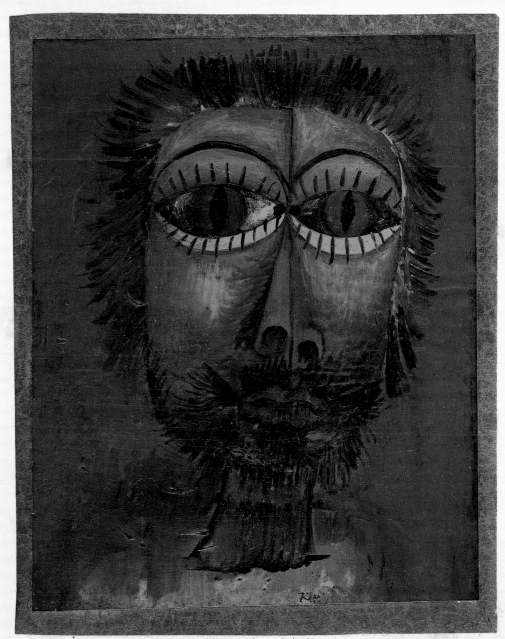

1921/124 Kopf eines berühmten Räubers

17 Das Fest der Astern

1921, 206
Ölfarbe auf Karton,
rückseitig Ölfarbe und Feder
35,5 × 51 cm
Privatbesitz, Deutschland

Das Fest der Astern, *verso*

17 The Festival of the Asters

1921, 206
Oil on cardboard,
on reverse oil and pen
35.5 × 51 cm
Private Collection, Germany

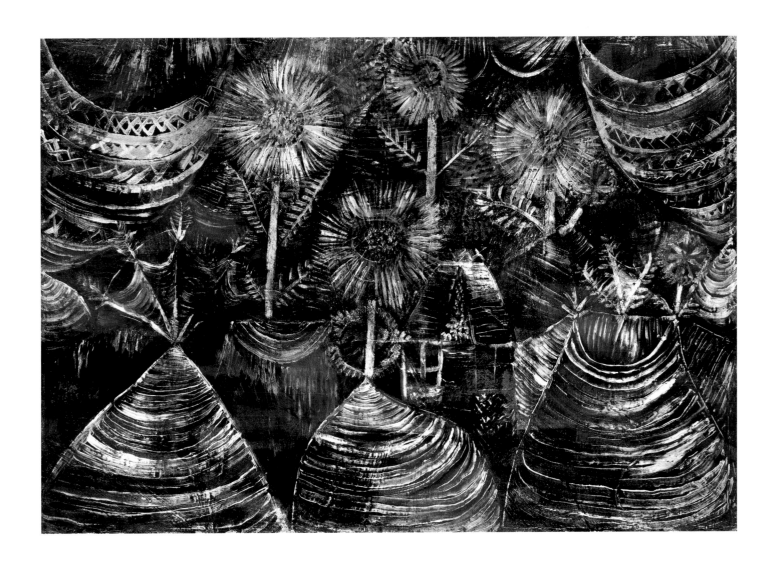

18 Feuerwind

1922, 17
Ölfarbe auf Papier, mit Ölfarbe eingefasst,
auf Karton
37,9 × 45,5 cm
Sammlung Rosengart, Luzern

18 Fire Wind

1922, 17
Oil on paper, bordered in oil,
mounted on cardboard
37.9 × 45.5 cm
Rosengart Collection, Lucerne

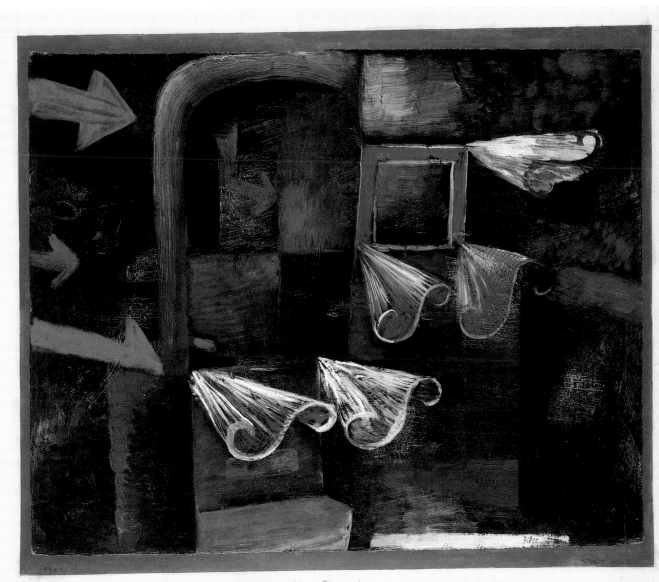

1922/17 Feuerwind

19 Rosenwind

1922, 39
Ölfarbe auf Leimgrundierung auf Papier,
mit Aquarell und Feder eingefasst, auf Karton
38,2 × 41,8 cm
Schenkung LK, Klee-Museum, Bern

19 Rose Wind

1922, 39
Oil on glue priming on paper,
bordered in watercolour and pen,
mounted on cardboard
38.2 × 41.8 cm
Gift of LK, Klee-Museum, Bern

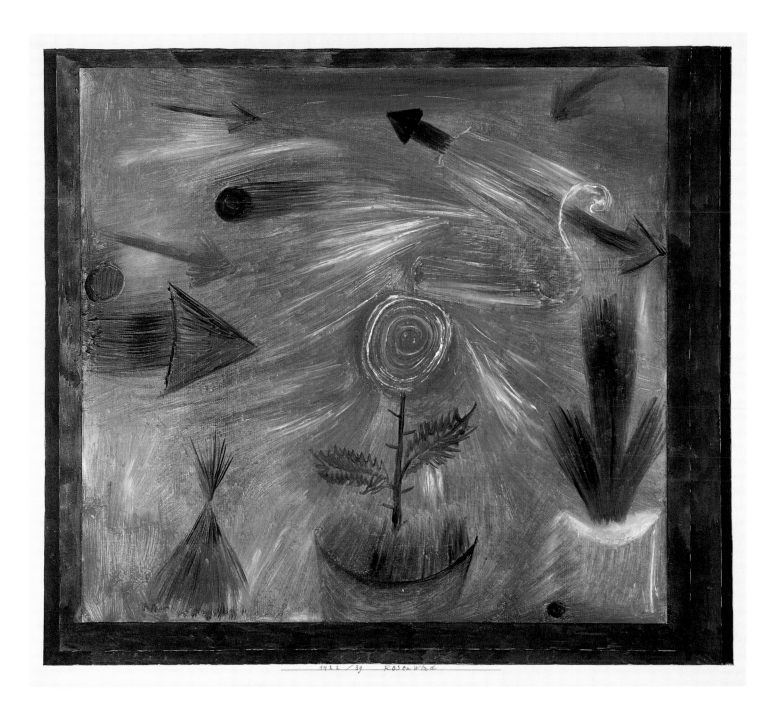

1922 /39 Rosenwind

20 Herzdame

1922, 63
Aquarell und Bleistift auf Papier,
mit Aquarell und Feder eingefasst, auf Karton
29,5 × 16,4 cm
Sammlung Rosengart, Luzern

20 Queen of Hearts

1922, 63
Watercolour and pencil on paper,
bordered in watercolour and pen,
mounted on cardboard
29.5 × 16.4 cm
Rosengart Collection, Lucerne

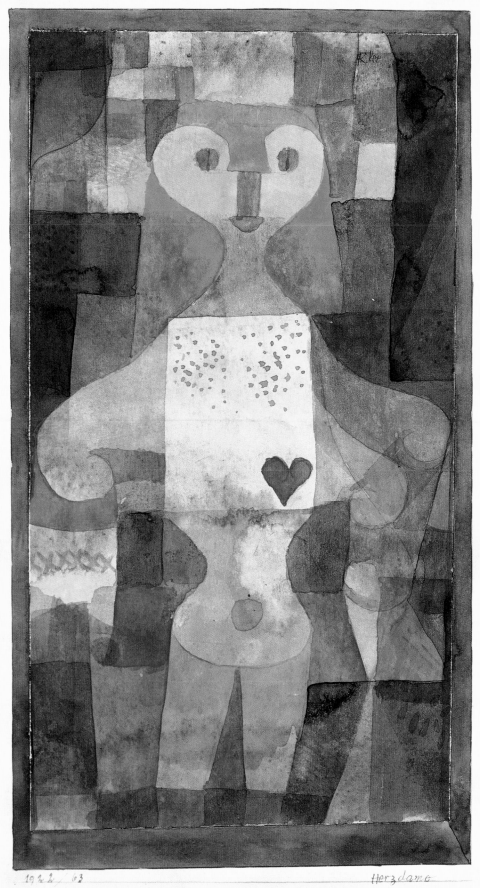

1942 63 Herzdame

21 betroffener Ort

1922, 109
Feder, Bleistift und Aquarell auf Papier,
oben und unten Randstreifen mit Aquarell und Feder,
auf Karton
30,7 × 23,1 cm
Paul-Klee-Stiftung, Kunstmuseum Bern, Inv. Nr. F 29

21 Affected Place

1922, 109
Pen, pencil and watercolour on paper,
marginal strips on top and bottom
in watercolour and pen, mounted on cardboard
30.7 × 23.1 cm
Paul Klee Foundation, Kunstmuseum Bern
Inv. No. F 29

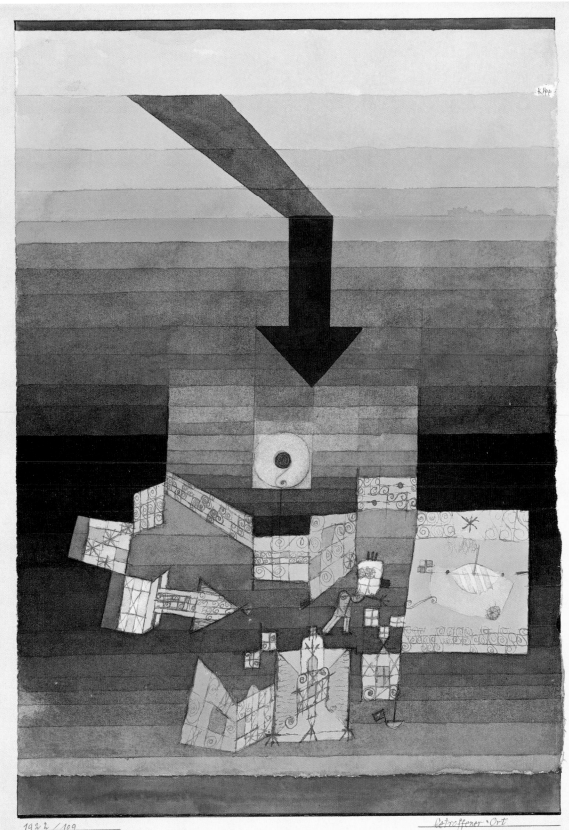

Klpp

1922/109
S 11

Betroffener Ort

22 Schauspieler

1923, 27
Ölfarbe auf Papier, mit Ölfarbe und
Feder eingefasst, auf Karton
46,5 / 45,8 × 25 cm
Privatbesitz, Schweiz

22 Actor

1923, 27
Oil on paper, bordered in oil and pen,
mounted on cardboard
46.5 / 45.8 × 25 cm
Private Collection, Switzerland

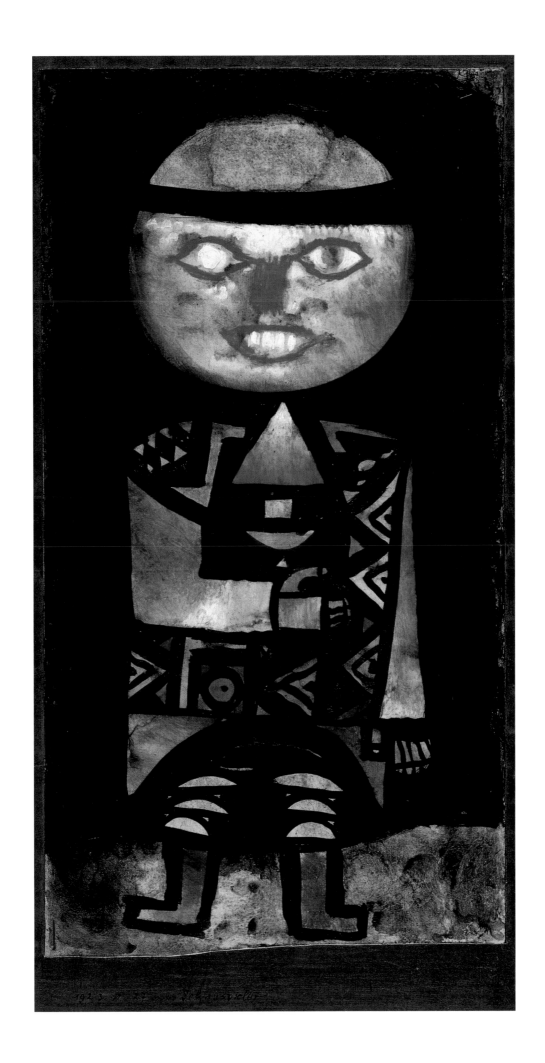

23 Feuerwind

1923, 43
Ölpause, Aquarell und Ölfarbe auf Ölgrundierung
auf Papier, mit Aquarell und Feder eingefasst,
unten Randstreifen mit Aquarell und Feder, auf Karton
43,2 × 30,2 cm
Paul-Klee-Stiftung, Kunstmuseum Bern, Inv. Nr. F 35

23 Fire Wind

1923, 43
Oil transfer drawing, watercolour and oil on oil priming
on paper, bordered in watercolour and pen, strip on the bottom
in watercolour and pen, mounted on cardboard
43.2 × 30.2 cm
Paul Klee Foundation, Kunstmuseum Bern
Inv. No. F 35

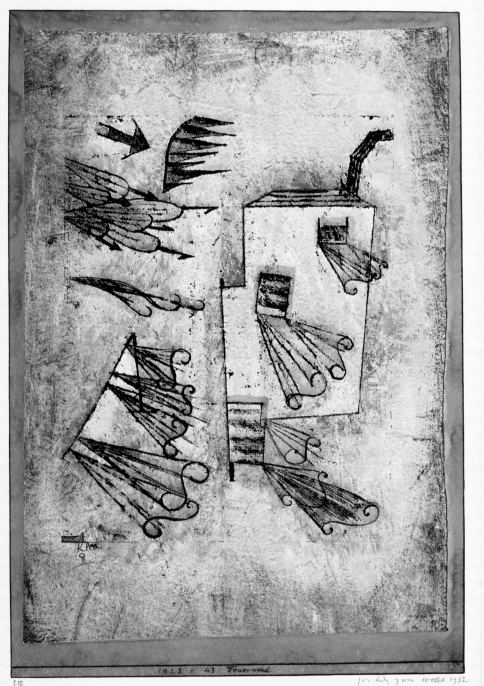

1923 43 Feuerwind

24 Harmonie blau = orange

1923, 58
Ölfarbe auf schwarzer Grundierung auf Papier,
mit Aquarell und Feder eingefasst,
unten Randstreifen mit Aquarell und Feder, auf Karton
37,3 × 26,4 cm
Sammlung Rosengart, Luzern

24 Harmony in Blue = Orange

1923, 58
Oil on black priming on paper,
bordered in watercolour and pen,
strip on the bottom in watercolour and pen,
mounted on cardboard
37,3 × 26.4 cm
Rosengart Collection, Lucerne

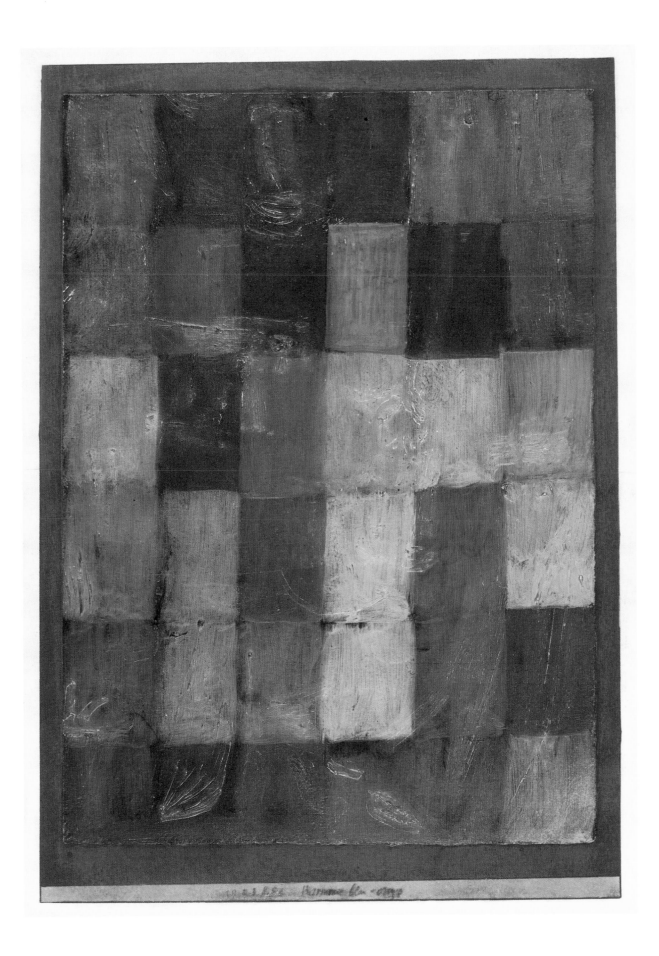

25　Eros

1923, 115
Aquarell, Gouache und Bleistift auf Papier,
zerschnitten und neu kombiniert,
unten Randstreifen mit Aquarell und Feder,
mit Gouache und Feder eingefasst, auf Karton
33,3 × 24,5 cm
Sammlung Rosengart, Luzern

25　Eros

1923, 115
Watercolour, gouache and pencil on paper,
cut and re-combined, strip on the bottom
in watercolour and pen, bordered in gouache and pen,
mounted on cardboard
33.3 × 24.5 cm
Rosengart Collection, Lucerne

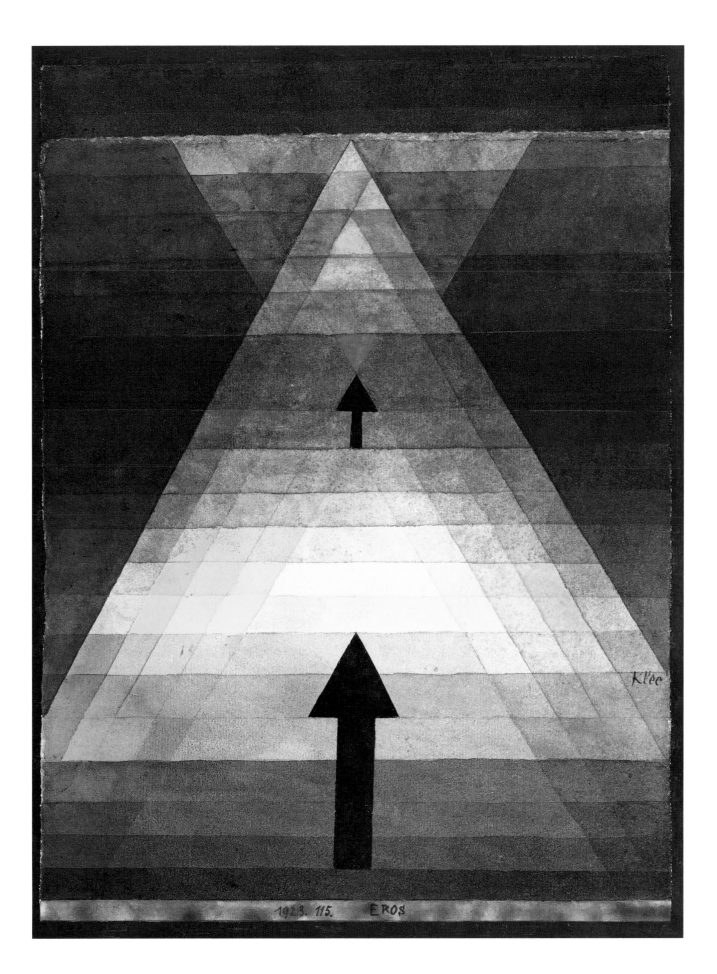

Klee

1923. 115. EROS

26 Der Berg der heiligen Katze

1923, 120
Ölpause, Bleistift und Aquarell auf Papier,
unten Randstreifen mit Aquarell und Feder,
mit Gouache und Feder eingefasst, auf Karton
48,5 × 31,8 cm
Privatbesitz, Deutschland

26 The Mountain of the Sacred Cat

1923, 120
Oil transfer drawing, pencil and watercolour on paper,
marginal strip on the bottom in watercolour and pen,
bordered in gouache and pen, mounted on cardboard
48.5 × 31.8 cm
Private Collection, Germany

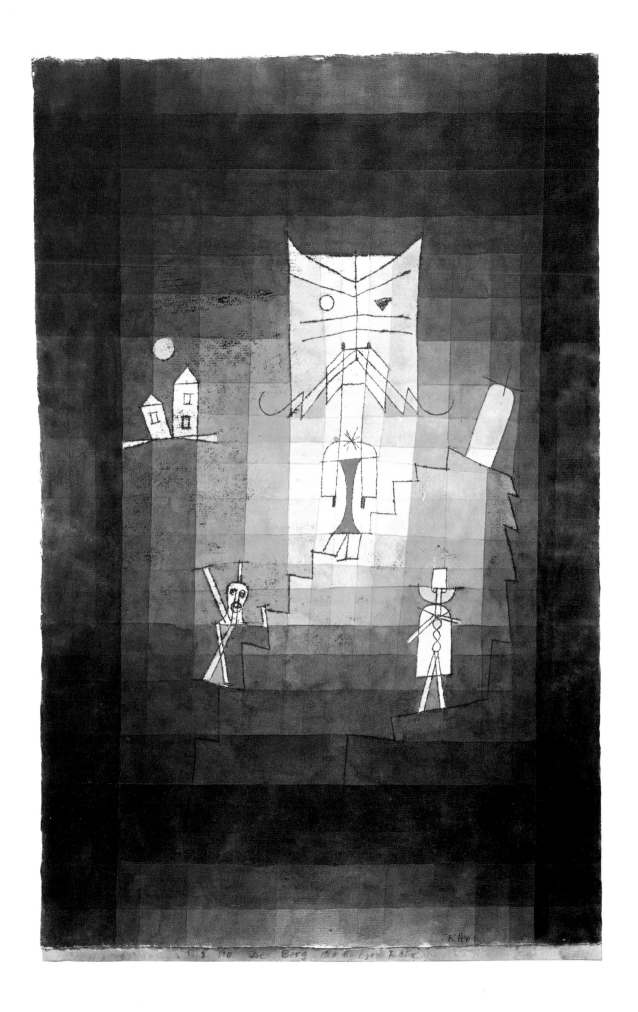

27 Nördlicher Ort

1923, 140

Aquarell auf Papier, zerschnitten

und neu kombiniert, auf Karton

23,5 × 36,5 cm

Privatbesitz, Schweiz

27 Northern Village

1923, 140

Watercolour on paper, cut and re-combined,

mounted on cardboard

23.5 × 36.5 cm

Private Collection, Switzerland

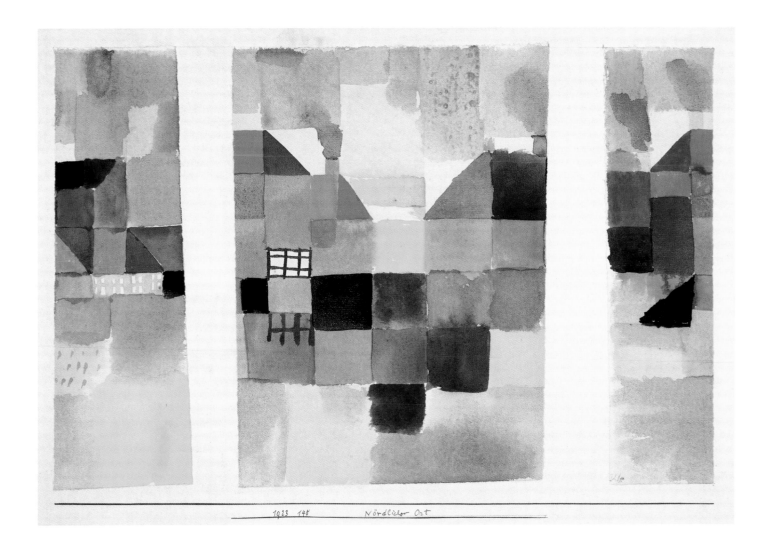

1923 148 Nördlicher Ort

28 Strasse im Lager

1923, 146
Ölpause und Aquarell auf Papier,
oben und unten Randstreifen mit Aquarell
und Feder, unten zweiter Randstreifen
mit Aquarell und Feder, auf Karton
25,3 × 31 cm
Sammlung Rosengart, Luzern

28 Street in the Camp

1923, 146
Oil transfer drawing and watercolour on paper,
marginal strips on top and bottom in watercolour
and pen, second strip on the bottom in water-
colour and pen, mounted on cardboard
25.3 × 31 cm
Rosengart Collection, Lucerne

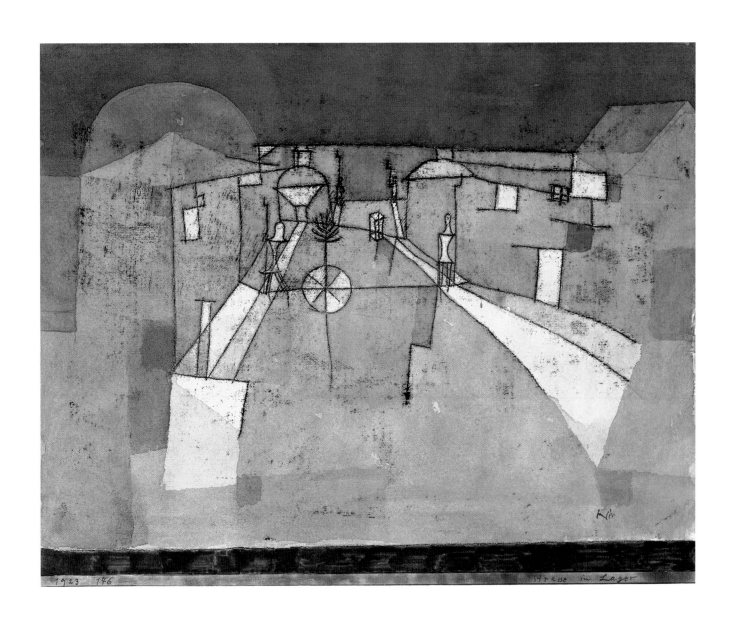

1923 146 Strasse im Lager

29 Haeusliches Requiem

1923, 151
Ölpause, Bleistift und Aquarell auf Papier,
oben und unten Randstreifen mit Gouache und Feder,
unten zweiter Randstreifen mit Aquarell und Feder, auf Karton
31,2 × 38,5 cm
Privatbesitz, Schweiz

29 Domestic Requiem

1923, 151
Oil transfer drawing, pencil and watercolour on paper,
marginal strips on top and bottom in gouache and pen,
second strip on the bottom in watercolour and pen,
mounted on cardboard
31.2 × 38.5 cm
Private Collection, Switzerland

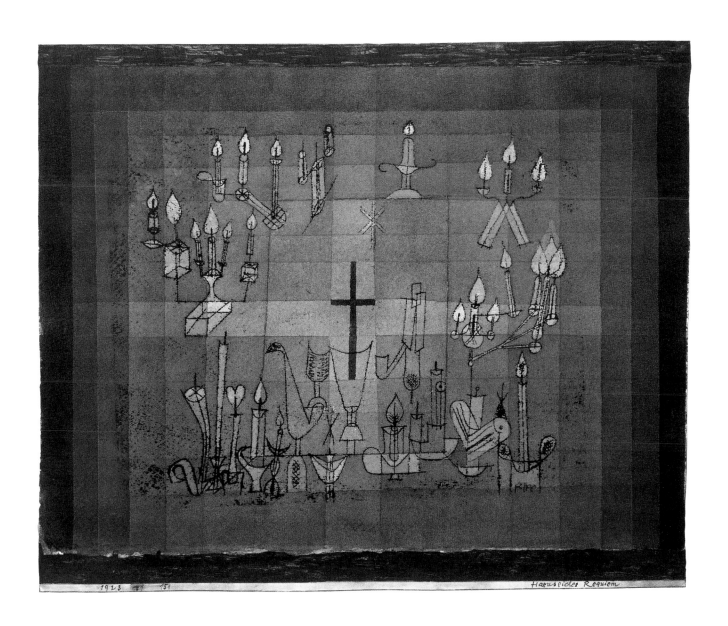

1923 ij 151 Haeusliches Requiem

30 Sternverbundene

1923, 159
Aquarell und Bleistift auf Papier,
mit Aquarell und Feder eingefasst,
unten Randstreifen mit Aquarell
und Feder, auf Karton
32,4 / 32,8 × 48,3 / 48,7 cm
Privatbesitz, Schweiz

30 Connected to the Stars

1923, 159
Watercolour and pencil on paper,
bordered in watercolour and pen,
marginal strip on the bottom
in watercolour and pen,
mounted on cardboard
32.4 / 32.8 × 48.3 / 48.7 cm
Private Collection, Switzerland

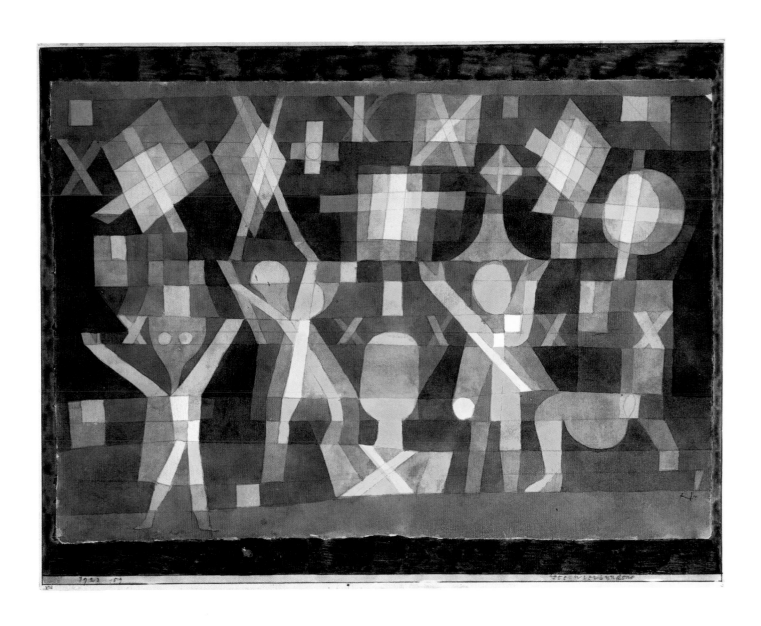

31 Nördlicher Ort

1923, 173

Aquarell auf Kreidegrundierung auf Papier,

mit Gouache und Feder eingefasst,

unten Randstreifen mit Aquarell und Feder, auf Karton

28,5 × 36,5 cm

Die Sammlung Berggruen in den Staatlichen Museen zu Berlin

31 Northern Village

1923, 173

Watercolour on chalk priming on paper,

bordered in gouache and pen,

marginal strip on the bottom in watercolour and pen,

mounted on cardboard

28.5 × 36.5 cm

The Berggruen Collection, Staatliche Museen zu Berlin

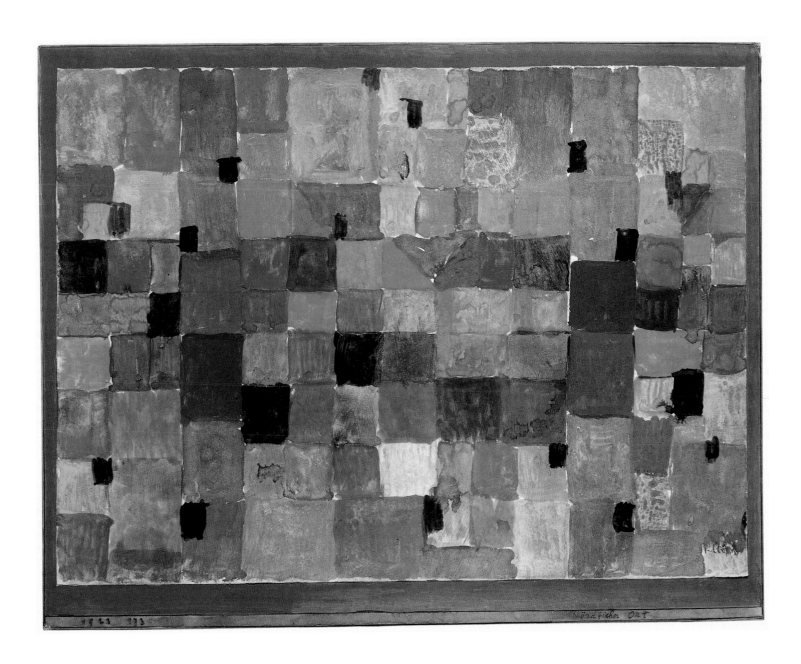

1943. 113 Nördlicher Ort

32 landschaftlich-physiognomisch

1923, 179
Aquarell auf Kreidegrundierung auf Papier,
mit Aquarell und Feder eingefasst,
unten Randstreifen mit Aquarell und Feder, auf Karton
23,8 × 26,8 cm
Sammlung Rosengart, Luzern

32 Scenic-Physiognomic

1923, 179
Watercolour on chalk priming on paper,
bordered in watercolour and pen,
marginal strip on the bottom in watercolour and pen,
mounted on cardboard
23.8 × 26.8 cm
Rosengart Collection, Lucerne

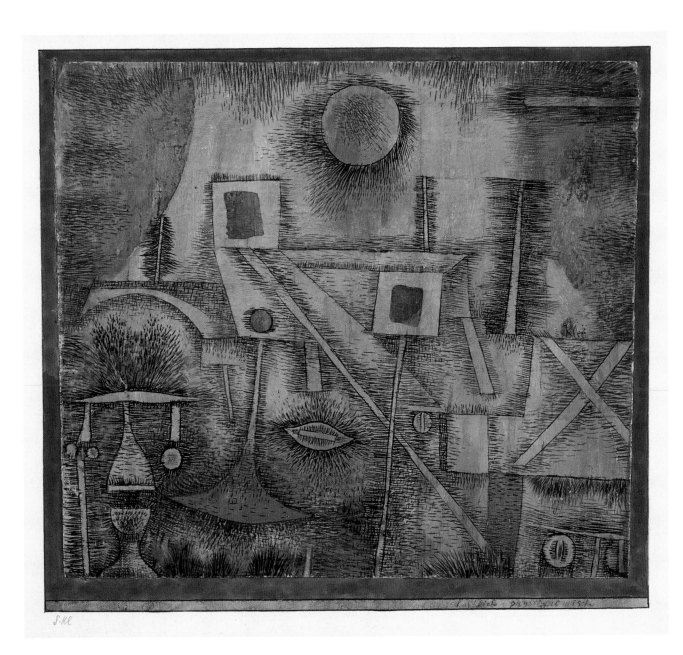

33 Wasserpÿramiden

1924, 115
Aquarell auf Leinen, unten mit Gouache ergänzt,
darunter Randstreifen mit Aquarell und Feder,
mit Gouache und Feder eingefasst, auf Karton
35 × 42 cm
Privatbesitz, Schweiz

33 Water Pyramids

1924, 115
Watercolour on linen, completed in gouache,
underneath marginal strip in watercolour and pen,
bordered in gouache and pen, mounted on cardboard
35 × 42 cm
Private Collection, Switzerland

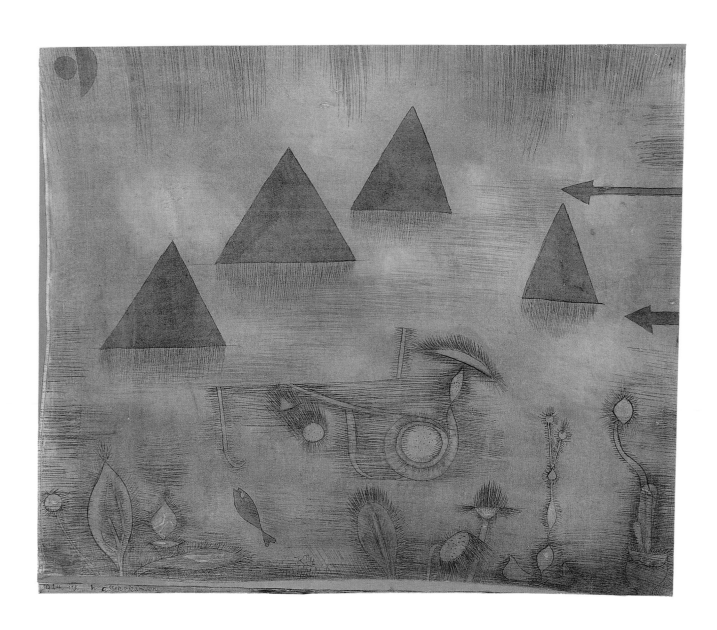

34 komische Figur aus einem bayrischen Volksstück

1924, 170

Feder und Aquarell auf Papier, oben und unten Randstreifen

mit Gouache und Feder, auf Karton

22,7 × 20,3 cm

Privatbesitz, Schweiz

34 Comic Character from a Bavarian Folk Play

1924, 170

Pen and watercolour on paper, marginal strips on top

and bottom in gouache and pen, mounted on cardboard

22.7 × 20.3 cm

Private Collection, Switzerland

35 wie ein Glasfenster

1924, 290 (Ö 2)
Ölfarbe auf Gipsgrundierung auf Gaze auf Karton,
rückseitig Aquarell und Feder auf weißer Grundierung
auf Gaze, auf Keilrahmen genagelt
42,2 × 28,2 cm
Sammlung Rosengart, Luzern

35 Like a Window Pane

1924, 290 (Ö 2)
Oil on plaster priming on gauze on cardboard,
on the reverse watercolour and pen on white priming
on gauze, nailed onto stretcher
42.2 × 28.2 cm
Rosengart Collection, Lucerne

36 Kreuz- und Spiralblüten

1925, 9

Aquarell auf Kleistergrundierung auf Papier,

mit Gouache und Feder eingefasst,

unten Randstreifen mit Aquarell und Feder, auf Karton

23,2 × 30,7 cm

Privatbesitz, Deutschland

36 Crucifers und Spiral Flowers

1925, 9

Watercolour on glue priming on paper,

bordered in gouache and pen,

marginal strips on the bottom in watercolour and pen,

mounted on cardboard

23.2 × 30.7 cm

Private Collection, Germany

1925. 9. Kreuz- und Spiral blüten

VIII

37 Lebkuchen-Bild

1925, 12 (K 2)
Ölfarbe und Feder auf Kreidegrundierung
auf Karton auf Keilrahmen genagelt
21,6 × 28,6 cm
Die Sammlung Berggruen
in den Staatlichen Museen zu Berlin

37 Gingerbread Picture

1925, 12 (K 2)
Oil and pen on chalk priming on
cardboard, nailed onto stretcher
21.6 × 28.6 cm
The Berggruen Collection,
Staatliche Museen zu Berlin

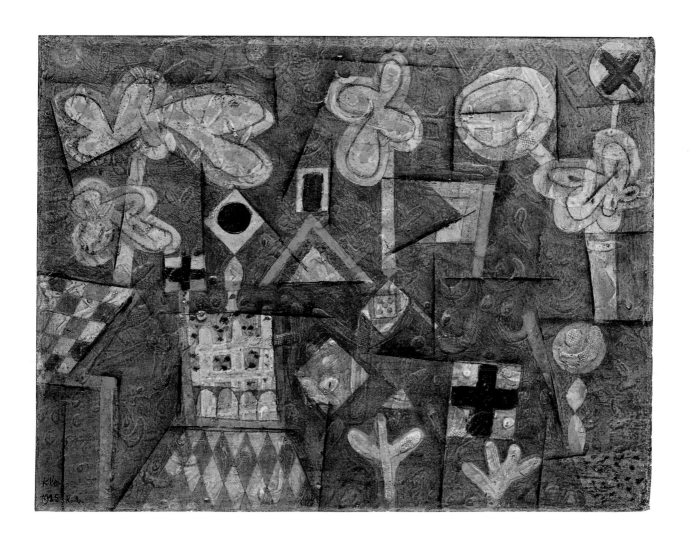

38 Betrachtung beim Frühstück

1925, 113 (B 3)
Aquarell und Gouache auf Papier, oben und unten Randstreifen
mit Aquarell und Feder, auf Karton
23,5 × 28,2 cm
Die Sammlung Berggruen in den Staatlichen Museen zu Berlin

38 Contemplation at Breakfast

1925, 113 (B 3)
Watercolour and gouache on paper,
marginal strips on top and
bottom in watercolour and pen,
mounted on cardboard
23.5 × 28.2 cm
The Berggruen Collection, Staatliche Museen zu Berlin

IV 1925 B.3. Betrachtung beim Frühstück

39 die Sängerin der komischen Oper

1925, 225 (W 5)

Lithographie, mit Aquarell gespritzt

60 × 45,8 cm

Sammlung Rosengart, Luzern

39 The Singer of the Comic Opera

1925, 225 (W 5)

Lithography and sprayed watercolour

60 × 45.8 cm

Rosengart Collection, Lucerne

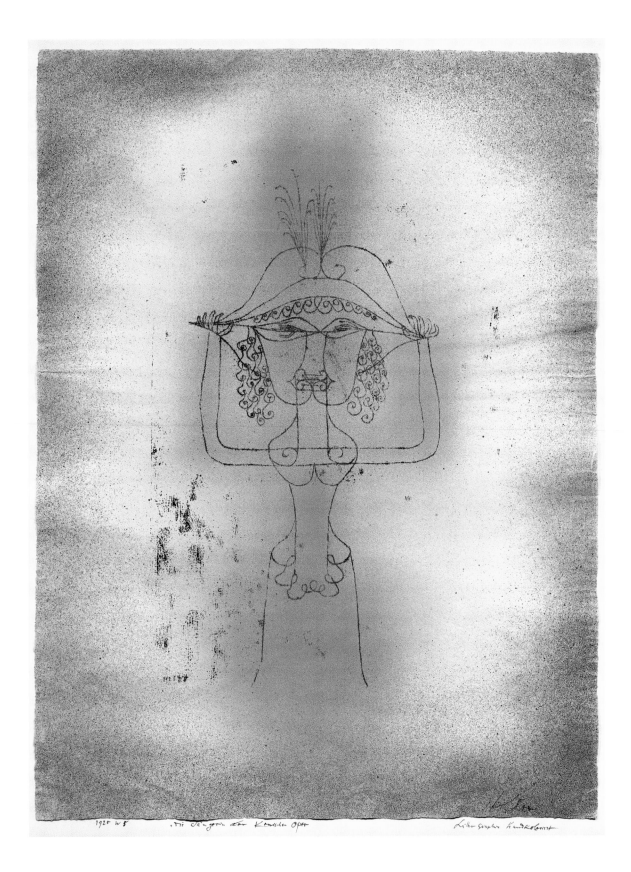

1925 W 5 "Die Sängerin der Komischen Oper" Lithographie Handkoloriert

40 Felsen tempel mit Tannen

1926, 12 (K 2)

Feder und Aquarell auf Papier auf Karton

17,8 × 31,9 cm

Sammlung Rosengart, Luzern

40 Rock-Cut Temple with Fir Trees

1926, 12 (K 2)

Pen and watercolour on paper,

mounted on cardboard

17.8 × 31.9 cm

Rosengart Collection, Lucerne

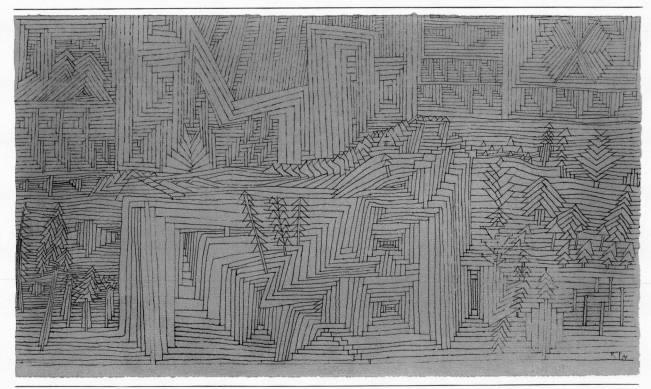

II 1926. X. 2. Felsen tempel mit Tannen

41 Fisch – physiognomisch

1926, 30 (M 0)
Feder und Aquarell auf Papier auf Karton
46,9 × 31,1 cm
Sammlung Rosengart, Luzern

41 Fish – Physiognomic

1926, 30 (M 0)
Pen and watercolour on paper,
mounted on cardboard
46.9 × 31.1 cm
Rosengart Collection, Lucerne

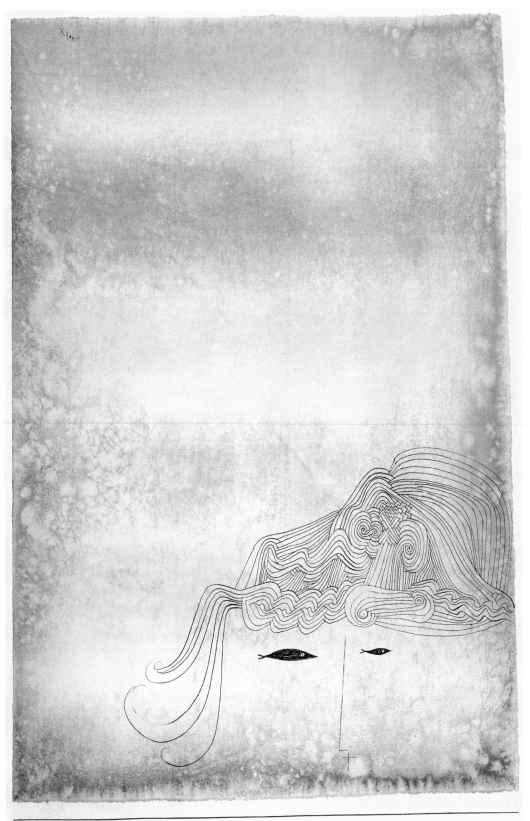

1926. M null Fisch-physiognomisch

42 Waldlichtung

1926, 118 (B 8)

Aquarell auf Papier auf Karton

36,8 × 51,2 cm

Paul-Klee-Stiftung, Kunstmuseum Bern, Inv. Nr. F 56

42 Clearing in the Forest

1926, 118 (B 8)

Watercolour on paper, mounted on cardboard

36.8 × 51.2 cm

Paul Klee Foundation, Kunstmuseum Bern

Inv. No. F 56

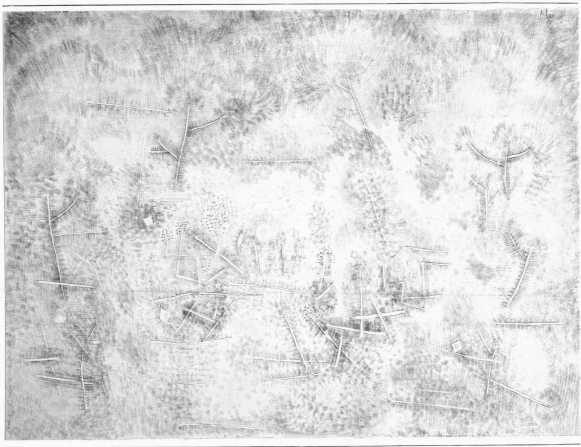

I 1926 B 8. Waldlichtung

43 Geist bei Wein und Spiel

1927, 16 (K 6)
Ölfarbe auf Leinwand;
originale Rahmenleisten
85 × 66 cm
Privatsammlung

43 Spirit Drinking and Gambling

1927, 16 (K 6)
Oil on canvas,
original frame strips
85 × 66 cm
Private Collection

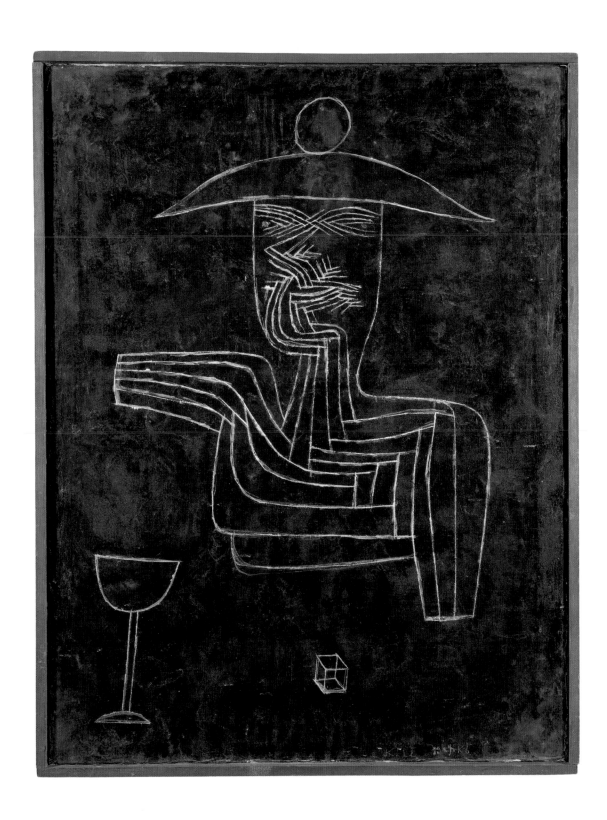

44 Spinnennetz

1927, 28 (L 8)

Ölfarbe auf Leinwand auf Karton,

mit Bleistift und Kleisterfarbe eingefasst,

auf zweiten Karton; originale, gefasste Rahmenleisten

40,5 × 35 cm

Bayerische Staatsgemäldesammlungen,

Staatsgalerie moderner Kunst, München, Inv. Nr. L 1731

44 Cobweb

1927, 28 (L 8)

Oil on canvas on cardboard,

bordered in pencil and coloured paste,

on second cardboard mount; original painted frame strip

40.5 × 35 cm

Bayerische Staatsgemäldesammlungen,

Staatsgalerie moderner Kunst, Munich, Inv. no. L 1731

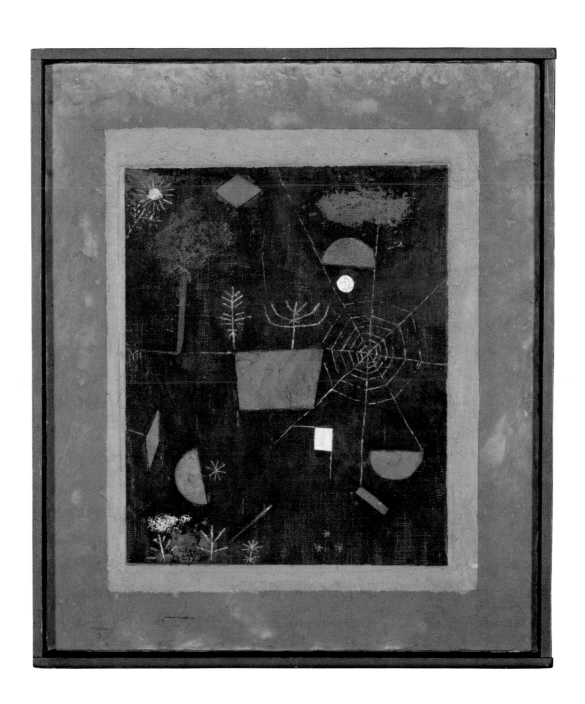

45 kleiner Narr in Trance 2

1927, 170 (G 10)

Ölpause auf Papier mit Leimtupfen auf Karton

46,5 × 30,4 cm

Sammlung Rosengart, Luzern

45 Small Fool in Trance 2

1927, 170 (G 10)

Oil transfer drawing on paper with spots of glue,

mounted on cardboard

46.5 × 30.4 cm

Rosengart Collection, Lucerne

46 Partie aus G.

1927, 245 (Y 5)

Ölpause und Aquarell auf Papier auf Karton

32,5 × 24 cm

Die Sammlung Berggruen in den Staatlichen Museen zu Berlin

46 Part of G.

1927, 245 (Y 5)

Oil transfer drawing and watercolour on paper,

mounted on cardboard

32.5 × 24 cm

The Berggruen Collection, Staatliche Museen zu Berlin

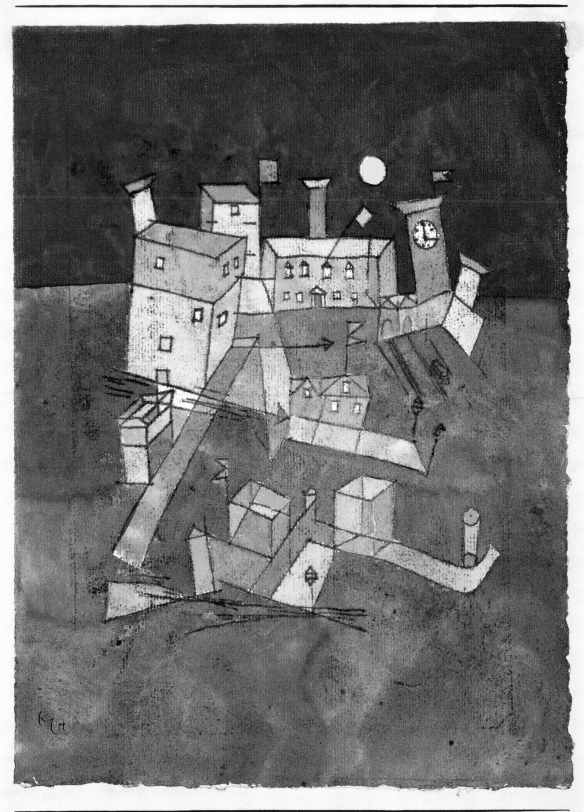

1927 Y5. Partie aus G.

47 Kleinglieder in Lagen

1928, 81 (R 1)
Aquarell auf Papier, mit Gouache
und Kreide eingefasst, auf Karton
36 × 16,5 / 17 cm
Privatbesitz, Schweiz

47 Small Structures in Layers

1928, 81 (R 1)
Watercolour on paper,
bordered in gouache and chalk,
mounted on cardboard
36 × 16.5 / 17 cm
Private Collection, Switzerland

1928

48 Stadtperspective

1928, 137 (D 7)
Feder und Aquarell auf Papier,
unten aquarellierter Papierstreifen angesetzt,
mit Aquarell und Feder eingefasst, auf Karton
43,5 × 34,5 cm
Privatbesitz, Deutschland

48 Urban Perspective

1928, 137 (D 7)
Pen and watercolour on paper,
watercoloured paper strip added
at the bottom, bordered in watercolour
and pen, mounted on cardboard
43.5 × 34.5 cm
Private Collection, Germany

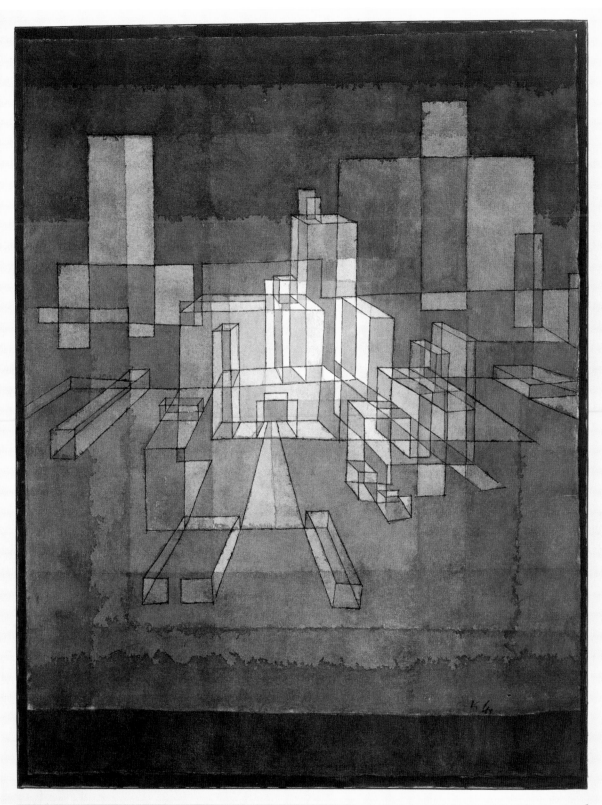

1928 D7 Stadt perspectiv

49 Monument an der Grenze des Fruchtlandes

1929, 40 (M 10)

Aquarell und Feder auf Papier auf Karton

45,8 × 30,7 cm

Sammlung Rosengart, Luzern

49 Monument on the Border of the Fertile Country

1929, 40 (M 10)

Watercolour and pen on paper, mounted on cardboard

45.8 × 30.7 cm

Rosengart Collection, Lucerne

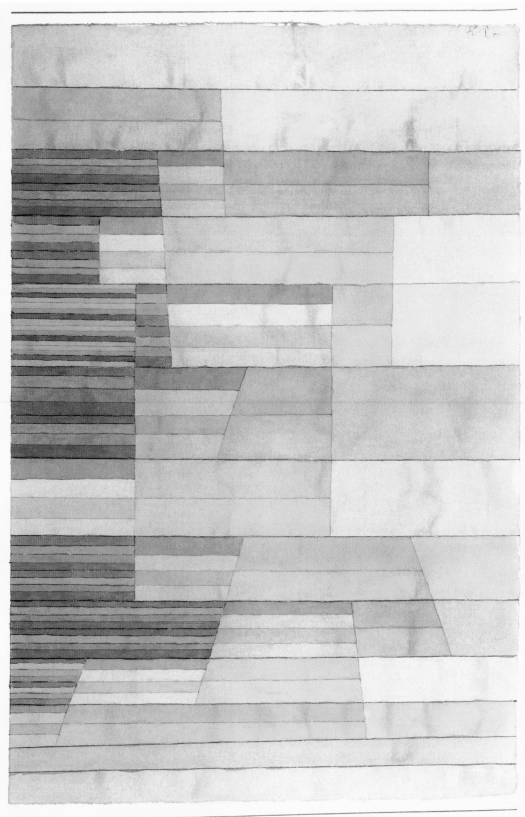

50 kristallinische Landschaft

1929, 75 (Qu 5)

Aquarell auf schwarzer Grundierung

auf Papier auf Karton

33,3 × 42 cm

Sammlung Rosengart, Luzern

50 Crystalline Landscape

1929, 75 (Qu 5)

Watercolour on black priming on paper,

mounted on cardboard

33.3 × 42 cm

Rosengart Collection, Lucerne

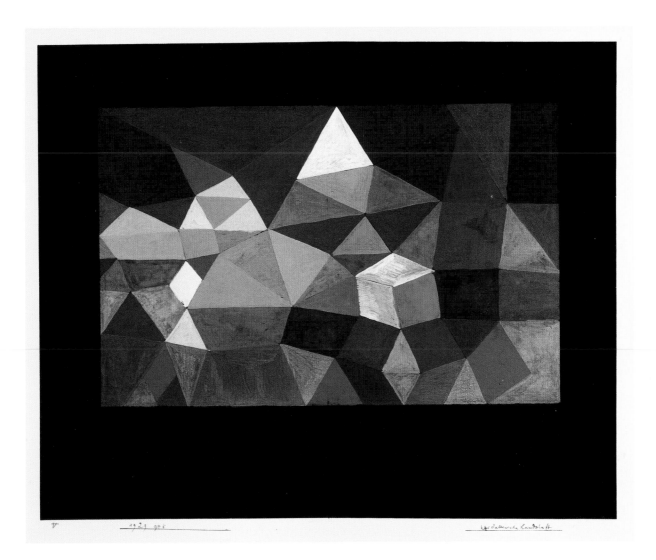

51 physiognomische Genesis

1929, 125 (C 5)
Aquarell, Feder und Bleistift auf Papier auf Karton
32 × 24,3 / 23,8 cm
Privatbesitz, Schweiz

51 Physiognomic Genesis

1929, 125 (C 5)
Watercolour, pen and pencil on paper,
mounted on cardboard
32 × 24.3 / 23.8 cm
Private Collection, Switzerland

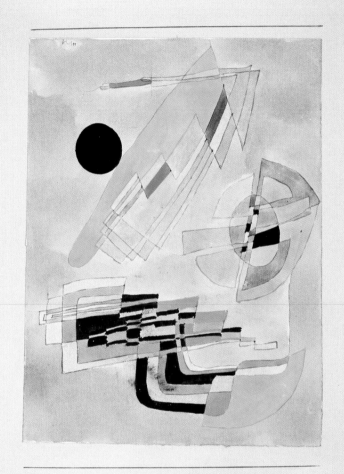

52 Lichtbreitung I

1929, 242 (Y 2)

Aquarell auf Papier auf Karton

24,3 × 18 cm

Privatbesitz, Schweiz

52 Light-Broadening I

1929, 242 (Y 2)

Watercolour on paper,

mounted on cardboard

24.3 × 18 cm

Private Collection, Switzerland

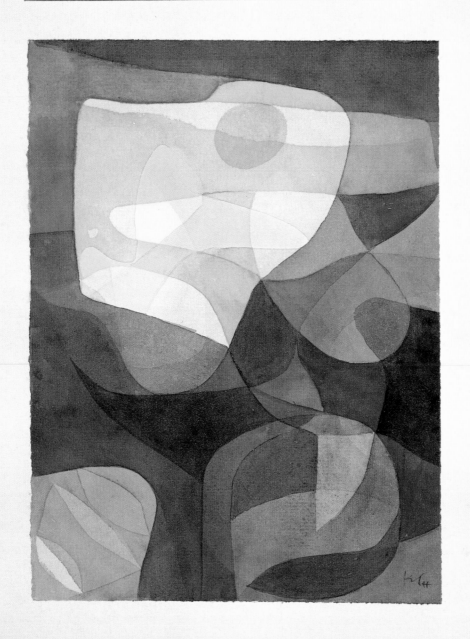

1929 V2 Licht breitung I

53 belichtetes Blatt

1929, 274 (OE 4)
Aquarell und Feder auf Papier auf Karton
30,9 × 23 cm
Paul-Klee-Stiftung, Kunstmuseum Bern, Inv. Nr. F 66

53 Illuminated Leaf

1929, 274 (OE 4)
Watercolour and pen on paper,
mounted on cardboard
30.9 × 23 cm
Paul Klee Foundation, Kunstmuseum Bern
Inv. No. F 66

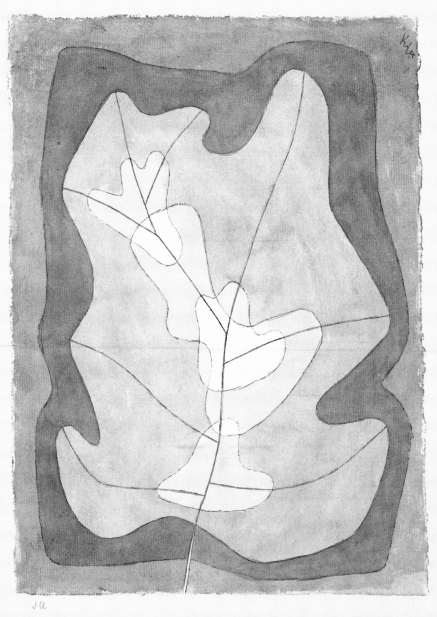

1929. OE.4. belichtetes Blatt

54 vor dem Schnee

1929, 319 (3 H 19)
Aquarell und Feder auf Papier, unten Randstreifen
mit Aquarell und Feder, auf Karton
33,5 × 39 cm
Privatbesitz, Schweiz

54 Before the Snow

1929, 319 (3 H 19)
Watercolour and pen on paper,
paper strip added at the bottom
in watercolour and pen,
mounted on cardboard
33.5 × 39 cm
Private Collection, Switzerland

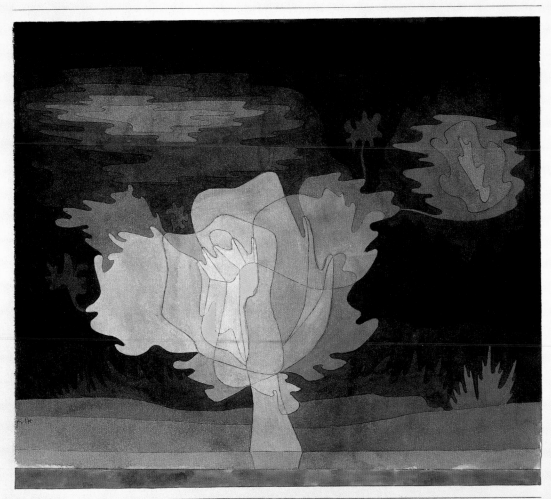

1929 3.H 99 vor dem Schnee

55 Stilleben

1929, 345 (3 H 45)

Aquarell und Feder auf Papier auf schwarzem Karton

26,5 × 21 cm

Sammlung Rosengart, Luzern

55 Still Life

1929, 345 (3 H 45)

Watercolour and pen on paper,

mounted on black cardboard

26.5 × 21 cm

Rosengart Collection, Lucerne

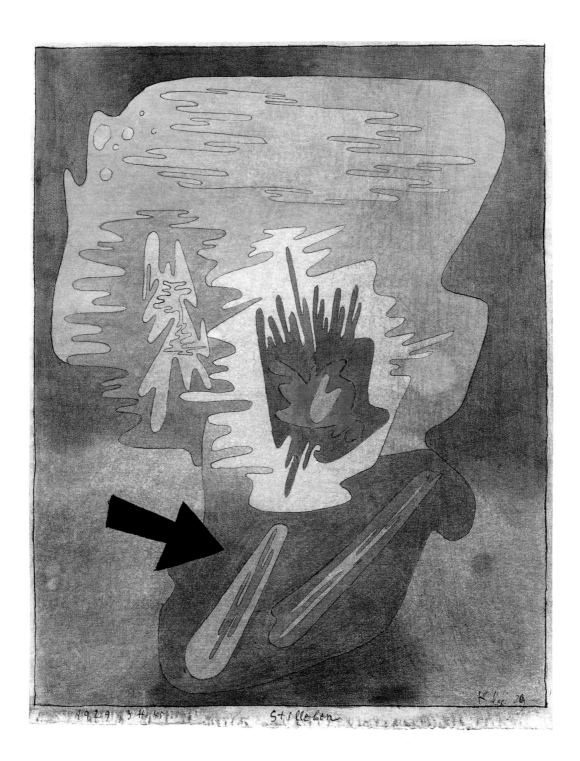

1929 3 H,45 Stilleben Klee 28

56 witterndes Tier

1930, 64 (P 4)

Feder und Aquarell auf Papier auf Karton

31,9 × 47,8 cm

Paul-Klee-Stiftung, Kunstmuseum Bern, Inv. Nr. F 71

56 Animal Catching a Scent

1930, 64 (P 4)

Pen and watercolour on paper,

mounted on cardboard

31.9 × 47.8 cm

Paul Klee Foundation,

Kunstmuseum Bern

Inv. No. F 71

witterndes Tier

57 Eroberer

1930, 129 (W 10)

Aquarell und Feder auf Baumwolle, oben und unten

Randstreifen mit Gouache und Feder, auf Karton

40,5 × 34,2 cm

Paul-Klee-Stiftung, Kunstmuseum Bern, Inv. Nr. F 75

57 Conqueror

1930, 129 (W 10)

Watercolour and pen on cotton,

marginal strips on top and bottom in gouache and pen,

mounted on cardboard

40.5 × 34.2 cm

Paul Klee Foundation, Kunstmuseum Bern

Inv. No. F 75

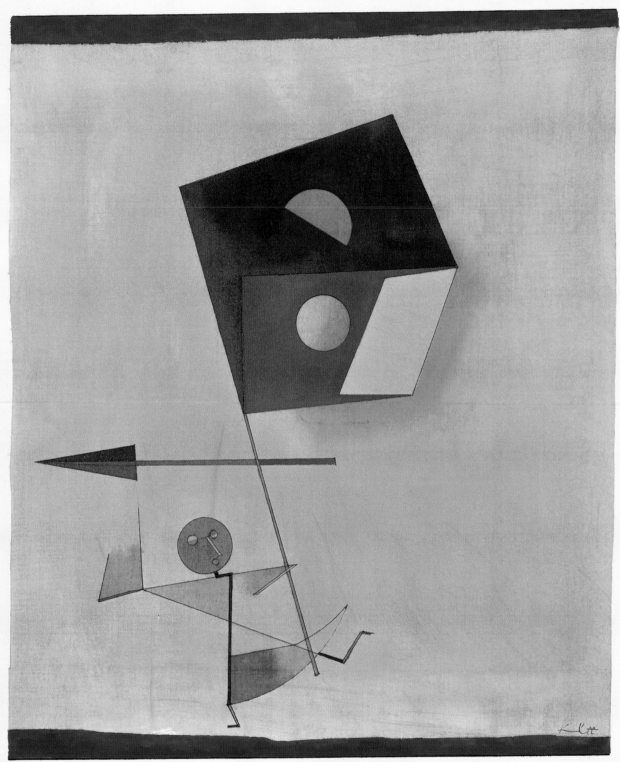

S.ce 1930 W10 Eroberer

58 sechs Arten

1930, 134 (X 4)
Feder und Aquarell auf Baumwolle auf Karton
29,8 / 29,2 × 46,2 / 48,8 cm
Privatbesitz, Schweiz

58 Six Kinds

1930, 134 (X 4)
Pen and watercolour on cotton,
mounted on cardboard
29.8 / 29.2 × 46.2 / 48.8 cm
Private Collection, Switzerland

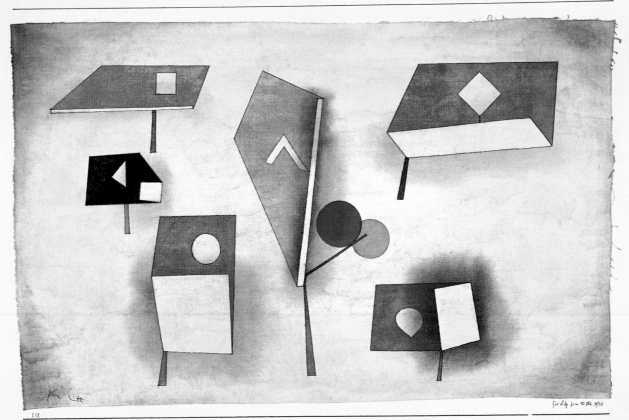

59 Springer

1930, 183 (C 3) gespalten 1
Aquarell, teilweise gespritzt,
und Feder auf Baumwolle auf Sperrholz;
originale Rahmenleisten
51 × 53 cm
Schenkung LK, Klee-Museum, Bern

59 Jumper

1930, 183 (C 3), split 1
Watercolour, partly sprayed,
and pen on cotton on plywood,
original frame strips
51 × 53 cm
Gift of LK, Klee-Museum, Bern

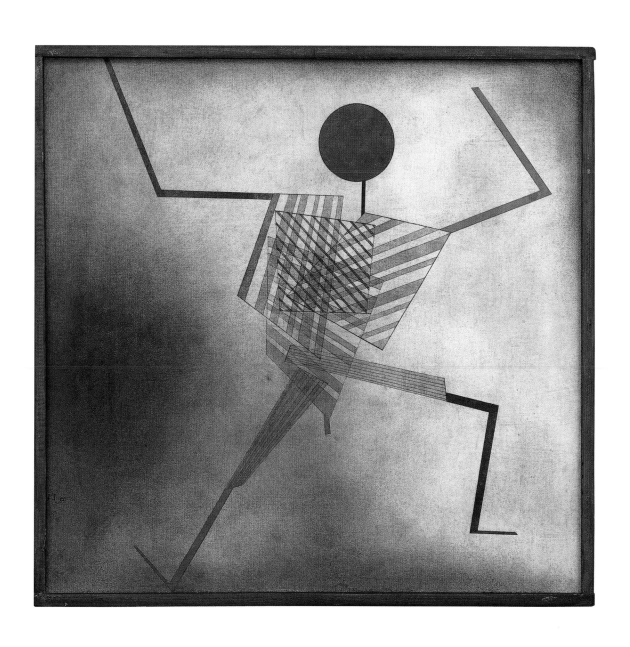

60 Kindheit des Erwählten

1930, 186 (C 6)
Kleisterfarbe und Aquarell auf Papier,
oben und unten Randstreifen
mit Aquarell und Feder, auf Karton
23,9 × 30,5 cm
Sammlung Rosengart, Luzern

60 Childhood of the Chosen One

1930, 186 (C 6)
Coloured paste and watercolour on paper,
marginal strips on top and bottom
in watercolour and pen, mounted on cardboard
23.9 × 30.5 cm
Rosengart Collection, Lucerne

5c

1930 C.6. Kindheit des Erwählten

61 Märchen des Nordens

1930, 235 (G 5)
Ölfarbe auf Papier, mit Gouache und Feder eingefasst,
auf Karton
33,1 × 42 cm
Öffentliche Kunstsammlung Basel, Kunstmuseum,
Geschenk Richard Doetsch-Benzinger, Inv. Nr. 1756

61 Tale of the North

1930, 235 (G 5)
Oil on paper, bordered in gouache and pen,
mounted on cardboard
33.1 × 42 cm
Öffentliche Kunstsammlung Basel, Kunstmuseum,
Gift of Richard Doetsch-Benzinger, Inv. No. 1756

1930 J5. Märchen des Nordens

62 Romantischer Park

1930, 280 (OE 10)
Ölfarbe, Aquarell und Feder
auf Karton auf Keilrahmen genagelt
33 × 50 cm
Sammlung Rosengart, Luzern

62 Romantic Park

1930, 280 (OE 10)
Oil, watercolour and pen on cardboard,
nailed onto stretcher
33 × 50 cm
Rosengart Collection, Lucerne

63 entwurf für einen Mantel

1931, 91 (N 11)

Aquarell und Bleistift auf Papier auf Karton

37,7 × 23,6 cm

Schenkung LK, Klee-Museum, Bern

63 Design for a Cloak

1931, 91 (N 11)

Watercolour and pencil on paper,

mounted on cardboard

37.7 × 23.6 cm

Gift of LK, Klee-Museum, Bern

64 Ruinen von Git

1931, 155 (R 15)

Ölfarbe auf Karton auf Keilrahmen genagelt

29 × 23,6 cm

Sammlung Rosengart, Luzern

64 Ruins of Git

1931, 155 (R 15)

Oil on cardboard,

nailed onto stretcher

29 × 23.6 cm

Rosengart Collection, Lucerne

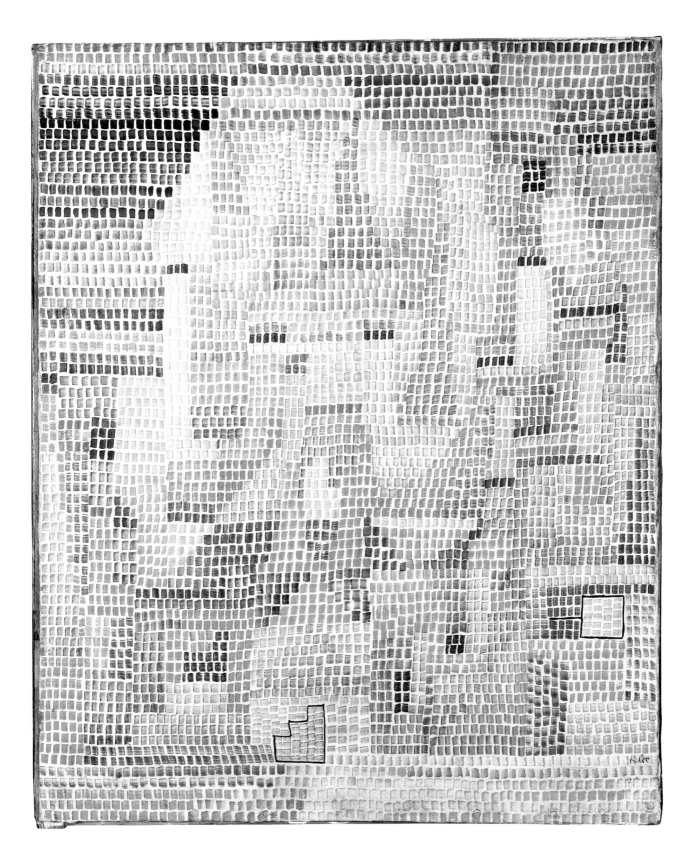

65 Portal einer Moschee

1931, 161 (S 1)

Feder und Aquarell auf Papier auf Karton

37,5 × 29 cm

Die Sammlung Berggruen

in den Staatlichen Museen zu Berlin

65 Portal of a Mosque

1931, 161 (S 1)

Pen and watercolour on paper,

mounted on cardboard

37,5 × 29 cm

The Berggruen Collection, Staatliche Museen zu Berlin

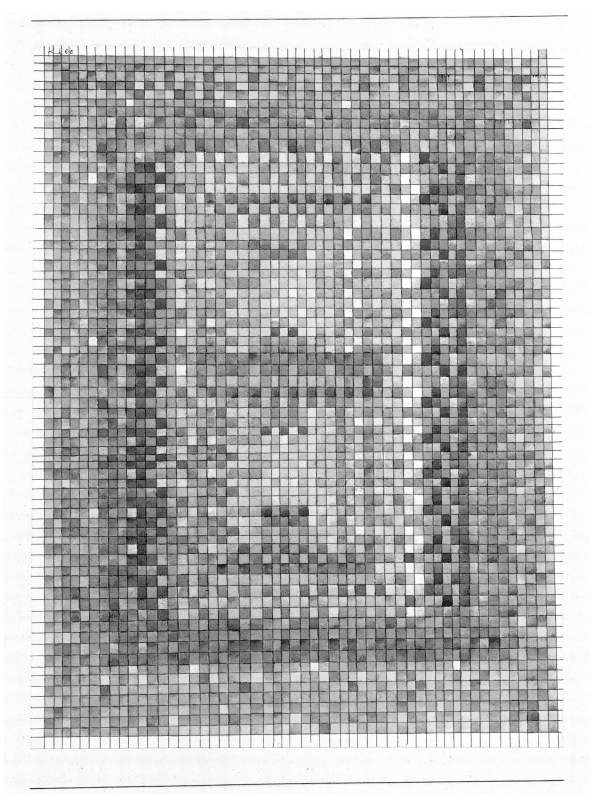

Scl 1931 S.1. Portal einer Moschee

66 Städtebild »Graben«

1931, 254 (W 14)

Aquarell auf Leimgrundierung auf Papier auf Karton

32,2 × 20,7 cm

Privatbesitz, Deutschland

66 Picture of the Town 'Graben'

1931, 254 (W 14)

Watercolour on glue priming on paper,

mounted on cardboard

32.2 × 20.7 cm

Private Collection, Germany

Klee

1931 W 14 Städtebild „Graben"

67 Ort der Verabredung

1932, 138 (Qu 18)

Aquarell und Ölfarbe auf Sperrholz auf Holzleisten,

am Rand mit Gaze abgedeckt; originale Rahmenleisten

30 × 48,5 cm

Kunstmuseum Bern, Leihgabe aus Privatbesitz, Inv. Nr. Lg 2137

67 Meeting Place

1932, 138 (Qu 18)

Watercolour and oil on plywood on battens,

borders covered with gauze, original frame strips

30 × 48.5 cm

Kunstmuseum Bern, on loan from a private collection

Inv. No. Lg 2137

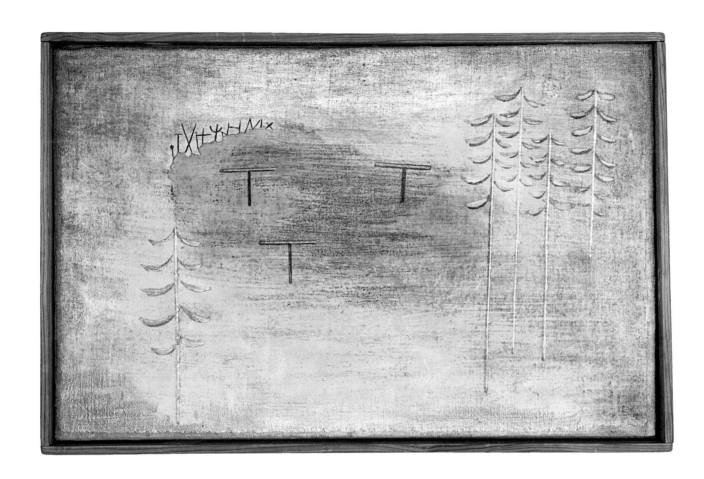

68 Abend im Tal

1932, 187 (T 7)
Ölfarbe auf Karton,
rückseitig ganzflächig Ölfarbe
33,5 × 23,3 cm
Privatbesitz, Schweiz

68 Evening in the Valley

1932, 187 (T 7)
Oil on cardboard,
oil covering the whole reverse surface
33.5 × 23.3 cm
Private Collection, Switzerland

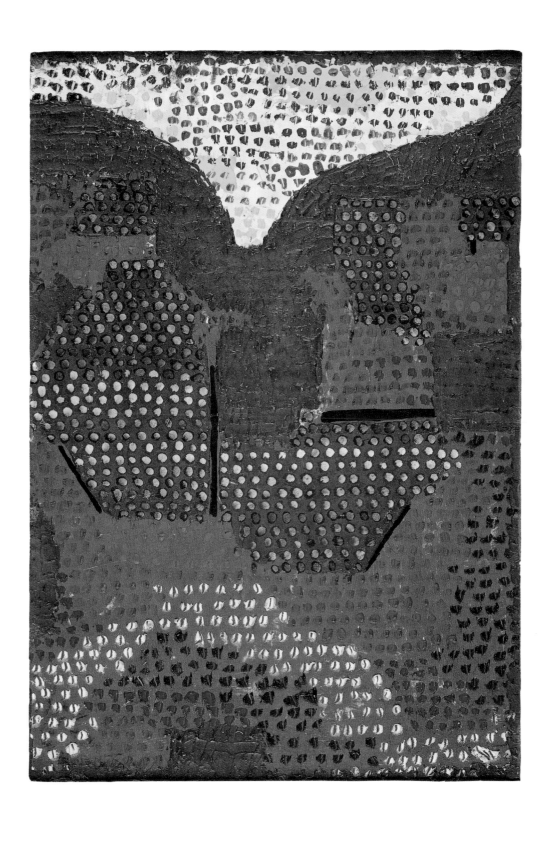

69 Stilleben in die Breite

1932, 287 (Y 7)
Aquarell auf Seide auf Sperrholz;
originale, gefasste Rahmenleisten
20 × 56,5 cm
Schenkung LK, Klee-Museum, Bern

69 Still Life in Width

1932, 287 (Y 7)
Watercolour on silk on plywood;
original painted frame strips
20 × 56.5 cm
Gift of LK, Klee-Museum, Bern

70 Der Schritt

1932, 319 (Z 19)
Ölfarbe und Bleistift auf Jute auf Keilrahmen
71 × 55,5 cm
Schenkung LK, Klee-Museum, Bern

70 The Step

1932, 319 (Z 19)
Oil and pencil on jute,
mounted onto stretcher
71 × 55.5 cm
Gift of LK, Klee-Museum, Bern

71 Ohne Titel

um 1932
Ölfarbe auf Karton
33,7 / 33,3 × 50,5 cm
Schenkung LK, Klee-Museum, Bern

71 Untitled

c. 1932
Oil on cardboard
33.7 / 33.3 × 50.5 cm
Gift of LK, Klee-Museum, Bern

72 Vollmondopfer

1933, 452 (H 12)

Öl- und Wachsfarbe auf Papier auf Karton

36,1 × 54,3 cm

Sammlung Rosengart, Luzern

72 Sacrifice at Full Moon

1933, 452 (H 12)

Oil and encaustic colour on paper,

mounted on cardboard

36.1 × 54.3 cm

Rosengart Collection, Lucerne

Klee

1930 H 12 voll mon d opfer

73 Die Erfindung

1934, 200 (T 20)
Wasserfarbe, teilweise gespritzt,
auf Baumwolle auf Sperrholz
50,5 × 50,5 cm
Privatbesitz, Schweiz

73 The Invention

1934, 200 (T 20)
Watercolour, partly sprayed, on cotton,
mounted on plywood
50.5 × 50.5 cm
Private Collection, Switzerland

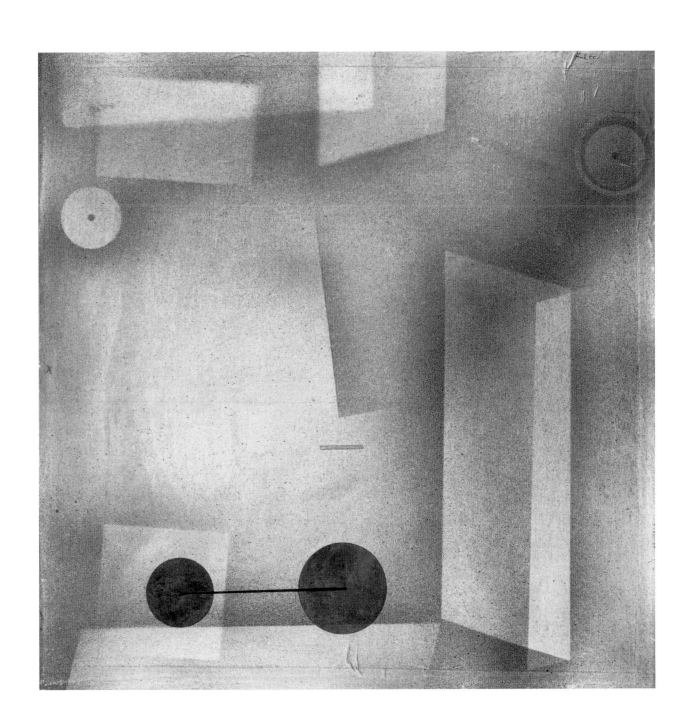

74 Engel im Werden

1934, 204 (M 4)
Ölfarbe, mit dem Spachtel aufgetragen,
auf Grundierung auf Leinwand auf Sperrholz
50,7 × 50,7 cm
Privatbesitz, Schweiz

74 Angel in the Making

1934, 204 (M 4)
Oil, applied by spatula, on priming on canvas,
mounted on plywood
50.7 × 50.7 cm
Private Collection, Switzerland

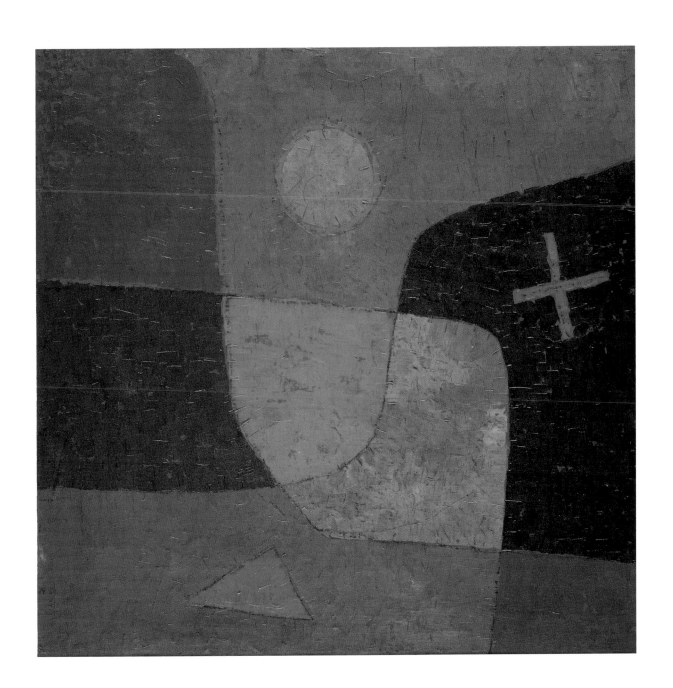

75 Bergdorf (herbstlich)

1934, 209 (U 9)
Ölfarbe auf weißer Grundierung
auf Leinwand auf Sperrholz
71,5 × 54,4 cm
Sammlung Rosengart, Luzern

75 Mountain Village (Autumnal)

1934, 209 (U 9)
Oil on white priming on canvas,
mounted on plywood
71.5 × 54.4 cm
Rosengart Collection, Lucerne

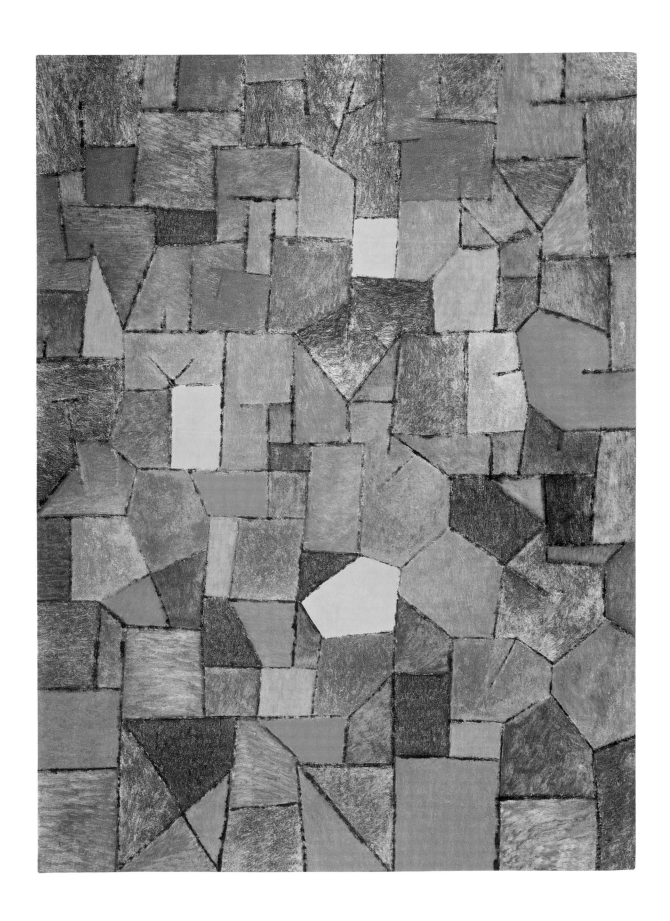

76 Landschaft am Anfang

1935, 82 (N 2)
Aquarell auf Gipsgrundierung auf Gaze auf Karton
33,5 × 58,5 cm
Privatbesitz, Schweiz

76 Landscape in the Beginning

1935, 82 (N 2)
Watercolour on plaster priming on gauze,
mounted on cardboard
33.5 × 58.5 cm
Private Collection, Switzerland

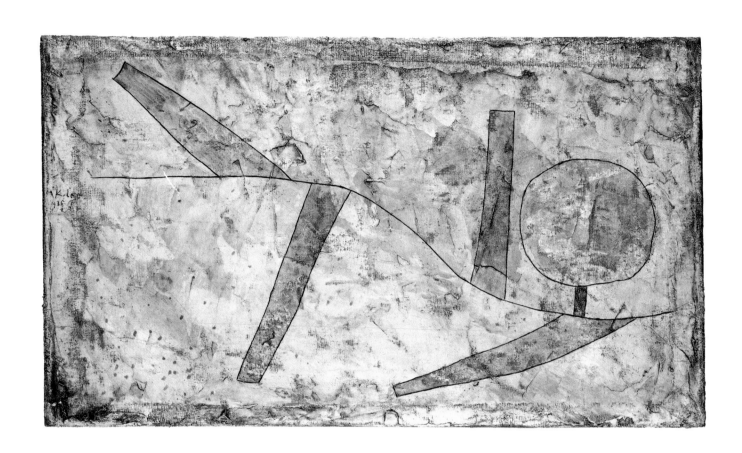

77 gelb unterliegt

1935, 103 (P 3)
Aquarell auf Grundierung auf Papier auf Karton
21,7 × 33 cm
Sammlung Strobel, Stuttgart

77 Yellow Succumbs

1935, 103 (P 3)
Watercolour on priming on paper,
mounted on cardboard
21.7 × 33 cm
Strobel Collection, Stuttgart

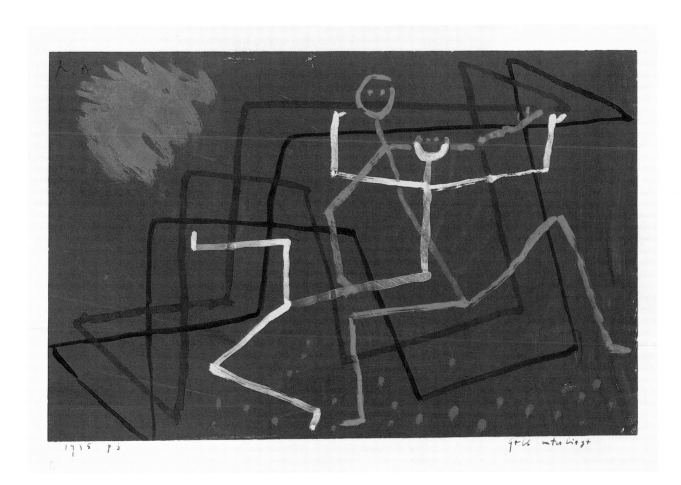

1935 J3 gelb unterliegt

78 Citronen - Ernte

1937, 219 (U 19)
Aquarell auf Grundierung auf Jute auf zweiter Jute
mit weißer Grundierung auf Keilrahmen
70 × 46 cm
Fondation Pierre Gianadda, Martigny

78 Lemon Harvest

1937, 219 (U 19)
Watercolour on priming on jute,
on second jute with white priming,
mounted onto stretcher
70 × 46 cm
Fondation Pierre Gianadda, Martigny

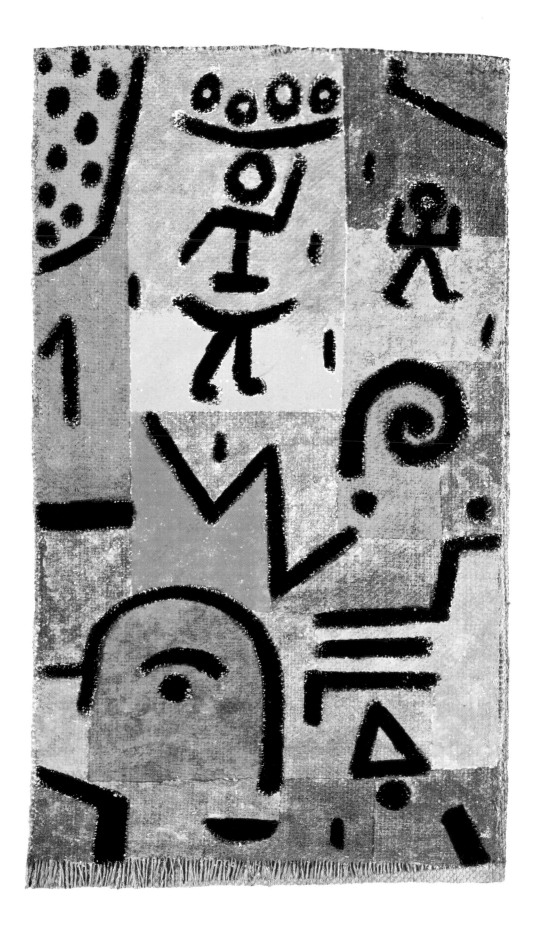

79 ABC für Wandmaler

1938, 320 (T 20)
Ölfarbe, Zeichnung eingeritzt,
auf Gipsgrundierung auf Jute auf Karton
56 × 37,8 cm
Sammlung Rosengart, Luzern

79 ABC for a Muralist

1938, 320 (T 20)
Oil, scratched drawing,
on plaster priming on jute,
mounted on cardboard
56 × 37,8 cm
Rosengart Collection, Lucerne

1938 T 20 ABC für Wandmaler

80 bunte Gruppe

1939, 1133 (JK 13)
Kreide, Ölfarbe und Aquarell auf
Baumwolle mit Leimtupfen auf Karton
42/41 × 39/39.5 cm
Privatbesitz, Schweiz

80 Colourful Group

1939, 1133 (JK 13)
Chalk, oil and watercolour
on cotton with spots of glue,
mounted on cardboard
42/41 × 39/39,5 cm
Private Collection, Switzerland

1939 J K 13 bunte Gruppe

BIOGRAPHY

1879

Paul Klee is born on 18 December in Münchenbuchsee, near Bern, Switzerland. His father, Hans Klee (1849–1940), a German, is a music teacher at the Bernisches Staatsseminar in Hofwil, Bern. His mother, Ida Marie, née Frick (1855–1921), is Swiss, and studied singing at the conservatory in Stuttgart.

1880

The Klee family moves to Bern.

"As far as my artistic bent goes, there is a legendary great-uncle in my mother's family who is supposed to have been a successful portrait painter in London, but the family soon lost all trace of him. My maternal grandmother drew, painted and embroidered as did every woman of good family in the Biedermeier period: flowers and suchlike pretty things. When I was a very small child, she introduced me to the pleasures of drawing and colouring.

My father comes from Thuringia; my mother is half French and half Swiss. Her French descent is a matter not completely clarified; that side of her family may be from southern France." Paul Klee, diary entries, quoted Felix Klee, *Paul Klee: His Life and Work* in *Documents*, New York, 1962, p. 3f.

1883

First drawings by Klee.

"My first childhood drawings were highly imaginative illustrations. No thought of any model in nature. Flowers, animals, churches, watering cans, horses, wagons, sleds and garden pavilions were recurrent themes. One source of inspiration was sheets of pictures with French verses."

Paul Klee, diary entries, p. 4

1886

Starts primary school in Bern; violin lessons from Karl Jahn. "Jahn had been well taught himself, and followed his model Joachim closely, partly because he was not one of those major talents who learn most from themselves. Nevertheless, his general abilities gave him an excellent basis for personal contacts; this and his outstanding ethical qualities made him an ideal teacher." Paul Klee, 'Karl Jahn as a teacher' in *Schriften* , p. 115

1890

Starts Secondary School at the Progymnasium Bern.

"I attended the first four grades of the local primary school; then my parents sent me to the municipal Progymnasium. I then entered the Literarschule of the Gymnasium. After I passed the cantonal examinations, I graduated in the fall of 1898." Paul Klee, curriculum vitae in Diaries, p. XIX

"Nature does love me! She consoles me and makes promises to me. On such days I am invulnerable. Outwardly smiling, inwardly laughing more freely, a song in my soul, a twittering whistle on my lips, I cast myself on the bed, and keep watch over my slumbering strength." *Diaries*, 54

1898

Starts studying art in October, first at Heinrich Knirr's private art school in Munich.

"Backward glance. At first I was a child. Then I wrote nice essays and was also able to reckon (until about my eleventh or twelfth year). Then I developed a passion for girls. Then came the time when I wore my school cap tilted back on my head and only buttoned the lowest button of my coat (fifteen). Then I began to consider myself a landscapist and

cursed humanism. I would gladly have left school before the next to last year, but my parents' wishes prevented it. I felt like a martyr. Only what was forbidden pleased me. Drawing and writing. After having barely passed my final examination, I began to paint in Munich."

Diaries, 63

1899

Meets the pianist Lily Stumpf, the daughter of a Munich doctor. Klee's mother, Ida, becomes paralysed and remains so for the rest of her life.

"I met the lady who was to become my wife in the autumn of 1899, while I was playing music."

Diaries, 83

The quintet in the studio at Heinrich Knirr's art school, Munich, 1900. Gift of the Klee family, held in the Paul Klee Foundation, Bern

1900

Admitted to the Munich Akademie in October, enrols in Franz von Stuck's class.

"To be a student of Stuck sounded good. In reality, however, it was not half so splendid. Instead of coming to him with a sound mind I brought a thousand pains and many prejudices. In the realm of colour I found it hard to progress. Since the tone provided by mood predominated strongly in my

mastery of form, I sought to find as much profit as possible here at least. And, in this respect, a great deal really was to be gained at Stuck's."

Diaries, 122

1901

Six-month study-tour of Italy with the sculptor Hermann Haller, starting in October (Milan, Genoa, Leghorn, Pisa, Rome, Naples, Florence). Returns to Bern in May 1902:
"Ancient Italy remains the chief thing for me even now, the main basis. There is a certain melancholy in the fact that no present lives up to this past. It is probably ironical that ruins should be admired more than what has been well preserved."

Diaries, 371

"Actually, the main thing now is not to paint precociously but to be or, at least, to become an individual. The art of mastering life is the prerequisite for all further forms of expression, whether they are paintings, sculptures, tragedies, or musical compositions. Not only to master life in practice, but to shape it meaningfully within me and to achieve as mature an attitude before it as possible. Obviously this isn't accomplished with a few general precepts but grows like Nature."

Diaries, 411/412

1903

First etchings; violinist in the Bern municipal orchestra.
"June 1903. Toward the end of the month I prepared engravings; first, invented appropriate drawings. Not that I want to become a specialist now. But painting with its failures cries out for the relief of minor successes. Nowadays I am a very tired painter, but my skill as a draughtsman holds up."

Diaries, 512

1905

Journeys to Paris with Hans Bloesch and Louis Moilliet. Visits the Louvre and the Musée du Luxembourg (31 May – 13 June).
"Paris gave me impressions that extend well beyond the bounds of visual art, my feelings for humanity suffered an

The Klee family in the garden at Obstbergweg 6, Bern, September 1906. Bequest of the Klee family, held in the Paul Klee Foundation, Bern

awful depression there; in the particular field of art, however, I raised myself to considerable heights, I have at last attained a free vantage-point over the artistic world throughout the ages. Paris completed what other places began. I even got considerably closer to the Spanish masters Velázquez, Goya and Zuloaga, particularly the first two."

<div align="right">Letter from Bern to Lily Stumpf, 15 June 1905</div>

1906

Journeys to Berlin with Hans Bloesch (8–16 April)
"Wednesday, 4. 11. To the Centennial Exhibition (National Gallery). Paid particular attention to Feuerbach, Marees,

Leibl, Trübner, Menzel, and Liebermann. Empire and Biedermeier did not exactly appeal to me."

<div align="right">*Diaries,* 765</div>

Marries Lily Stumpf (1876–1946) on 15 September. Lives at Ainmillerstr. 36 in the district of Schwabing, in Munich, from October.

"I am legally a spouse, for at the registry office I walked through the door labelled 'Married.' Herr Henzi dispensed noble exhortations to us from behind a large bouquet of flowers, which his words skirted, sometimes to the left, sometimes to the right, and which he addressed sometimes to me, other times to my bride. On the Münsterplatz the market was open, and the butchers had a laugh as we walked by their stands. Such were their simple souls."

<div align="right">*Diaries,* 778</div>

1907

First encounter with prints by Daumier and Ensor and works of the French Impressionists.

"Above all else there was the magnificent *Absinthe Drinker* by Manet, which helped me greatly in my efforts with tonality. Then a large array of works which gradually move toward colourism, from Bon Boc to Lady with Parasol. Either the *Absinthe Drinker* is really the strongest work of the lot, or I am particularly attuned to it at this time. By Monet, there were landscapes of Paris (Boulevard scene!) and surroundings. Courbet was represented by the great picture *The Wrestlers*."

Diaries, 785

"… in the summer of 1907 I devoted myself entirely to the appearance of nature and upon these studies built my black-and-white landscapes on glass, 1907/08. No sooner have I mastered that stage than nature again bores me. Perspective makes me yawn. Should I now distort it (I have already tried distortions in a mechanical way)? How shall I most freely cast a bridge between inside and outside?" *Diaries*, 831

The Klee's son, Felix, is born on 30 November.

1908

Visits van Gogh exhibitions in the Zimmermann and Brakl galleries in Munich.
"Van Gogh is congenial to me, 'Vincent' in his letters. Perhaps nature does have something. There is no need, after all, to speak of the smell of earth; it has too peculiar a savour. The words we use to speak about it, I mean, have too peculiar a savour." *Diaries*, 804

Conducts correction classes for a few months in the Debschitz art school.
"The people there draw industriously, but are also quite mediocre. It's questionable whether I am achieving very much there. But it is not without interest." *Diaries*, 819

"With new strength from my naturalistic etudes, I may dare to enter my prime realm of psychic improvisation again. Bound only very indirectly to an impression of nature, I may

again dare to give form to what burdens the soul. To note experiences that can turn themselves into linear compositions even in the blackest night. Here a new creative possibility has long since been awaiting me, which only my frustration resulting from isolation interfered with in the past. Working in this way, my real personality will express itself, will be able to emancipate itself into the greatest freedom."

Diaries, 842

1909

Visits the Marées exhibition at the Munich Secession; sees pictures by Cézanne and Matisse. Summer holidays in Bern and Beatenberg (3 June – late October).
"Nature can afford to be prodigal in everything, the artist must be frugal down to the smallest detail, Nature is garrulous to the point of confusion, let the artist be truly taciturn. Moreover, in order to be successful, it is necessary never to work toward a conception of the picture completely thought out in advance. Instead, one must give oneself completely to the developing portion of the area to be painted. The total impression is then rooted in the principle of economy: to derive the effect of the whole from a few steps. Will and discipline are everything. Discipline as regards the work as a whole, will as regards its parts. Will and craft are intimately joined here; here, the man who can't do, can't will. The work then accomplishes itself out of these parts thanks to discipline that is directed toward the whole. If my works sometimes produce a primitive impression, this 'primitiveness' is explained by my discipline, which consists in reducing everything to a few steps. It is no more than economy; that is, the ultimate professional awareness. Which is to say, the opposite o f real primitiveness. I also saw eight pictures by Cézanne at the Sucession. In my eyes he is the teacher *par excellence*, much more of a teacher than van Gogh." *Diaries*, 857

1910

Exhibition of fifty-six works at the Kunstmuseum in Bern, the Kunsthaus in Zurich and a gallery in Winterthur, Switzerland.
"March. And now an altogether revolutionary discovery: to adapt oneself to the contents of the paintbox is more impor-

tant than nature and its study. I must some day be able to improvise freely on the chromatic keyboard of the rows of watercolour cups."

<div align="right">Diaries, 873</div>

Produces illustrations for Voltaire's Candide. Visits Louis Moilliet on Lake Thun and meets August Macke. Meets Wassily Kandinsky and the Blue Rider artists in Munich. Contributes to the magazine Die Alpen, edited by Bloesch.
"Kandinsky wants to organize a new society of artists. Personal acquaintance has given me a somewhat deeper confidence in him. He is somebody and has an exceptionally fine, clear mind."

<div align="right">Diaries, 903</div>

1912

Contributes seventeen works to the second Blue Rider exhibition at the Galerie Golz. Second visit to Paris from 2–18 April. Meets Delaunay and Le Fauconnier, sees paintings by Matisse, Picasso, Braque, Rousseau, Derain, Vlaminck, etc. in the Uhde Collection, and at Kahnweiler's and Bernheim Jeune's.

Translation of Delaunay's essay Sur la Lumière, which was published in 'Der Sturm.'
"Nature is imbued with a rhythm that in its multiplicity cannot be constrained. Art should imitate it in this, in order to purify itself to the same height of sublimity, to raise itself to visions of multiple harmony, a harmony of colours separating and coming together again in the same action. This synchronic action is the actual and only subject (sujet) of painting."

<div align="right">Robert Delaunay, About Light, in Schriften, p. 116f.</div>

1913

Takes part in the 'Erster Deutscher Herbstsalon' (First German Autumn Salon) in Berlin.
"Tie small-scale contrasts together compositionally, but also large-scale contrasts; for instance: confront chaos with order, so that both groups, which are separately coherent, become related when they are placed next to or above each other; they enter into the relation of contrast, whereby the characters of both sides are mutually heightened. Whether I can

Paul Klee (in the background) with August Macke on a donkey and a guide outside the mosque in Kairouan, 1914, from August Macke's photo album, Westfälisches Landesmuseum für Kunst und Kulturgeschichte, Münster

already accomplish such things is questionable on the positive side — and more than questionable, unfortunately, on the negative side. But the inner urge is there. The technique will develop in time."

<div align="right">Diaries, 921</div>

1914

In April, journeys to the south of France and Tunisia with Louis Moilliet and August Macke (Tunis, Hammamet, Kairouan; return via Palermo, Naples, Rome). Founder-member of the 'Neue Münchner Sezession.'
"Wednesday, 4. 8. Tunis. My head is full of the impressions of last night's walk. Art–Nature–Self. Went to work at once and painted in watercolor in the Arab quarter. Began the synthesis of urban architecture and pictorial architecture. Not yet pure, but quite attractive, somewhat too much of the mood, the enthusiasm of travelling in it — the Self, in a word. Things will no doubt get more objective later, once the intoxication has worn off a bit."

<div align="right">Diaries, 926f.</div>

"The evening is indescribable. And on top of everything else a full moon came up. Louis urged me to paint it. I said: it will be an exercise at best: Naturally I am not up to this kind of

Paul Klee (far right, standing on ground) as a soldier in the Landshut training battalion, Bavaria, 1916. Bequest of the Klee family, held in the Paul Klee Foundation, Bern

nature. Still, I know a bit more than I did before. I know the disparity between my inadequate resources and nature. This is an internal affair to keep me busy for the next few years."

Diaries, 926k

"I try to paint. The reeds and bushes provide a beautiful rhythm of patches." *Diaries*, 926m

"At two o'clock, Kairouan. Small French suburb with two hotels. Our thirst for tea is abundantly slaked, so that the discovery of this marvelous Kairouan may be carried through properly. At first, an overwhelming tumult, culminating that night with the *Mariage arabe*. No single thing, but the total effect. And what a totality it was! The essence of *A Thousand and One Nights*, with a ninety-nine percent reality content. What an aroma, how penetrating, how intoxicating, and at the same time clarifying. Nourishment, the most real and substantial nourishment and delicious drink. Food and intoxication. Scented wood is burning. Home?" *Diaries*, 926n

"I now abandon work. It penetrates so deeply and so gently into me, I feel it and it gives me confidence in myself without effort. Colour possesses me. I don't have to pursue it. It will possess me always, I know it. That is the meaning of this happy hour: Colour and I are one. I am a painter."

Diaries, 926o

1915

Rainer Maria Rilke visits Klee in the summer; journeys to Switzerland; Klee produces some sculptures.

"One deserts the realm of the here and now to transfer one's activity into a realm of the yonder where total affirmation is possible.

Abstraction.

The cool Romanticism of this style without pathos is unheard of. The more horrible this world (as today, for instance), the more abstract our art, whereas a happy world brings forth an art of the here and now." *Diaries*, 951

"I have long had this war inside me. This is why, interiorly, it means nothing to me. And to work my way out of my ruins, I had to fly. And I flew. I remain in this ruined world only in memory, as one occasionally does in retrospect. Thus, I am 'abstract with memories.'" *Diaries*, 952

1916

Franz Marc is killed at Verdun on 4 March. Klee enters military service on 11 March. Military training in Landshut and Munich and later at the airforce base in Schleissheim, near Munich, in the summer. Escorts military transport convoys.

"When I tell what kind of person Franz Marc is, I must at once confess that I shall also be telling what kind of person I am, for much that I participated in belonged also to him. He is more human, he loves more warmly, is more demonstrative. He responds to animals as if they were human. He raises them to his level. He does not begin by dissolving himself, becoming merely a part in the whole, so as to place himself on the same level with plants and stones and animals … I place myself at a remote starting point of creation, whence I state 'a priori' formulas for men, beasts, plants, stones and the elements, and for the whirling forces …" *Diaries*, 1008

1917

Accompanied a military convoy to Nordholz near Cuxhaven. Returned via Berlin. Visited Herwarth Walden and Bernhard Koehler. Transferred to the flying-school at Gersthofen near Augsburg. Exhibition at Der Sturm gallery, a financial success.

"We investigate the formal for the sake of expression and of the insights into our soul which are thereby provided. Philosophy, so they say, has a taste for art; at the beginning I was amazed at how much they saw. For I had only been thinking about form, the rest of it had followed by itself. An awakened awareness of 'the rest of it' has helped me greatly since then and provided me with greater variablility in creation. I was even able to become an illustrator of ideas again, now that I had fought my way through formal problems. And now I no longer saw any abstract art. Only abstraction from the transitory remained. The world was my subject, even though it was not the visible world." *Diaries*, 1081

The Jury at a meeting of the New Secession Munich, 1919
From left to right, seated: Hess, Unold, Püttner, Caspar, Seewald, Scharff. Standing: Maria Caspar-Filser, Erbslöh, Kanoldt, Eberz, Klee, Wrampe, Schülein, Großmann, Gött, Coester

1918

On leave from military service, Klee returns to his family in Munich in December, after the end of the war. Discharged in February 1919.
"Yesterday afternoon I took a nice walk. The scene was drenched in a sulphur yellow, only the water was a turquoise blue—blue to deepest ultramarine. The sap colours the meadows in yellow, carmine, and violet.

I walked about in the river bed, and since I was wearing boots, I was able to wade through the water in many places. I found the most beautiful polished stones. I took along a few washed-out tiles. It is just a short step from this to plastic form." *Diaries*, 1102

"I remember as if it had happened only a short time ago the December of 1918 when my father returned home in a field-grey uniform at Christmas time to our small, modest, dark apartment in Schwabing. Christmas is a matter of great importance to a child. My mother shut herself up mysteriously in the music room where she made a suspicious rustling over the Christmas packages, and my father was happy to be released from all other duties and to be able to celebrate his thirty-ninth birthday and Christmas peacefully with his family." Felix Klee, 'Erinnerungen,' in *Paul Klee: Diaries*, 422

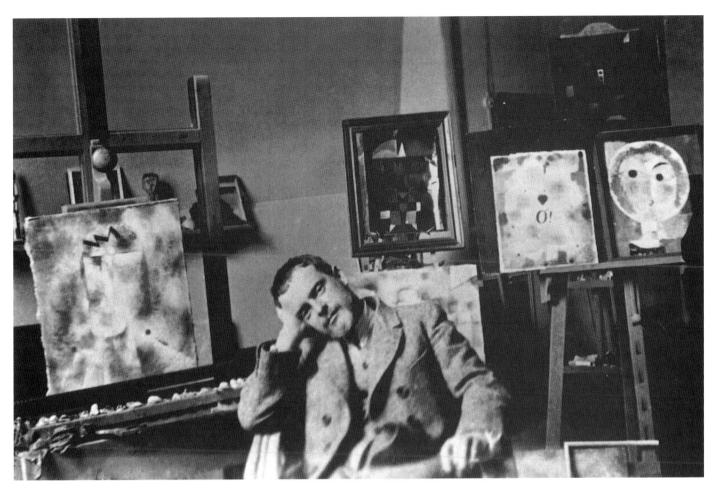

Paul Klee in his Weimar Studio, 1922, photo: Felix Klee. Bequest of the Klee Family, held in the Paul Klee Foundation, Bern

1919

Studio in Munich in the Late Baroque Suresnes Palais in Werneckstrasse; member of the arts committee of the Räterepublik (Bavarian Soviet Republic); travels to Switzerland in June after the collapse of the Republic; in June and July Baumeister and Schlemmer unsuccessfully attempt to secure a post for Klee in Stuttgart. Contract with the Hans Goltz gallery in Munich in October.

"Hans Goltz, the courageous art dealer who had earlier displayed abstract art to the astounded citizens of Munich in his rooms on Briennerstrasse, twice signed a three-year contract with my father. As I have said, our own apartment lacked suitable working space and my father began looking around for a studio. He found one in the charming little Rococo palace of Suresnes on Werneckstrasse in the old quarter of Schwabing. Here he rented a splendid room with a view of the ancient park full of grottoes and winding paths, and of the adjacent English Garden."

<div align="right">Felix Klee, Paul Klee, p. 51</div>

1920

Is appointed to the Bauhaus in Weimar by Walter Gropius on 29 October.

Theoretical essay published in Edschmid's anthology *Creative Credo*.

"An apple tree in blossom, its roots, the rising sap, the trunk, a cross section with annual rings, the blossom, its structure, its sexual functions, the fruit, the core and seeds. An interplay of states of growth."

<div align="right">Paul Klee, in Creative Credo, 1920</div>

"Arrived safely, met by Itten and Muche. Discussed things with Gropius. Looked round the Bauhaus this morning, then signed the contract with Gropius at lunchtime. This is not final until it has been ratified by the government. This afternoon I am going to the housing office (formality). Cordially and see you on Sunday! Regards to Felix etc. Yours, Paul."

<div align="right">Card to Lily Klee, 26 November 1920</div>

"Since we did not find a place to live in Weimar, my father temporarily divided his time between Munich and Weimar, spending two weeks in one place and two weeks in the other. A year later, in October, 1921, we moved out of the metropolis of Munich to the highly individual small town so rich in tradition in the heart of Thuringia. We found a spacious four-room apartment above Goethe Park, in the house belonging to Count Keyserling. Each day we walked through the park to the Bauhaus. My father went up to his studio on the third floor and I to the cabinetworkers' shops in the rear building, where I worked. At every season of the year Klee made the walk fascinating with his observations. In winter we watched the small coots on the frozen Ilm; like unskillful ice skaters, they frequently tumbled over; in summer the innumerable songbirds, the woodpeckers, the ringdoves; and in the spring my father would tell me the names of all the flowers we saw."

Felix Klee, *Paul Klee*, pp. 53 f.

1921

Starts teaching at the Bauhaus on 1 January. Spends the summer in Possenhofen on Lake Starnberg. Moves to Weimar in September.

Begins writing up his Bauhaus lectures in the winter semester 1921/22 ('Beiträge zur bildnerischen Formlehre').

"In the first place, what do we mean by movement in the work? As a rule our works don't move. After all, we are not a robot factory. No, in themselves our works, or most of them, stay quietly in place, and yet they are all movment. Movement is inherent in all becoming, and before the work is, it must become, just as the world became before it was, after the words: "In the beginning God created the world," and must go on becoming before it is (will be) in the future … Seen cosmically, movement is fundamental and as an unending power needs no impulse. The stillness of objects in the earthly sphere is the material inhibition of movement. It is fallacious to assume that the earth's attraction is the norm. The history of the work, which is chiefly genesis, may be briefly characterized as a secret spark from somewhere, which kindles the spirit of man with its glow and moves his hand; the spark moves through his hand, and the movement is translated into matter." Paul Klee, *Beiträge zur bildnerischen Formlehre*, 27 February 1922

1922

Summer in Possenhofen. Kandinsky is appointed to the Bauhaus.

"The summers of the years 1920 to 1922 were a delight to all of us, for we spent them in Possenhofen on Starnberg Lake. My father particularly enjoyed being able to swim to his heart's delight after painting, to go for walks, and above all to fish. The first year—1920—we stayed in the house called 'Greeting to God' owned by a Frau von Eckardt, and took our meals in the neighbouring tavern, 'The Shower.' For the next two years —1921 and 1922—we had five rooms at the home of a fisherman named Gebhardt, near the steamer landing stage. My father painted out in the open air on the huge balcony, using a bench as an easel." Felix Klee, *Paul Klee*, pp. 72f.

1923

The essay 'Wege des Naturstudiums' is published in a Bauhaus anthology. Spends the winter on the island of Baltrum.

"For the artist, dialogue with nature remains a conditio sine qua non. The artist is a man, himself nature and a part of nature in natural space." Paul Klee, *Ways of Studying Nature*

1924

First exhibition of Klee's work held in America at the Société Anonyme in New York in January/February, organized by Katherine Dreier. Lecture 'On Modern Art' given at the Art Association in Jena. Foundation of the 'Blaue Vier' (Blue Four) group by Emmy Galka Scheyer (Klee, Kandinsky, Feininger, Jawlensky). Travels to Sicily (Taormina, Mazzaro, Syracuse, Gela). The Bauhaus closes down in Weimar on 26 December, and reopens in Dessau.

"From type to prototype. Presumptuous is the artist who does not follow his road through to the end. But chosen are those artists who penetrate to the region of that secret place where primeval power nurtures all evolution. There, where the power-house of all time and space — call it brain or heart of creation — activates every function; who is the artist who would not dwell there? In the womb of nature, at the source of creation, where the secret key to all lies guarded. But not all

can enter. Each should follow where the pulse of his own heart leads. So, in their time, the Impressionists — our opposites of yesterday — had every right to dwell within the matted undergrowth of everyday vision. But our pounding heart drives us down, deep down to the source of all. What springs from this source, whatever it may be called, dream, idea or phantasy-must be taken seriously only if it unites with the proper creative means to form a work of art. Then those curiosities become realities — realities of art which help to lift life out of its mediocrity. For not only do they, to some extent, add more spirit to the seen, but they also make secret visions visible." Paul Klee, *On Modern Art*, 1924, pp. 49 f.

Paul Klee in his Weimar studio, early 1926
photo: Felix Klee

1925

Klee's *Pädagogisches Skizzenbuch* is published. First exhibition in Paris.
"Since the 'master's' house which was being built specially for Klee was not ready before the summer of 1926, we remained

Wassily Kandinsky and Paul Klee, Dessau 1927
photo: Lily Klee, Bequest of the Klee family,
held in the Paul Klee Foundation, Bern

Wassily Kandinsky and Paul Klee, Hendaye plages, France, 1929
photo: Nina Kandinsky. Bequest of the Klee family, held in the Paul
Klee Foundation, Bern

Stresemannallee. The colony consisted of five houses: a single house for the director and four double houses for the masters. In these houses lived Gropius, Moholy-Nagy, Feininger, Muche, Schlemmer, Kandinsky and Klee. Hence we were separated from the Kandinskys only by a wall; we saw and greeted one another daily without in the least interfering with one another. Our little settlement was situated in one of those pine groves characteristic of central Germany, and had no fences to the rear." Felix Klee, *Paul Klee*, p. 55

"But my favourite outing was a trip to Oranienbaum and Wörlitz. The latter place was surrounded by an enchanting park full of lakes and watercourses that made the visitor forget the monotony of the surrounding Elbe flatlands. We strolled past Aeolian harps and exotic giant trees, across rickety footbridges, and took the ferries to the islands. Here Paul Klee was thoroughly in his element, and many of his pictures with plant or water subjects were the outcome of visits to this wonderful park." Felix Klee, *Paul Klee*, p. 57

1927

Summer visits to the island of Porquerolles, near Toulon, and Corsica.
"Sometimes when we young people went swimming, my father retreated to the cliffs, spread out a handkerchief and did drawings from nature to his heart's desire. Later, he travelled on alone to Corsica, which he told about with immense enthusiasm. He had an everlasting longing for the south, for the Mediterranean, and his contacts with these lands visibly transformed him; in spite of the intense heat he always came from such trips with his vitality and creativity greatly strengthened." Felix Klee, *Paul Klee*, pp. 62 f.

in our Weimar home for the time being. Once again Klee spent a year travelling at two-week intervals back and forth between the two cities. He had a furnished room with the Kandinsky's and taught in the provisional quarters of the new Bauhaus." Felix Klee, *Paul Klee*, p. 55

1926

Moves to Dessau in July. Travels to Italy in October/November (Elba, Milan, Genoa, Pisa, Florence, Ravenna).
Opening of the Bauhaus building designed by Gropius (December).
"In July, 1926, we moved into one of the master's houses in Dessau. Burgkühnauerallee 7, a street that was later renamed

1928/29

Spends the summer in Brittany. Essay 'Exact Experiments in the Realm of Art' published in the magazine Bauhaus.

From 17 December 1928–17 January 1929, travels to Egypt (Alexandria, Cairo, Gizeh, Luxor, Karnak, Valley of the Kings, Thebes, Aswan, Elephant Island).

Paul Klee in front of the temple ruins in Agrigento, Sicily, 1931, photo: Lily Klee. Bequest of the Klee family, held in the Paul Klee Foundation, Bern

Spends the summer in the Villa Louisiana, near Biarritz, in the south of France. Celebrates his fiftieth birthday in the Bauhaus. Exhibition at the Galerie Flechtheim in Berlin.

"You have probably heard about all that was going on last week, and I'm sure I don't need to spell out for you what it was like on my fiftieth and the few days afterwards. It would be difficult to bring order to the picture of very conflicting sentiments."

Letter to Felix Klee, 26 December 1926

1930

Exhibition in New York, Saarbrücken, Düsseldorf and Dresden. Klee is offered a post at the Kunstakademie (Art Academy) in Düsseldorf by Dr. Kaesbach.

Spends the summer in the Engadin and Viareggio. Mies van der Rohe becomes Director of the Bauhaus.

"Because of the promptness of the press I had two busy days, I quickly had to inform Kandinsky and Hannes Meyer that the Düsseldorf appointment is now settled in principle. It was predictable that this would be followed by an official visit from the Lord Mayor and Dr. Grote, and also that there would be no lack of promises from that side. Of course I stood firm, as I am not a reed and in the expectation that everything will be done in Düsseldorf to make the move easier."

Card to Lily Klee, 6 July 1930

Paul Klee in the Latomia del Paradiso, Syracuse, Sicily, 1931, photo: Lily Klee. Bequest of the Klee family, held in the Paul Klee Foundation, Bern

1931

Resignes from the Bauhaus; becomes Professor at the Academy in Düsseldorf. Second journey to Sicily (Syracuse, Ragusa, Agrigento, Palermo, Monreale).

"Once I worked at home all the time for weeks, and then I suddenly discovered on a walk near Bern that actually nature is incredibly beautiful. I then tried to capture this. Now, to, I always make studies out of doors, without directly drawing, but the eye does draw, and there are places that have an enormous influence. There is no area in which we can manage without nature-studies."

Petra Petitpierre, *Aus der Malklasse von Paul Klee,* on Klee's teaching in Düsseldorf

Hannes Meyer succeeds Gropius at the Bauhaus.

"… intuition is still not wholly dispensable. we produce evidence, reasons, support; we design models, we organize: all well and good. but we do not achieve totalization. we work hard; but genius is not hard work as the saying misleadingly suggests. hard work is not even a part of genius although men of genius are hard-working as well. Genius is Genius, is blessing, is without beginning and without end, is begetting."

Paul Klee, 'Exact Experiments in the Realm of Art,' 1928

"During this Egyptian trip, Klee worked very little, perhaps not at all. He merely stored up impressions. Later on, we constantly recognized themes in his work that dealt directly or indirectly with the landscape and the population of Egypt."

Felix Klee, *Paul Klee,* p. 63

Paul Klee in Dessau, 1932, photo: J. Albers

Moves from Dessau to Düsseldorf (Heinrichstrasse 36) in early May. On the Côte d'Azur in October (Nice, Saint-Raphaël, Hyères, Port-Cros, Toulon). Kahnweiler concludes an exclusive contract with Klee. Returns to Bern in December.

"Not since my return from Venice have I worked as in the last two weeks. The quantity is not the point, but the wholeness and the joy that thereby sets in every day for a few hours. Once again I managed to banish all scepticism from this process. And much is released that was threatening to become ballast. Everthing cast off. There are a few drawings that expressly deal with casting off ballast, fairly reactive things, far from the earlier drastic-reactive kind, but also sublimated or refined as such in character."

Letter to Lily Klee, 5 February 1933

"Now everything has been cleared out. I shall most probably leave this place tomorrow evening. Then come the wonderful days of Christmas, when bells ring in every child's head. I have grown a little older in the last few weeks. But I don't want to let any bitterness creep in, or only bitterness tempered with humour. It's easy enough for men. Women tend to resort in such cases to tears …" Letter to Felix Klee, 22 December 1933

1934

In Bern he lives first in Obstberg, then in Kollerweg, finally at Kistlerweg 6. Will Grohmann publishes his book on the drawings produced from 1921 to 1930, which is later seized by the Nazis.

1932

Sees the Picasso exhibition in Zürich in October. Travels to Venice and Padua. Bauhaus closes in Dessau and moves to Berlin.
"Art relates to creation like a simile. The bond with optical reality is very elastic. The world of form is sovereign for itself, but in fact not yet art in the highest circle. In the highest circle a mystery reigns over ambiguity — and the light of the intellect goes out pitifully." *Aphorism*, New Year 1932

1935

Onset of illness (scleroderma). Retrospective in the Kunsthalle, Bern.

1936

1933

Klee's house in Dessau is searched. Abusive criticism in Nazi press. Dismissed from the Düsseldorf Akademie on 1 May.

Treatment in Tarasp and Montana. Only twenty-five works are produced this year.

1937

Seventeen works by Klee are shown in the 'Degenerate Art' exhibition. Stays in Ascona in September. Picasso visites Bern in November.

"This new creative upsurge began in 1937, and was truly a surprise to all of us, Grohmann divides this last creative period into the following categories: humor of the late years, late pastels, symbol pictures with thin, heavy and outlined bars, large panels, conceptual pictures, tragicdemonic and intimations of death, the series of angels, and requiem.

Felix Klee, *Paul Klee*, p. 72

1938

Spends the summer in Beatenberg. Exhibitions in New York and Paris.

1939

Paul Klee in his studio in Kistlerweg, Bern, summer 1938
photo: Felix Klee, Grohmann-Archiv, Stuttgart

Braque visits Klee in April. Klee sees the Prado exhibition in Geneva in summer. Stays on Lake Murten in the autumn. 1253 works are produced during the year. Applies for Swiss citizenship, which is not granted during his lifetime.

"Production is increasing at a greater tempo, and I can't quite keep up with these children. They dart off. A degree of adjustment takes place in that drawings predominate. Twelve hundred numbers in 1939 is definitely a record, though."

Letter to Felix Klee, 29 December 1939

parably fruitful life, a harvest that seemed to add something quite new to all those brought in before. Anyone who had to watch how the sap began to dry up in the roots from which the body lives might see in the apparently more powerful tone of these late works something like the triumph of the creative will over the physical."

Georg Schmidt, speech at the funeral service in the chapel of the Bürgerspital in Bern on 2 July 1940

1940

Exhibition in Zurich in February. On 10 May admitted to the Orselina sanatorium in Locarno, and on 8 June to the Sant'Agnese hospital in Muralto, Locarno. Paul Klee dies on 29 June.

"Very quietly, just one individual amidst the thousandfold dying, the quietest, the most individual of all present-day artists has passed away. For a long time those close to him had been anxious about this precious life. For even in the last year a harvest ripened in the cycle of harvests of this incom-

"On this side I cannot be grasped,
For I live as much
With the dead
As with those yet unborn.
A little closer to creation than usual
And yet nowhere nearly close enough."

Paul Klee, *Der Ararat*, 1920

1 The seminal work on the public reception of Klee's work: Christine HOPFENGART, *Klee. Vom Sonderfall zum Publikumsliebling. Stationen seiner öffentlichen Resonanz in Deutschland 1905–1960*, Mainz 1989.

2 See especially the biographies by Hermann von WEDDERKOP, *Paul Klee*, Leipzig *1920* (= Junge Kunst, vol. *13*); Leopold ZAHN, *Paul Klee. Leben, Werk, Geist*, Potsdam 1920 and Wilhelm HAUSENSTEIN, *Kairuan oder eine Geschichte vom Maler Klee und von der Kunst dieses Zeitalters*, Munich 1921. — The problems inherent in the early biographies, especially those by Zahn and Hausenstein have been the subject of various discussions. Most recently, by Otto Karl WERKMEISTER, "Kairuan: Wilhelm Hausensteins Buch über Paul Klee", in: *Die Tunisreise. Klee, Macke, Moilliet*. Exh. cat., Westfälisches Landesmuseum für Kunst und Kulturgeschichte Münster, Landschaftsverband Westfalen-Lippe et al., 1983, pp. 76–95; HOPFENGART, *Klee. Vom Sonderfall* (see n. 1 above), pp. 23–26 and 41ff.; Otto Karl WERKMEISTER, "Klee vor den Toren von Kairouan", in: *Reisen in den Süden. "Reisefieber praecisiert"*. Exh. cat., Gustav-Lübcke Museum, Hamm et al., 1997, pp. 32–50, especially pp. 41–44 and Jenny ANGER, *Modernism and the Gendering of Paul Klee*, Providence 1997, pp. 25–32.

3 On the occasion of the Klee symposium in 1998, preliminary overviews were undertaken by Christian RÜMELIN, "Klee und der Kunsthandel", in: *Paul Klee – Kunst und Karriere. Beiträge des internationalen Symposiums in Bern*, Oskar Bätschmann and Josef Helfenstein (eds.), with the collaboration of Isabella Jungo and Christian Rümelin (= *Schriften und Forschungen zu Paul Klee*, vol. 1), Berne 2000, pp. 27–37; Christine HOPFENGART, "Klee an den deutschen "Museen der Gegenwart", 1916–1933", in: ibid., pp. 68–92 and Michael BAUMGARTNER, "Klee und seine frühen Sammler", in: ibid., pp. 93–106. However, these essays do not mention the later collectors who became interested in Klee only after 1925 or who lived outside of Germany. Numerous contemporary collections of interest are therefore not included in these works.

4 Most recently RÜMELIN, "Kunsthandel" (see n. 3 above).

5 In addition to his diaries (Paul KLEE, *Tagebücher 1898–1918*, critically revised edition, published by the Paul Klee Foundation, Berne, Wolfgang Kersten (ed.), Stuttgart/Teufen 1988) and letters to the family (Paul KLEE, *Briefe an die Familie 1893–1940*, 2 vols., Felix Klee (ed.), Cologne 1979), Klee's body of writing includes critical reviews and several pedagogical works. The latter are for the most part collected in: Paul KLEE, *Schriften*, Christian Geelhaar (ed.), Cologne 1976. A facsimile edition of the "Bildnerische Formenlehre" ["Theory of Pictorial Form"] was published by Glaesemer (Paul KLEE, *Beiträge zur bildnerischen Formlehre*, Jürgen Glaesemer (ed.), Basle/Stuttgart 1979). Klee's lecture at the opening of an exhibition at the Museum in Jena was published unabridged (Thomas KAIN, Mona MEISTER, Franz-Joachim VERSPOHL (eds.), "Paul Klee in Jena 1924. Der Vortrag", in: *Minerva. Jenaer Schriften zur Kunstgeschichte*, vol. 10, Jena 1999). The extensive pedagogical works were newly introduced to the public for the first time since Jürg Spiller's books on the same subject in: *Paul Klee. Die Kunst des Sichtbarmachens. Materialien zu Klees Unterricht am Bauhaus*. Exh. cat., Seedamm Kulturzentrum, Pfäffikon 2000.

6 An in-depth discussion of this relationship is not included here, as it has been the subject of numerous other works. Most recently: exh. cat. Pfäffikon 2000 (see n. 5 above).

7 With reference to the œuvre catalogue, see: Josef HELFENSTEIN, "Das Spätwerk als »Vermächtnis«. Klees Schaffen im Todesjahr", in: *Paul Klee. Das Schaffen im Todesjahr*. Exh. cat., Kunstmuseum Bern 1990, pp. 59–75, especially pp. 69–71; *Paul Klee. Im Zeichen der Teilung*. Exh. cat., Wolfgang KERSTEN and Osamu OKUDA, Kunstsammlung Nordrhein-Westfalen, Düsseldorf et al., 1995, p. 35f. and 46f.; Osamu OKUDA, "Paul Klee: Buchhaltung, Werkbezeichnung und Werkprozess", in: *Radical Art History: Internationale Anthologie, Subject: O. K. Werckmeister*, Wolfgang Kersten (ed.), Zurich 1997, pp. 374–397 and Eva WIEDERKEHR SLADECZEK, "Der handschriftliche Œuvre-Katalog von Paul Klee", in: contributions to Bern 2000 (see n. 3 above), pp. 146–158.

8 As the research for the *Catalogue raisonné Paul Klee* revealed, the technical notes in the hand-written œuvre catalogue are frequently and at times considerably inconsistent with the material findings. These discrepancies are still largely undocumented. In-depth knowledge in the fields of art restoration and art materials and techniques would be required for an exhaustive analysis of this problem, hence clarification cannot be given within the scope of the present work. — On Klee's painting technique, see most recently: Nathalie BÄSCHLIN, Béatrice ILG, Patrizia ZEPPETELLA, "Paul Klees Malutensilien. Zu Werkspuren und Gemäldeoberflächen", in: *Paul Klee. Die Sammlung Bürgi*. Exh. cat., Kunstmuseum Bern et al., 2000, pp. 183–197 and Nathalie BÄSCHLIN, Béatrice ILG, Patrizia ZEPPETELLA, "Beiträge zur Maltechnik von Paul Klee", in: contributions to Bern 2000 (see n. 3 above), pp. 173–203.

9 With regard to the exhibitions listed only in the œuvre catalogue, see the overview provided in ANGER, *Modernism* (see n. 2 above), pp. 327–392.

10 This point was already mentioned by OKUDA, "Buchhaltung" (see n. 7 above), p. 276. The relevant exhibitions are: exhibition at the Kunstmuseum Bern (August–September 1910), at the Kunsthaus Zürich (October 1910), in Zum hohen Haus, Winterthur (November 1910) and at the Kunsthalle Basel (January 1911).

11 Klee addressed this issue explicitly in his diaries: KLEE, *Tagebücher* (see n. 5 above), no. 895. Cf. WIEDERKEHR SLADECZEK, "Der handschriftliche Œuvre-Katalog" (see n. 7 above), p. 146. — The problem of subsequent revisions to the diaries — exhaustively discussed by Christian GEELHAAR, "Journal intime oder Autobiographie? Über Paul Klees Tagebücher", in: *Paul Klee. Das Frühwerk 1883–1922*, exh. cat., Städtische Galerie im Lenbachhaus, Munich 1980, pp. 246–260 — does not form a part of this study.

12 See KERSTEN/OKUDA, *Klee. Im Zeichen der Teilung* (see n. 7 above), p. 35f. and 46f.; Wolfgang KERSTEN, "Hoch taxiert: Paul Klees Ölbild 'Bühnenlandschaft' 1922. 178. Versuch einer historischen Einordnung", in: *Meisterwerke I. 9 Gemälde des deutschen Expressionismus*, exh. cat. Galerie Thomas, Munich 1995, pp. 108–121, especially p. 114f., simply notes that the date is not necessarily accurate, without further elaboration; see also OKUDA, "Buchhaltung" (see n. 7 above), pp. 375f., 379–383 and pp. 390–393; Osamu OKUDA, "Versinkende Villen — aufsteigende Baracken. Paul Klee und die Bauhaus-Debatten über den Konstruktivismus", in: *Aufstieg und Fall der Moderne*. Exh. cat., Kunstsammlungen zu Weimar 1999, pp. 336–343, here p. 336f. and finally WIEDERKEHR SLADECZEK, "Der handschriftliche Œuvre-Katalog" (see n. 7 above), p. 156f.; Gregor WEDEKIND, "Von Ameisen, Spinnen und Bienen. Paul Klee. Catalogue raisonné", in: *Kunstchronik*, no. 1, January 2001, pp. 32–37.

13 Refer to the insightful observations with numerous examples in OKUDA, "Buchhaltung" (see n. 7 above), pp. 377–379.

14 For these three sheets, see *Catalogue raisonné Paul Klee*, vol. 1, Wabern 1998, cat. no. 122, 136 and 137. Numerous other works are recorded in Klee's letters to his parents and especially to his fiancée Lily Stumpf (KLEE, *Briefe*, see n. 5 above) as well as in his diary entries (KLEE, *Tagebücher*, see n. 5 above). We must assume that Klee destroyed these works, since none have been traced.

15 The number of registered works is but one indicator of increased productivity. One the one hand, a number of works survive that were not registered, and on the other hand, Klee destroyed many drawings, especially once he had developed his technique of painting behind glass. There are several instances where he reports to his fiancée Lily Stump

that he just rinsed off a glass pane on which he had worked all day because he was not satisfied with the result. On the subject of behind glass painting, see: Marcel BAUMGARTNER, *Paul Klee und die Photographie*, Berne 1978, Jürgen GLAESEMER, *Paul Klee. Die farbigen Werke im Kunstmuseum Bern. Gemälde, farbige Blätter, Hinterglasbilder und Plastiken*, Berne 1976, especially pp. 20–22.

16 See OKUDA, "Buchhaltung" (see n. 7 above), p. 377f. and WIEDERKEHR SLADECZEK, "Der handschriftliche Œuvre-Katalog" (see n. 7 above), pp. 151–155, for information on the duplicates.

17 Entries made in indelible pencil are limited to 1919 and 1920. In particular for the following catalogue numbers: in 1919: 116–117, 123–136 and in 1920: 126–128.

18 This method of grouping is also evident in an early period between 1911 — when Klee began to catalogue his work — and 1917/1918. However, looking at the time period can only partially explain this method. It is likely that this was a general approach, which was subsequently implemented only in the so-called duplicate. The following numbers in the œuvre catalgoue (Cat. B1) are identifiable as groupings between 1918–1921 based on the handwriting style or on material. Individual sheets were not taken into consideration, omissions indicate a change in writing style. *1918*: 1–17, 18–33, 34–42, 43–90, 91–96, 97–119, 120–175, 176–194, 195–196, 199–211; *1919*: 1–11, 12–17, 18–32, 33–34, 35–51, 52–53, 54–59, 60–69, 70–79, 80–86, 87–90, 91–107, 108–111, 112–117, 118–122, 123–136, 137–151, 152, 153–155, 156–162, 166–175, 177–183, 184–190, 191–197, 198–202, 203–208, 210–211, 213–217, 218–228, 229–233, 234–265; *1920*: 1–6, 7–14, 15–16, 18–24, 27–44, 45–46, 47–74, 75–79, 80–90, 92–109, 110–119, 120–125, 126–128, 129–149, 150–163, 164–176, 177–200, 202–207, 210–212, 213–214, 218–221, 223–234. After 1920, the handwriting becomes more homogeneous and balanced, there are very few changes in writing utensils and the entries contain fewer revisions or additions in general. Hence, dividing the entries into groups after 1922 is only of limited value.

19 WIEDERKEHR SLADECZEK, "Der handschriftliche Œuvre-Katalog" (see n. 7 above), p. 156 note 64 provides proof citing examples of oil transfers and drawings from 1919. Numerous other cases, where the cat. no. for the drawing is higher than the number for the corresponding painting or oil transfer, document this practice well into the 1920s. This topic deserves further study.

20 A comparison of corrections from 1918–1922 illustrates this point: in 1918, corrections, additions or deletions were made in the following works out of a total of 211 catalogued works: 44, 88, 175, 179, 186, 187, 191, i.e. in approx. 3.3 per cent. In 1919, out of 265 registered works, the following entries were changed: 53, 155, 198, 223. Finally, the following out of a total of 234 were changed in 1920: 14, 21, 28, 30, 35, 36, 61, 72, 82, 83, 98, 122, 124, 134, 138, 139, 150, 151, 166, 185, 193, 199, 220. And in 1921, the following works out of 225 entries shows corrections: 1, 6, 7, 11, 23, 24, 31, 50, 51, 52, 59, 62, 175, 186, 191, 199, 217, 225. In 1922, out of 260 registered works the following were revised: 7, 16, 19, 30, 58, 116, 121, 137, 144, 172 and in 1923, out of 264 entries: 32, 59, 90, 100, 122, 230.

21 Klee first recorded these works in pencil; later he copied over each entry in pen and ink. In 1918: 107; in 1919: 184–190, 195; in 1920: 31, 120, 195; in 1921: 75, 88, 89, 142; in 1922: 67, 68, 92, 100, 101 and finally in 1923: 90, 91. The titles of the following entries remained in pencil only. This was not the case in 1918, but in 1919 it applies to 57, 152, 163, 165, 176, 209, 212; in 1920 to 45, 46, 215; in 1921 to 181; in 1922 to 110 and finally in 1923 to 72–75, 125, 138.

22 A systematic compilation is still outstanding, although the *Catalogue raisonné Paul Klee*, vols. 1 and 2, mention the differences in titles between duplicate and œuvre catalogue. Some examples are listed in OKUDA, "Buchhaltung" (see n. 7 above), p. 379, note 18.

23 See OKUDA, "Buchhaltung" (see n. 7 above), pp. 377–379, especially note 13 on p. 378. Okuda arrived at this number by comparing the original against the duplicate and the evidence of subsequent entries revealed by this comparison.

24 The early drawings based on historic works as well as drawings for illustration projects, in particular Blösch's "Musterbürger" (*Satirical Muse*, 1908; *He never tasted stolen fruit, had never been in neighbour's garden*, 1908; *Dort wird die Bildung in 2 Stunden Die ihm sonst abgeht, ins Gesicht geschrieben*, [*There the education is inscribed on his face in 2 hours, which he otherwise lacks*] 1908; *Everything draws him to the care institute*, 1908; CHORAL SOCIETY, 1908; *It's easy to break one's neck when climbing up the ladder Comfortably seated on the first rung (p. 42)*, 1908; *This hero's life too will end one day*, 1908) must be seen as exceptions. See also Reto SORG, Osamu OKUDA, "'Der Schönheit diene ich durch Zeichnung ihrer Feinde'. Das Musterbürger-Projekt von Hans Bloesch und Paul Klee", in: *Berner Almanach Literatur*, Adrian Mettauer, Wolfgang Pross and Reto Sorg (eds.) with the collaboration of Sabine Künzi, Berne 1998, pp. 375-405). Further exceptions are the 51 behind glass paintings and drawings for Voltaire's *Candide* (see, among others: Christian GEELHAAR, "Klee, illustrateur de Candide", in: L'Oeil, No. 237, April 1975, pp. 22–27 and Anne Sophie PETIT-EMPTAZ, "Candide lu par Klee", in: *Travaux sur le XVIIIe siècle. Hommage au professeur Jean Roussel*, Université d'Angers, 1995, pp. 21–31), the illustrations designed for Curt Corrinth, *Potsdamer Platz* (*Potsdamer Platz, I Prospect and Title Page*, 1919, 13; *IV. Strong One, o-oh oh You!*, 1919, 14; *VI. Berlin Our Stronghold, Suddenly Grew Tenfold in Population*, 1919, 15; *VII Impending Future Bred Deadly Danger*, 1919, 16; *X. Higher, More Distant, Receding*, 1919, 17) as well as the small number of illustrations intended for a bible edition (*Sketch for Psalm 137*, 1913, 156; *The Lord is my Shepherd ‹Psalm›*, 1915, 23; *Two Vignettes for Psalms*, 1915, 81; *Sketch for Psalms*, 1915, 142 — see Klaus LANKHEIT, "Bibel-Illustrationen des Blauen Reiters", in: *Anzeiger des Germanischen Nationalmuseums*, Nuremberg 1963, pp. 199–207).

25 I refer here to the following lithographs and corresponding preliminary drawings: *After Pencil Drawing from 1918. ï55*, 1919, 9 (based on: *Three Heads*, 1918, 155); *Acrobats in the Style of 1916 66*, 1919, 10 (based on: *Acrobats and Juggler*, 1916, 66); *After drawing 19/75*, 1919, 113 (based on: *Contemplation*, 1919, 75); *Lithograph Based on 1914 82*, 1919, 212 (based on: *The Terrible Dream*, 1914, 82); *Flowerpots (after 1915 114)*, 1920, 46 (based on: *Flowerpots*, 1915, 114); *After 1915/29*, 1920, 91 (based on: *A Genius Serves a Small Breakfast*, 1915, 29); *Lithograph after 1915/42*, 1923, 72 (based on: *Sun in Gate*, 1915, 42); *Lithograph after 15/114*, 1923, 74 (based on: *Flowerpots*, 1915, 114); *Lithograph after 15/125*, 1923, 75 (based on: *Collapsing*, 1915, 125).

26 Examples are: *The Hero with the Wing*, 1905, 38 and *Hero w. Wing*, 1905, 7; *Two Nudes in Lake*, 1907, 24 and *Female Nude Somersault; Male Nude on One Leg; Male Semi-Nude, Bathing*, 1907, 2.

27 An exhaustive discussion of the origins and history of this term would go beyond the scope of this contribution. For more detail, refer to the commentary in my essay on the "Stichtheorie und Graphikverständnis im 18. Jahrhundert" ["Theory of Etching and Interpretation of Graphic Art in the 18th century"], which will appear in the next edition of *Artibus et Historia*, vol. 44, 2001. To summarize, it was not until Adam von Bartsch's verdict in his foreword to *Peintre-Graveur* that graphic works and prints created for illustrations were regarded as somehow minor, while the "painter-etchers" referred in Bartsch's title were seen as more important, an attitude that survived well into the twentieth century.

28 On Klee's prints see the detailed work by James Thrall SOBY, *The Prints of Paul Klee*, New York 1945; further: Eberhard W. KORNFELD, *Verzeichnis des graphischen Werkes von Paul Klee*, Berne 1963; Marcel FRANCISCONO, "Paul Klees kubistische Graphik", in: *Paul Klee: Das graphische und plastische Werk. Mit Vorzeichnungen, Aquarellen und Gemälden*. Exh. cat., Wilhelm-Lehmbruck-Museum, Duisburg, Oct. 20, 1974 to Jan. 5, 1975, pp. 46–57; Christian GEELHAAR, "Paul Klees druckgraphische Kleinwelt,

1912–1932", in: ibid., pp. 58–67; Jürgen GLASEMER, "Die Druckgraphik von Paul Klee", in: ibid., pp. 18–29; Jürgen GLAESEMER, "'Die Kritik des Normalweibes'. Zu Form und Inhalt im Frühwerk von Paul Klee", in: ibid., pp. 38–46 (1. imprint in: *Berner Kunstmitteilungen*, No. 131/132, January/February 1972, pp. 2–11); Charles Werner HAXTHAUSEN, "Klee, the Reluctant Printmaker", in: *In celebration of Paul Klee 1879–1940. Fifty Prints.* Exh. cat., Stanford University Museum of Art, Sept. 25, 1979 to Nov. 4,1979, pp. 9–17; Jim M. JORDAN, "Klee's Prints & Oil Transfer Works: Some Further Reflections", in: *The Graphic Legacy of Paul Klee.* Exh. cat., Bard College, Annandale-on-Hudson, Oct. 23, 1983 to Dec.28, 1983, pp. 87–105; Gregor WEDEKIND, *Paul Klee. Inventionen*, Berlin 1996.

29 In a letter to Rudolf Probst on March 12, 1926, Joachim Probst Estate, Ilvesheim, Klee stated emphatically: "I don't sell drawings, but I think that the availability for sale of the watercolours will suffice to increase my credit with you after this exhibition." — The exhibition referred to was one which Probst planned together with Klee for the same year. See RÜMELIN, "Kunsthandel" (see n. 3 above), p. 29.

30 See Klee's letter to Daniel-Henry Kahnweiler, January 10, 1934, Louise Leiris Gallery, Paris: "Dear Kahnweiler, I knew that there would be more German aggravation to come. Still, this caper took me by surprise. The drawings were not at Flechtheim's to be sold, but to be made available to the publisher who had expressed interest in a volume on Klee as draughtsman with a text by Grohman[n], or at least he seemed to or might have wanted to. I didn't want to remove them from Germany so that, if the plan should become reality, they would have been at hand for reproduction. Now, a demon has brought them to you … keep them if you wish, […] but *not for sale* – since 1920 I haven't sold a single drawing, which are all [otherwise] in my possession and every now and then I will present one as a gift as a special recognition. And even if this weren't my attitude, then especially these drawings could not be sold, because Grohman[n] selected them with great diligence and care for release in the book as soon as an opportunity would present itself. […]"

31 This fact has already been established in several works, most recently in RÜMELIN, "Kunsthandel" (see n. 3 above), p. 34.

32 In a letter to his wife Lily on January 30, 1933, in: *Klee, Briefe* (see n. 5 above), p. 1225f., especially p. 1226.

33 Will GROHMANN, "Handzeichnungen von Paul Klee", in: *Monatshefte für Bücherfreunde und Graphiksammler*, 1st volume, No. 5, 1925, pp. 216–226. The following works were reproduced: *Sad Policemen*, 1913, 54 copy; *Ship Arsenal*, 1915, 155; *Hofmanesque Scherzo*, 1918, 182; *Shameless Animal*, 1920, 115; *Somnambulant Dancer*, 1921, 58; *Ram Taking a Walk*, 1921, 197; *Procession on Tracks*, 1923, 77.

34 Will GROHMANN, *Paul Klee. Handzeichnungen 1921–1930*, Potsdam/ Berlin 1934, pp. 17–28, a list of graphic art created between 1921 and 1930 can be found on p. 28.

35 See also the commentary in Jürgen GLAESEMER, *Paul Klee. Handzeichnungen II. 1921–1936*, Berne 1984, pp. 92–95.

36 On this aspect of Klee's body of work, see HELFENSTEIN, "Spätwerk als 'Vermächtnis'" (see n. 7 above), pp. 59–62. One should note, however, that this attitude does not only apply to the late work which Helfenstein studied, but was already in evidence from the early 1920s onward.

37 This first category of this kind begins with the entry of *Windows and Roofs (yellow-red)*, 1919, 96.

38 GROHMANN, *Handzeichnungen* (see n. 34 above), p. 3.

39 Ibid., p. 3.

40 Ibid., p. 4f.

41 Grohmann used this term only in his German translation (GROHMANN, *Handzeichnungen* (see n. 34 above), p. 6) without elaborating on references or engaging in a critical exploration of Klee's creative process. Klee is openly described as a "great personality […] with a unique unconscious intelligence", capable of creating the New by controlling his consciousness and thus avoiding mere mimetic imitation.

42 In the exhibition *Paul Klee. 60. Galerie Neue Kunst Hans Goltz*, Munich, May 17 to June 25, 1920, 103 exponents of 371 were drawings, that is some 27 %, while the Berlin exhibition of 1923 (*Paul Klee*. Nationalgalerie, Kronprinzenpalais, Berlin, February 1923) featured 173 drawings in a total of 270 exponents, i.e. nearly 64 %.

43 The misconception of how many drawings were actually created and how many were exhibited in Berne was great indeed. The exhibition in Berne (1935) included only 26 drawings among 273 exponents, that is less than 10 % of the total exhibition. In particular, the exhibited drawings were: *Animated Dance*, 1930, 92 (T 2); *Conversation Lying Down*, 1933, 95 (P 15); *Burning and Glowing*, 1933, 105 (Qu 5); *Tree Ballet*, 1933, 111 (Qu 11); *Doctor and Girl*, 1933, 116 (Qu 16); *Shoot-Out*, 1933, 131 (R 11); *Masked Group*, 1933, 133 (R 13); *Supposed Quantities*, 1933, 151 (S 11); *The Work of Art*, 1933, 154 (S 14); *Spiritual and Worldly*, 1933, 159 (S 19); *Advertising*, 1933, 166 (T 6); *Father and Son*, 1933, 168 (T 8); *On Pieces of String*, 1933, 175 (T 15); *Bound Slave*, 1933, 182 (U 2); *House Slave*, 1933, 183 (U 3); *Visit of the Gods*, 1933, 212 (V 12); *Lion R and Lion A*, 1933, 294 (Z 14); *Two Large Women Have to Get Past*, 1933, 325 (B 5); *Animals on Pasture*, 1933, 359 (C 19); *Now [You're] in for a Hiding*, 1933, 364 (D 4); *Penitent on Show*, 1933, 367 (D 7); *Catastrophes*, 1933, 368 (D 8); *Warrior with Scars*, 1933, 412 (F 12); *Sibyl*, 1934, 14 (14); *Last Leafs*, 1934, 34 (K 14); *Flowering*, 1934, 157 (R 17). — A major selection of drawings was only shown again in the *Gedächtnisausstellung Paul Klee 1879–1940*, the first posthumous exhibition at the Graphische Sammlung, ETH Zurich, October 19 to December 21, 1940, based on the selection for the exhibition in Berlin in 1923.

44 During the evaluation of the œuvre catalogue in preparation for the *Catalogue raisonné Paul Klee* (up to 1933), 285 cross-references of this kind have been traced.

45 Since some of the aforementioned 285 cases include instances where individual works are referred to twice or more, the total number of references is 324. 55 refer to later works, that is they provide a chronological view of the creative process, 192 are retrospective, that is they name the source of inspiration, 57 refer to works that have the same work number or one that is in close proximity in the œuvre catalogue, and only 20 references were too vague to establish a concrete link.

46 21 cases are not particularly characteristic, since Klee was referring to drawings or works he had created much earlier. In particular, these cases are: *Landscape in Blue*, 1917, 72; *(New Version [of] Head Creating) in Miniature Style*, 1917, 77; *Drawing of the Unlucky Star of Ships*, 1917, 152; *With the Mountain Chain*, 1919, 31; *With Two Dromedaries and 1 Donkey*, 1919, 32; *Scene from Kairouan*, 1920, 35; *Scene from Kairouan*, 1920, 36; *Houses by the Sea*, 1920, 134; *Southern Villa Garden*, 1920, 135; *At the Gates of Kairouan*, 1921, 4; *Kairouan*, 1921, 118; *Südlicher Frühlings Landschaft [SouthSouthern Spring Landscape]*, 1923, 175; *After Tunisian Note from 1914*, 1923, 181; *After an Impression from 1910 (View of Neuenb. Lake)*, 1924, 227; *Ships (Two Plus One)*, 1931, 8 (8); *Fisherman Scene*, 1931, 9 (9); *Scene A from Kairouan (after Drawing [from] 1914)*, 1931, 27 (K 7); *Scene B from Kairouan (after Drawing from 1914)*, 1931, 28 (K 8); *Readiness*, 1931, 232 (V 12); *Embracing*, 1932, 67 (M 7); *The Gate*, 1932, 230 (V 10).

47 Carl EINSTEIN, *Die Kunst des 20. Jahrhunderts*, Berlin 1926, pp. 140–143.

48 For details on the oil transfer technique, see: GLAESEMER, "Druckgraphik" (see n. 28 above), p. 27 as well as notes 31 and 32; GLAESEMER, *Handzeichnungen II* (see n. 35 above), pp. 13–23.

49 Most recently in his contribution: Charles W. HAXTHAUSEN, "Zwischen Darstellung und Parodie. Klees 'auratische' Bilder", in: *Beiträge Bern 2000* (see n. 3 above), pp. 9–26.

50 This is also demonstrated in the use of special priming methods, which Klee recorded in his œuvre catalogue. The oil transfer was reprinted onto a different ground in the following 49 cases: *Ducks*, 1919, 195; *In the*

Style of Bach, 1919, 196; *Birds Descending and Arrows in the Air*, 1919, 201; *The Stag*, 1919, 202; *Message from the Spirit of the Air*, 1920, 7; *Salomé*, 1920, 11; *Greeks and Barbarians*, 1920, 12; *Black Magic*, 1920, 13; *Bob*, 1920, 33; *Shameless Animal*, 1920, 115; *The Great Emperor, Equipped for Battle*, 1921, 131; *Barbarian Venus*, 1921, 132; *Dance of the Mourning Child II*, 1922, 20; *Arabian City*, 1922, 29; *Mural from the Temple of Yearning thither*, 1922, 30; *Monument in a Cemetery*, 1922, 31; *Festive Prologue*, 1922, 34; *Castle in the Air*, 1922, 42; *Wild Man*, 1922, 43; *MA*, 1922, 52; *Dance, Monster, to my Gentle Song!*, 1922, 54; *Fashion Picture*, 1922, 91; *Fool in Christ*, 1922, 92; *Contact between Two Musicians*, 1922, 93; *The Theatre of Exotics*, 1922, 120; *Apparatus in the Surgery of Dr. Ph.*, 1922, 121; *The Chariot of Virtue (in Memory of October 5, 1922.)*, 1922, 123; *Lady with Animals II*, 1922, 166; *Ghost of a Genius*, 1923, 38; *Singer L. as Fiordiligi*, 1923, 39; *Fire Wind*, 1923, 43; *Travel Coach*, 1923, 44; *Final Scene of a Tragicomedy*, 1923, 144; *Excursion on Horseback on the Oger*, 1923, 157; *In Love*, 1923, 169; *Idol for Domestic Cats*, 1924, 14; *Lightning*, 1924, 135; *Lieschen and the Guilty Ones*, 1924, 259; *Odyssean*, 1924, 260; *Clock Plants*, 1924, 261; *Flotilla*, 1925, 1; *Fishermen's Boats*, 1925, 2; *Fish Image*, 1925, 5; *Perspective-Scherzo*, 1925, 6; *View of a Fortress*, 1925, 7; *VAST (Rosenhafen)*, 1925, 8; *Storm over the City*, 1925, 210 (V o); *Portrait, Sketch Mrs. Hck. 3*, 1927, 174 (H 4); *Animated Connections*, 1930, 25 (L 5).

51 Only two examples are given here. Many more examples can be found in: GLAESEMER, *Handzeichnungen II* (see n. 35 above) on pp. 13–23.

52 The literature on these three works is recorded in the *Catalogue raisonné Paul Klee*, vol. 4, under No. 2841, 3015 and 3136.

53 These are: *Sad Policemen*, 1913, 54 copy; *Farewell!*, 1926, 105 (A 5) copy; *Near Rosen*, 1926, 107 (A 7) copy; *Two Girls*, 1926, 108 (A 8) copy; *Tall Step*, 1926, 110 (B o) copy; *New Centre*, 1926, 111 (B 1) copy; *Circus Rider*, 1926, 148 (E 8) copy; *Child Escaping*, 1926, 166 (G 6) copy; *Ballet*, 1926, 178 (H 8) copy; *Mr. Lune*, 1926, 179 (H 9) copy; *Fleeing*, 1926, 180 (J o) copy; *Sketch of Children's Playground*, 1926, 189 (J 9) copy; *Lively Beach*, 1926, 230 (W 10) copy; *Well-wisher*, 1938, 462 (B 2) copy.

54 For further detail on the dedications, turn to the last paragraph in this contribution.

55 OKUDA, "Buchhaltung" (see n. 7 above) pointed out that Klee only began to use a line in the work number after 1920; consequently, works that are recorded with such a line can only have been mounted after that time. Similarly, in the case of the dot above the number "1", which Klee began to use only after 1919.

56 It is probable that Klee also began to apply adhesive in a different manner after 1919. Having covered the entire support surface in adhesive and thus attaching the paper fully to the carton in earlier years, he began around 1919 to attach it only by applying a few blots of glue. Throughout the 1920s, both styles were used, but from 1930 or thereabouts onward, Klee used exclusively the latter method.

57 Only 19 of these paintings, usually oil on paper and rarely on textile [e.g. canvas], were created prior to 1933. These are: *German Landscape (River Party)*, 1921, 79; *Farmhouse*, 1924, 120; *Memorial E*, 1924, 122; *Orchard*, 1925, 79 (Qu 9); *Village*, 1925, 122 (C 2); *Fenced in*, 1928, 74 (Qu 4) gespalten 1; *Landing*, 1928, 102 (A 2); *Sculpture after a Vase*, 1930, 179 (B 9); *Principal Thought*, 1930, 180 (B 10); *Ascending City District*, 1930, 233 (G 3); *House by the Water*, 1930, 234 (G 4); *Bust*, 1930, 265 (AE 5); *Animal Frenzy*, 1930, 279 (OE 9); *At the White Gate*, 1931, 42 (L 2); *Who Kills Whom*, 1931, 47 (L 7); *Offerings*, 1931, 48 (L 8); *Trees in October*, 1931, 87 (N 7); *Like an Overgrown Garden*, 1932, 23 (K 3); *Plants in Courtyard*, 1932, 25 (K 5); *Burning*, 1932, 142 (R 2); *Newly Designed Garden*, 1937, 27 (K 7); *One Girl, Two Glasses of Schnapps*, 1938, 224 (P 4); *Magdalene before the Conversion*, 1938, 455 (A 15); *Circumlocutions*, 1938, 416 (Y 16); *Girl with Corsage*, 1938, 453 (A 13); *On Wheels*, 1939, 1091 (GH 11); *Foiled Flight*, 1939, 1090 (GH 10); *Also a Portrait of the Body*, 1939, 1119 (Hi 19) — Conversely, similar borders are marked on the cardboard backings for 1,275 watercolours.

58 One such example is: *View onto the Harbour of Hamammet*, 1914, 35. See *Catalogue raisonné Paul Klee*, vol. 2, Wabern 2000, No. 1144.

59 In a letter to Daniel-Henry Kahnweiler on October 15, 1936, at the Galerie Louise Leiris, Paris, Klee writes: "[…] meanwhile Dr. Geyger has brought you the pieces, [which] I have taken off their mounts at his request, otherwise a parcel of this kind would have attracted attention in his experience. Should this Collection [sic] or parts thereof be returned to me in Switzerland, one would have to follow a similar approach because they have crossed the border without being cleared by customs. This circumstance imposed some limits on my selection, because delicate papers would not have stood up [to transport in this manner]."

60 The following works have thus far been identified as part of this shipment: *Trees among Rocks*, 1933, 266 (Y 6); *Lonely Blossom*, 1934, 5 (5); *Artificial Symbiosis*, 1934, 7 (7); *Two in Confinement*, 1934, 13 (13); *Figure, Coming into Being*, 1935, 60 (L 20); *Collected Landscape Details*, 1935, 78 (M 18); *Scene with Acrobats*, 1935, 101 (P 1); *House on Hillside*, 1935, 110 (P 10). — Unfortunately a list, which Klee sent by separate mail, has not survived.

61 These borders can be verified in 420 works, of which only two (*Portrait Sketch of Felix*, 1908,73 and *Nude*, 1910, 124) are from the early period. 39 works with this characteristic were created between 1914 and the end of 1918, all others after 1919.

62 This does not indicate the strips created by securing a sheet of watercolour paper when painting outdoors. Those are noticeable in several watercolours from Tunisia and on watercolours created during a vacation at the North Sea in 1923. The quality is very different from that of the strips which Klee used deliberately on the cardboard backings. See: GLAESEMER, *Farbige Werke* (see n. 15 above), p. 31 and KERSTEN/OKUDA, *Zeichen der Teilung* (see n. 7 above), p. 48.

63 In total, Klee mounted 75 paintings on canvas onto cardboard, among them three works that are not recorded in the œuvre catalogue. It is interesting to note that the majority of the catalogued works (64) to which this process was applied, were created before 1934.

64 In this case, there were at least 63 works, with an even more marked distribution as only three such pieces were created after 1934. These especially, were treated in part as paintings and framed, but also mounted onto cardboard like works on paper. There is no evident pattern that would explain why Klee decided to mount some of these works on cardboard and not others; at any rate, the decision seems not to have been linked to the size of the image surface.

65 In four cases, Klee first glued the gauze onto paper and then onto cardboard, specifically in: *Ab Ovo*, 1917, 130; *With Descending Dove*, 1918, 118; *Sphinx-like*, 1919, 2; *Garden Gate*, 1932, 75 (M 15). — Klee's use of the so-called paper-linen forms another special category of 21 works. In these cases, he would first prime a linen fabric and then glue into onto paper. As was the case in the paintings on gauze, some of these pieces are framed like paintings while others are mounted onto cardboard and subsequently treated as works on paper. Klee applied this technique to the following works: *Tower Villas*, 1918, 119; *Two Summer Castles*, 1918, 120; *The Dream*, 1918, 121; *Fortress (Festive Mood)*, 1918, 126; *Fortress with Setting Sun*, 1918, 127; *Interior Architecture*, 1918, 129; *The City of the Blue Star*, 1918, 140; *The Fortress of the Black Sphere*, 1918, 141; *Harbour Image*, 1918, 142; *Village Pyramid*, 1918, 152; *Gazebos*, 1919, 8; *Swiss Landscape*, 1919, 46; *Abstract with Crescent Moon*, 1919, 47; *Abstract with Full Moon*, 1919, 48; *With the Rotating Black Sun and the Arrow*, 1919, 63; *Built Landscape in Green, Called "Forest Building"*, 1919, 198; *Full Moon in Walls*, 1919, 210; *The House of the Blue Star*, 1920, 136; *Similar [to] 1920/136*, 1920, 137; *The Great Emperor, Equipped for Battle*, 1921, 131; *Barbarian Venus*, 1921, 132.

66 This applies to a total of 57 cases, included coloured sheets of paper.

67 This applies to a total of 64 works, of which ten feature silver-coloured paper or strips of silver foil and four gold foil or gold-tinted paper.

68 One work (*City with the Three Cupolas*, 1914,2) was mounted on green cardboard, two on brown paper (*Oriental Experience*, 1914, 111 and *Ab Ovo*, 1917, 130); three are mounted on black cardboard or painted directly on black paper: *Sheep*, 1910, 108; *The Castle*, 1913, 6; *Lovers*, 1920, 147; *Still Life*, 1929, 345 (3 H 45), *Entering*, 1937, 248 (W 8).

69 The pieces with gold paper are: *The Hopeless*, 1914, 58; *Window and Palm Trees*, 1914, 59; *Miniature Framed in Gold*, 1916, 7; *Cosmically Imbued Landscape*, 1917, 76; *V*, 1918, 15; *Hakimora before His Last Call to Arms*, 1918, 22; *Ghosts as Acrobats*, 1918, 37; *Couple*, 1918, 64; *Hypocrites*, 1919, 213; *Autumnal Sound*, 1920, 86; *Kairouan, at the Gates*, 1921, 4; *The Mountain Bedecked with Flags*, 1921, 15; *Billy-goat*, 1921, 16; *Man under Pear Tree*, 1921, 19; *He kissed Me With His Lips (from the Song of Songs)*, 1921, 142; *Girl from Saxony*, 1922, 132; *Dwarf Herald on Horseback*, 1923, 186 — With silver paper: *Park*, 1914, 115; *Cats*, 1915, 27; *Birds Engaged in Scientific Sexual Experiments*, 1915, 28; *(Funny?)*, 1915, 31; *"Right Angles, 4-sided Silver Margin"*, 1915, 32; *Untitled*, 1915, 34; *Nightingale Singing*, 1917, 81; *Once upon a Time Risen out of the Grey of the Night…*, 1918, 17; *Bird Empire*, 1918, 23; *Composition in Three Parts*, 1918, 40; *Poor Sinners*, 1918, 59; *Memorial Stone for N*, 1918, 80; *Flower Myth*, 1918, 82; *Fortress Garden*, 1919, 188; *Villas on Lake*, 1920, 84; *Harlequin on Bridge*, 1920, 164; *Destroyed Site*, 1920, 215; *Inscription*, 1921, 3; *Dry-Cool Garden*, 1921, 83; *Dream City*, 1921, 106; *View from Window (North Sea Island)*, 1923, 259; *Fairy-tale Picture*, 1924, 185; *Sound of Sicily*, 1924, 291; *Portrait of an Asian Man*, 1924, 297; *View of Mountain Shrine*, 1926, 18 (K 8); *Games of a Different Kind*, 1932, 123 (Qu 3); *Barbed Boat*, 1936, 17 (17). — In both cases [gold and silver paper] no distinction is made whether a strip of [metallic] paper was used, or whether the work was mounted onto a full sheet of paper or surrounded by a passe-partout composed of individual strips of paper. — There seems to be one exception: *Urban Scheme with Green Church Tower*, 1919, 191; here strips of copper paper were attached at the top and bottom.

70 One important example are his thoughts on how to present his inventions at the exhibition in Munich in 1906 (*Internationale Kunstausstellung des Vereins bildender Künstler Münchens "Secession"*. Kgl. Kunstausstellungsgebäude am Königsplatz, Munich, June 1906). — See Klee's letters to Lily Stumpf on April 28, 1906, in: KLEE, *Briefe* (see n. 5 above), p. 619f.; on April 30, 1906, in: ibid., p. 621f.; and on May 1, 1906, in: ibid., p. 623f.

71 The title for the painting is given as "girl writing". It is unclear which work this title refers to since no painting has ever been located with this title or in the format indicated in the diary.

72 Paul Klee to Lily Stumpf, February 26, 1906, in: KLEE, *Briefe* (see n. 5 above), pp. 595–597, here p. 596.

73 This is only partly true for works mounted on cardboard and prints. Whenever it seemed desirable or necessary to do so, Klee used a traditional passe-partout suitable for picture frames with removable backs. See also the letters cited in note 70.

74 Klee sold the work to Otto Ralfs in 1929, after 1931 it was in the collection of the Dresden Gemäldegalerie until it was confiscated by the Nazis in 1937 and finally purchased by the Zurich collectors Emil and Clara Friedrich-Jezler in 1939. It was destroyed by fire in transport in 1940. Most recently mentioned in: *Catalogue raisonné Paul Klee*, vol. 3, Wabern 1999, No. 4067 as well as HOPFENGART, "Klee an den deutschen Museen" (see n. 3 above), pp. 81f. and 89.

75 Recently several letters, which had been unknown until now were found in the family estate. They document the process in detail, and this is particularly interesting because it is probably the only instance where Klee's contact with a private collector is documented by a complete set of correspondence from both parties. I am grateful to Rolf and Helga Marti-Huber for drawing my attention to this matter. The sale took place as follows: Huber saw the painting at the exhibition in Lucerne (*Paul Klee,*

Fritz Huf. Kunstmuseum Luzern, April 26 – June 3, 1936) and approached Klee directly with regard to a purchase (Othmar Huber to Paul Klee, May 11, 1936, Klee family estate, deposited with the Paul Klee Foundation). Lily replied on her husband's behalf that the price was 1000 Swiss Francs if the sale was made directly through Klee and not reported to the exhibition organisers (Lily Klee to Othmar Huber, May 14, 1936, private collection). An agreement to purchase followed (Othmar Huber to Paul Klee, May 15, 1936, Klee family estate, deposited with the Paul Klee Foundation). Klee asked his wife to communicate how happy they both were that Huber had purchased the painting. "You've made an excellent choice and will receive a painting by Klee which we both love and value very much." The letter went on to say that the painting would only be shipped at the beginning of June, because it had to be returned to Berne first in order to avoid revealing the sale to the exhibition organisers (Lily Klee to Othmar Huber, May 27, 1936, private collection). At the beginning of June, however, Lily Klee announced that the painting would not be sent to Glarus until the beginning of July, because Klee wanted to check it one more time (Lily Klee to Othmar Huber, June 6, 1936, private collection). Huber replied that he would take the painting without any further review by the artist (Othmar Huber to Paul Klee, June 8, 1936, Klee family estate, deposited with the Paul Klee Foundation). Lily Klee finally noted the receipt of the purchase price at the beginning of August (Lily Klee to Othmar Huber, August 4, 1936, private collection).

76 Lily Klee to Othmar Huber, undated [August 1936], private collection.

77 Numerous other works show this emphasis on the image surface even after 1933 by means of a double frame, even though this invariably results in a three-dimensional structure. Cf. for example: *Castle in the Air*, 1922, 42; *Letter Image*, 1924, 116; *Cathedral*, 1924, 138; *Fish Image*, 1925, 5 (fig. 2), *Aquarium*, 1927, 8; *Full Moon*, 1927, 23; *A Page from the Book of the City*, 1928, 46 (N 6); *Dummy*, 1931, 261 (X 1); *Blue Night*, 1937, 208 (U 8); *Symbols in Yellow*, 1937, 210 (U 10); *Intent*, 1938, 126 (J 6); *Park near Lu.*, 1938, 129 (J 9); *Love Song under New Moon*, 1939, 342 (Y 2); *Snow-Storm-Ghosts*, 1939, 352 (Y 12); *Still Life on Leap-Day*, 1940, 233 (N 13); *Death and Fire*, 1940, 332 (G 12).

78 In five cases at least, Klee either protected paintings himself behind glass or suggested that this should be done. Specifically: *View from Window*, 1920, 27; *Red Landscape*, 1921, 192; *Stroke of Lightning*, 1924, 135; *OZAR (City View)*, 1928, 141 (E 1); *Colourful Landscape*, 1928, 142 (E 2).

79 Such generalisations — most recently in Wolfgang KERSTEN, "Paul Klee. Kunst der Reprise", in: *Lehmbruck, Brancusi, Léger, Bonnard, Klee, Fontana, Morandi: Texte zu Werken im Kunstmuseum Winterthur*, Dieter Schwarz (ed.), Winterthur/Düsseldorf 1997, pp. 105–135 — are no more than art historical myth-making with a myopic emphasis on one single aspect and not attempt at establishing the relevant context. While [Kersten's] specific observations with regard to the work in question — *Flowering*, 1934, 199 (T 19) — are accurate, the value he attaches to them is too great and unjustifiable, especially when one considers the lack of a methodological inquiry and the obvious parallels, in this aspect, between Klee and other artists.

80 This is especially evident in the subsequent work on the watercolours and drawings from Tunisia, some of which Klee completed in Munich in 1914, only to return to them again in 1919 and in 1923. This may be connected to Klee's attempt at creating a myth surrounding his stay [in Tunis], [or] his efforts at revising the reception he had received, perhaps in the interest of establishing a corresponding biographical construct. On this topic, see most recently: ANGER, *Modernism* (see n. 2 above), pp. 25–39 and Jenny ANGER, "Der dekorative Klee", in: *Beiträge Bern 2000* (see n. 3 above), pp. 239–253.

81 For a detailed and well-researched exploration of this topic, see: Osamu OKUDA, "Zerteilen und Neukombinieren – über die spezielle Technik von Paul Klee", in: *Bunkagaku-Nenpo, University of Kobe*, No. 2, March 1983,

pp. 61–98; Wolfgang Kersten, Paul Klee. *Zerstörung, der Konstruktion zuliebe?*, Marburg 1987; Wolfgang KERSTEN, Osamu OKUDA, "Die inszenierte Einheit zerstückelter Bilder. Paul Klees Gebrauch der Schere im Jahr 1940", in: *Paul Klee. Das Schaffen im Todesjahr.* Exh. cat., Kunstmuseum Bern, August 17 to November 4, 1990, pp. 101–109 as well as KERSTEN/OKUDA, *Zeichen der Teilung* (see n. 7 above) and most recently: Mari KOMOTO, "Repentirs de Klee. La fonction autocritique du collage dans les Œuvres découpées et re-composées", in: *Histoire de l' Art*, No. 44, 1999, pp. 35–47.

82 KERSTEN/OKUDA, *Zeichen der Teilung* (see n. 7 above) mention 95 other works in their exhibition catalogue, which were cut into pieces and combined into new configurations; in the meantime, research on the *Catalogue raisonné Paul Klee* has increased the number to 107.

83 This method was used in: *"A and B"*, 1914, 184; *Mists Pass over the Sinking World*, 1915, 15; *In Memoriam J.R.*, 1917, 94; *R. Mi. (Marine)*, 1917, 117; *Drawg. on Envelope*, 1917, 157; *Lower and Higher Animals*, 1918, 180; *The Fish*, 1918, 185; *Picture Inscription*, 1920, 117; *Marine Landscape with Celestial Body*, 1920, 166; *Comedy*, 1921, 109; *"Drawing I for 1922/42"*, 1922, 40; *Horizontal = in Motion*, 1924, 52; *Farewell Then!*, 1927, 256 (Z 6); *Miracles of the Future*, 1928, 161 (G 1); *In Front of and Behind the Bridge*, 1928, 173 (H 3).

84 See also, the comments by KERSTEN, in: *Zerstörung* (wie Anm. 81), S. 99.

85 For a typology of the principles at work in the découpages, see KERSTEN, *Zerstörung* (see n. 81 above), p. 95f. and further KERSTEN/OKUDA, *Zeichen der Teilung* (see n. 7 above), pp. 14–17.

86 These are (the numbering refers to the Catalogue raisonné Paul Klee, vol. 1): *Untitled*, circa 1899 split 1 (Ref. No. 125); *Untitled*, circa 1899 split 2 (Ref. No. 126); *Untitled*, 1902 split 1 (Ref. No. 151); *Untitled*, 1902 split 2 (Ref. No. 152); *Untitled*, circa 1904 split 1 (Ref. No. 189); *Untitled*, 1908 split 1 (Ref. No. 384); *Untitled*, 1908 split 2 (Ref. No. 385); *Untitled*, circa 1909 split 2 (Ref. No. 465); *Swamp Legend*, 1919, 163 split 1; *Untitled*, 1919, 163 split 2; *Three White Bell Flowers*, 1920, 182 split 1; *Untitled*, 1920, 182 split 2; *Garden in Level II (with Small Gazebo)*, 1920, 185 split 1; *Untitled*, 1920, 185 split 2; *Urn Grave of Family Ochsenfrosch*, 1922, 182 split 1; *Untitled*, 1922, 182 split 2; *Reconstruction*, 1926, 190 (T 0) split 1; *Untitled*, 1926, 190 (T 0) split 2; *Fenced in*, 1928, 74 (Qu 4) split 1; *Untitled*, 1928, 74 (Qu 4) split 2; *Jumper*, 1930, 183 (C 3) split 1 (pl. 59); *Untitled*, 1930, 183 (C 3) split 2 (fig. 9); *Dancer (on Yellow)*, 1930, 204 (E 4) split 1; *Untitled*, 1930, 204 (E 4) split 2; *At Seven o'Clock over the Rooftops*, 1930, 211 (S 1) split 1; *Untitled*, 1930, 211 (S 1) split 2; *Four-Part Palace*, 1933, 355 (C 15) split 1; *Untitled*, 1933, 355 (C 15) split 2; *Female Mask*, 1933, 482 (AE 2) split 1; *Untitled*, 1933, 482 (Ae 2) split 2; *Black Symbols*, 1938, 114 (H 14) split 1; *Untitled*, 1938, 114 (H 14) split 2; *Dawning*, 1939, 347 (Y 7) split 1; *Untitled*, 1939, 347 (Y 7) split 2; *Blue Flower*, 1939, 555 (CC 15) split 1; *Untitled*, 1939, 555 (CC 15) split 2; *Wave Sculpture*, 1939, 1128 (JK 8) split 1; *Untitled*, 1939, 1128 (JK 8) split 2.

87 This applies to some 110 works. Precise data are unavailable, since not all paintings could be viewed in the original during the preparation of the *Catalogue raisonné* or because some of the backings are partially obscured. Hence, this figure should be taken as the lowest limit.

88 In the upper left-hand corner of the painting, Klee noted the work number "1924, 198". The entry in the œuvre catalogue reads: "Oil on paper, black oil ground glued on white". — To date, the work has not been verified. The reference in the *Catalogue raisonné Paul Klee*, vol. 4, Wabern 2000, No. 3570 must be revised in view of the results that have now come to light. It is simply impossible that Klee would have left a work unfinished, completed it some ten years later and then sold it, while the same work would already surface earlier at Ferdinand Möller's in Berlin in the context of executing the estate of Heinrich Kirchhoff's collection. The painting entitled "Tropical Landscape" which is named in a list (Jawlensky-Archives, Locarno) cannot be identical to this work, although confirmation has not been possible until now.

89 Cf. Therese BHATTACHARYA-STETTLER, "'Es ist frei und einfach beim Meister Klee'. Unveröffentlichte Tagebuchauszüge von Otto Nebel (1892–1971)", in: *Berner Almanach Literatur*, Bern 1998 (Berner Almanach: vol. 2), pp. 297–312, especially the entry on July 10, 1934, p. 303.

90 While some numbers have been recorded or assigned twice, this was never the case with paintings. Altogether, there were only 12 works, where Klee put down a previously recorded work number.

91 Few studies have focused on this problem. Important insight was provided in the late 1970s by Regula SUTER-RAEBER, in: "Paul Klee. Der Durchbruch zur Farbe und zum abstrakten Bild", in: Exh, cat. Munich 1979/1980, pp. 131–165. SUTER-RAEBER was the first to try to establish a precise chronology for the Tunisian watercolours. Subsequent studies to focus on this topic were the exception rather than the rule, among them: KERSTEN, "Hoch taxiert" (see n. 12 above), pp. 108–121; OKUDA, "Buchhaltung" (see n. 7 above) ; KERSTEN, "Kunst der Reprise" (see n. 79 above); OKUDA, "Versinkende Villen" (see n. 12 above) and Osamu OKUDA, "Erinnerungsblick und Revision. Über den Werkprozess Paul Klees in den Jahren 1919–1923", in: *Beiträge Bern 2000* (see n. 3 above), pp. 159–172. – See also the contributions by BÄSCHLIN/ILG/ZEPPETELLA (see n. 8 above).

92 The main difficulty lies in the fact that the individual phases can only be excluded on the basis of works that are only dated in the œuvre catalogue. It is difficult to avoid such circular argumentation at this point due to the scarcity of studies on the working process and attempts at establishing precise dates. Naturally, such dates would have to be validated by appropriate sources and applied to other works. Only then could one circumvent the methodological problem of having to rely upon the œuvre catalogue for dates.

93 Other typical examples for this style are: *Magic Theatre*, 1923, 25; *Strange Garden*, 1923, 160 and *Cosmic Flora*, 1923, 176.

94 Cf. for example: *Mountain Carnival*, 1924, 114.

95 e.g.: *Ad Marginem*, 1930, 210 (E 10) and *Romantic Park*, 1930, 280 (OE 10).

96 Especially in: *Bird Pep*, 1925, 197 (T 7).

97 On the topic of the exchange of paintings among artists, see: Josef HELFENSTEIN, "'Die kostbarsten und persönlichsten Geschenke' – Der Bildertausch zwischen Feininger, Jawlensky, Kandinsky und Klee", in: *Die Blaue Vier. Feininger, Jawlensky, Kandinsky, Klee in der Neuen Welt.* Exh. cat., Kunstmuseum Bern, December 5, 1997 to March 1, 1998; Kunstsammlung Nordrhein-Westfalen, Düsseldorf, March 28 to June 28, 1998, pp. 79–136 and Josef HELFENSTEIN, "'Ein kleines Publikum aus feinen Köpfen'. Klees Bildertausch mit befreundeten Künstlern", in: *Beiträge Bern 2000*, pp. 125–145.

98 In addition to initiator Otto Ralfs, the members were: Hannah Bürgi-Bigler, Berne; Rudolf Ibach, Barmen; Heinrich Stinnes, Cologne; Werner Vowinckel, Cologne; Otto Kirchhoff, Wiesbaden; Ida Bienert, Dresden; Richard Doetsch-Benziger, Basle; Hermann Rupf, Berne. Research remains to be done as to other members of the society or when they were active.

99 The Klee Society, its activities and the importance of the society for Klee's financial situation have not been sufficiently explored. For now, information can be found in: Stefan FREY, Wolfgang KERSTEN, "Paul Klees geschäftliche Verbindung zur Galerie Alfred Flechtheim", in: *Alfred Flechtheim. Sammler, Kunsthändler, Verleger.* Exh. cat., Kunstmuseum Düsseldorf, September 20, to November 1, 1987; Westfälisches Landesmuseum für Kunst und Kulturgeschichte, Münster, November 29, 1987 to January 17, 1988, pp. 64–91, especially p. 75.

100 Ibach received: *Blossoms in motion*, 1926, 232 (X 2), Stinnes received: *Fish, playing*, 1927, 121 (C 1), Hannah Bürgi was given: *northern Seaside Town*, 1927, 122 (C 2) and Werner Vowinckel: *with Tower and Bridge*, 1927, 125 (C

5). — To mark the yearend 1926/1927, Klee dedicated a gift to Hermann Bode, who received *six-legged Dog-Devil*, 1925, 250 (Z 0).

101 Rudolf Ibach was one of the most active collectors of this period and owned a total of 45 works by Klee. As chairman of the Barmer Ruhmeshalle he was moreover a most effective public proponent and patron of Klee. On Ibach, see most recently: HOPFENGART, "Klee an deutschen Museen" (see n. 3 above), p. 72f.; on Ibach's collection, see: Ulrike BECKS-MALORNY, *Der Kunstverein in Barmen 1866–1946. Bürgerliches Mäzenatentum zwischen Kaiserreich und Nationalsozialismus*, Wuppertal 1992; Werner J. SCHWEIGER, "Vom Sammeln in der Provinz. Rudolf Ibach 1873–1940", in: Henrike JUNGE (ed.), A*vantgarde und Publikum: Zur Rezeption avantgardistischer Kunst in Deutschland 1905–1933*, Cologne/Weimar/Vienna 1992, pp. 165–172; Werner J. SCHWEIGER, *Rudolf Ibach. Mäzen, Förderer und Sammler der Moderne, 1873–1940*, ed. by Adolf Ibach, Charlotte Mittelsten Scheid-Ibach and the community of heirs to Etta and Otto Stangl, private imprint, Bad Vöstau 1994; Ulrich BISCHOFF, "Förderung, Sicherung und Vermittlung Rudolf Ibach, Etta und Otto Stangl", in: *"Brücke"* und *"Der Blaue Reiter". Werke der Sammlung Etta und Otto Stangel*. Exh. cat., Kirchner Museum, Davos, December 21, 1996 to March 30,1997; Staatliche Kunstsammlungen, Gemäldegalerie Neue Meister, Dresden, October 12 to December 7, 1997, pp. 11–14.

102 Numerous drawings, in this case without dedication, were added to the premium edition of Grohmann's book on drawings (see n. 34). Unfortunately, no information has been uncovered to date as to who purchased a copy of the premium edition or which [original] drawing may have been added. For the same reason, the allocation of a drawing from the collection of the Hermann and Margrit Rupf Foundation cannot be verified. Rupf acquired a copy of the premium edition, but he did not record which drawing came with his copy.

103 The collectors received the following works on paper: Rudolf Ibach, the work referred to in n. 100; Werner Vowinckel: *With Tower and Bridge*, 1927, 125 (C 5); *Principal Thought*, 1930, 180 (B 10); *With his Grandmother*, 1933, 197 (U 17); *Her Son*, 1933, 269 (Y 9); *Head of a Boy WH*, 1933, 272 (Y 12); Richard Doetsch-Benziger: *Sm. Girl*, 1928, 97 (S 7); *Dismount!*, 1933, 179 (T 19); *Dance Rehearsal*, 1934, 64 (M 4); *Widespread Branches*, 1934, 76 (M 16); *Attempted Reconstruction*, 1937, 171 (S 11); *Blue-eyed Fish*, 1938, 206 (N 6); *A Gate (GATE)*, 1939, 911 (XX 11); Hannah Bürgi: *Road in the Hirschau*, 1907, 22; *A 1 lower Stockhornsee*, 1915, 164; *A 2. upper Stockhornsee*, 1915, 165; *A 3 Stockhornsee*, 1915, 166; *Rope Dancer*, 1923, 138; *Village*, 1925, 122 (C 2); *Northern Seaside Town*, 1927, 122 (C 2); *"Height!"*, 1928, 189 (J 9); *Exercises*, 1929, 286 (UE 6); *Exit*, 1933, 165 (T 5); *Lapdog N*, 1933, 234 (W 14); *Dimly Surrounded*, 1934, 74 (M 14); *Branch and Leaf*, 1934, 165 (S 5); *Grass*, 1935, 2; Otto Ralfs: *Untitled*, 1928 (Ref. No. 4756b); *Three Pyramids*, 1929, 323 (3 H 23); *Animal Theatre*, 1933, 177 (T 17); *Colourful Forest*, 1934, 58 (L 18); Ise Bienert: *southern Coast*, 1925, 39 (M 9); Ida Bienert: *Light and Some*, 1931, 228 (V 8); Hermann and Margrit Rupf received: *Above Water*, 1933, 45 (M 5); *Full Moon in Garden*, 1934, 214 (U 14); *Plant According to Rules*, 1935, 91 (N 11); *Old Cemetery*, 1937, 178 (S 18); *One-Fruit-Tree*, 1938, 215 (N 15); *Comrades Rambling*, 1939, 1115 (Hi 15); Hans Meyer-Benteli received: *Woman with Kerchief*, 1938, 179 (L 19); *Fruit-Bearing Blossom*, 1939, 905 (XX 5) – For Heinrich Kirchhof, Klee had drawn into a guest book (*Untitled*, 1922, Ref. No. 3086), as he did for Ralfs.

104 Grohmann received: *Small Comedy on the Meadow*, 1922, 107; *Physiognomic Crystallisation*, 1924, 15 and *Grete*, 1933, 409 (F 9); Georg Schmidt: *Taking a Break, Here*, 1930, 120 (V 10). Schmidt went on to purchase several works for his private collection throughout the 1940s and 1950s.

105 Bornand received: *Asters in Window*, 1908, 53; *Foot-bridge, in Rain*, 1910, 27; *New Buildings*, 1910, 42; *Sugiez*, 1910, 54; *Kiesen*, 1910, 73; *Berne, Original Entrance to City II*, 1911, 8; *Concert Hall*, 1911, 9; *Horse-Race II*, 1911, 48; *Munich Train Station IA.*, 1911, 86.

106 *Hill Landscape with the Black Sun*, 1918, 52: on the cardboard mount, Klee wrote: "To Mrs. Schülein for beautiful Fripp."

107 Klee maintained a cordial relationship with Alois Schardt, who had greatly promoted his work first at the National Gallery in Berlin, then in Hellerau and in Halle, and again at the National Gallery. The close relationship is evident in a letter by Klee to Schardt, of which a draft version has survived. Klee to Alois Schardt, December 8, 1933, draft in Klee family estate deposited with Paul Klee Foundation: "Dear Dr Schardt Now You — the last pillar — have gone too, which I deeply regret. I ask [myself]: what will the State-sanctioned German Art look like? [We would be] better off without state support!" — Schardt owned: *Two Kiosks*, 1922, 66 and *Dune Cemetery*, 1924, 216, and had received the following as a gift from Klee: *Diametrical Range in Red-Orange and Blue-Green*, 1922, 70. — On Schardt's career as Museum associate and later director, see: HOPFENGART, "Klee und deutsche Museen" (see n. 3 above), pp. 74–76, 80f. and p. 83f.

108 Galka Scheyer, who eventually had an exquisite collection of the "Blue Four", was given: *The Saint*, 1921, 107 and *Actor as Woman*, 1923, 49.

109 From Klee Boesch received: *Before the Start*, 1911, 49; *Country Homes on Beach*, 1914, 214; *Well-wisher*, 1938, 462 (B 2), and from Lily: *Southern Settlement*, 1924, 234.

110 Klee dedicated the following to various members of the Galston family: *"Two Watercolour- and Pen and Ink Drawings, Angle Motif"*, 1917, 69; *Song of the Journey by Boat*, 1918, 166; *Untitled*, 1919 (Ref. No. 2330); *Picture Inscription for Irene, When She's More Grown Up (No. 1.)*, 1920, 116; *Harlequin on Bridge*, 1920, 164; *Where Eggs Come From and the Good Roast (for Florina-Irene)*, 1921, 6; *Animal Tricks (for Florina)*, 1921, 7; *Exotic River Landscape*, 1922, 158.

111 Klee had presented a small pencil drawing to his aunts as a New Year's gift in 1898: *(Elfenau) Early-Spring*, 1898, *Catalogue raisonné Paul Klee*, vol. 1, No. 109, drawn in the Elfenau region near Bern.

112 To his mother he gave: *Pregnancy*, 1907, 19; *Nursery n. Munich with House*, 1910, 28; *Houses in Park*, 1910, 72; *Streetside Café in Tunis*, 1914, 55; *sm. Harbour*, 1914, 146. It is interesting to note, that the behind glass painting *Pregnancy*, 1907, 19 returned into the possession of Klee, who then reserved it for his estate collection with a note on the cardboard backing. To his sister he gave: *n. Merligen*, 1893 (Ref. No. 51); *Birseck Tower n. Arlesheim (Ct. Basle)*, 1896 (Ref. No. 94); *Untitled*, 1896 (Ref. No. 98); *Untitled*, 1897 (Ref. No. 101); *near Boll (at the foot of Dentenberg mountain)*, 1897 (Ref. No. 106); *In the Daehlhoelzli*, 1898 (Ref. No. 110); *St. Peters Island*, 1898 (Ref. No. 111); *Untitled*, 1898 (Ref. No. 113); *Untitled*, 1898 (Ref. No. 116); *Untitled*, circa 1899 split 1 (Ref. No. 125); *Untitled*, circa 1899 split 2 (Ref. No. 126); *Untitled*, circa 1899 (Ref. No. 127); *Untitled*, 1902 split 1 (Ref. No. 151); *Untitled*, 1902 split 2 (Ref. No. 152); *Untitled*, circa 1903 (Ref. No. 170); *Untitled*, circa 1905 (Ref. No. 230); *Untitled*, circa 1906 (Ref. No. 268); *Untitled*, 1908 split 1 (Ref. No. 384); *Untitled*, 1908 split 2 (Ref. No. 385); *Untitled*, circa 1908 (Ref. No. 387); *Untitled*, circa 1909 (Ref. No. 463); *Untitled*, circa 1909 (Ref. No. 464); *House on Canal*, 1912, 105; *Untitled*, circa 1912 (Ref. No. 898); *Landscape n. Fryburg*, 1915, 247; *Untitled*, circa 1915 (Ref. No. 1591); *Untitled*, circa 1915 (Ref. No.1594) and to his father: *Still Life - Sketch*, 1909, 30; *View into Forest*, 1909, 64; *Small Market Scene*, 1911, 15; *Mountain Hut*, 1911, 59; *Young Birds*, 1912, 121; *Yellow Horse and Purple Sign*, 1912, 166; *The Battlefield*, 1913, 2; *Road at Lake*, 1913, 117; *Study after Aged Dromedary*, 1914, 208; *Untitled*, circa 1915 (Ref. No. 1591).

113 Klee dedicated the following works to his wife: a print of: *Charm (fem. grace)*, 1904, 15; as well as: *Fire Wind*, 1923, 43 (pl. 23); for Lily, 1923, 168; *Cosmic Flora*, 1923, 176; *The Beetle*, 1925, 237 (X 7); *Ships at Rest*, 1927, 176 (H 6); *Non-composition in Space*, 1929, 124 (C 4); *Plantlike-Strange*, 1929, 317 (3 H 17); *Six Kinds*, 1930, 134 (X 4); *Grieving*, 1934, 8 (8); *Pyramid*, 1934, 41 (L 1).

114 *Cosmic Flora*, 1923, 176 was a birthday present for Lily Klee in 1928 and *Fire Wind*, 1923, 43 once again on the occasion of her birthday in 1932.

115 In 1929, she received *Non-composition in Space*, 1929, 124 (C 4) and at Christmas *Plantlike-Strange*, 1929, 317 (3 H 17); in 1934, first: *Pyramid*, 1934, 41 (L 1) and later *Grieving*, 1934, 8 (8).

116 Among them the behind glass paintings, two of the so-called Chinese Poems (specifically: *Hoch und stralend [sic] steht der Mond. Ich habe meine Lampe ausgeblasen, und tausend Gedanken erheben sich von meines Herzensgrund. Meine Augen strömen über von Tränen,* [roughly: *The Moon is high and bright. I have extinguished my lamp, a thousand thoughts rise from the bottom of my heart. My eyes overflow with tears.*] 1926, 20 and *Und ach, was meinen Kummer noch viel bitterer macht ist, dass Du nicht einmal ahnen magst, wie mir ums Herz ist,* [roughly: *Alas, my sorrow is all the more bitter, for you may not even guess the state of my heart*] 1916, 22; Klee had sold the remaining drawings based on these poems to Adolf Rothenberg in 1919) as well as the drawings reproduced in the "Sturm-Bilderbuch". On these and the exclusion from sale of these drawings, see most recently: RÜMELIN, "Kunsthandel" (see n. 3 above), p. 35.

117 This term is derived from Klee's own definition, specifically for *Pregnancy*, 1907, 19.

118 See: GLAESEMER, *Handzeichnungen II* (see n. 35 above), p. 159 note 14; FREY/ KERSTEN, "Paul Klees geschäftliche Verbindung" (see n. 99), p. 78 and most recently RÜMELIN, "Kunsthandel" (see n. 3 above), p. 31f.

119 Exceptions are: *The Inventor of the Nest*, 1925, 33 (M 3) and *Magic Theatre*, 1923, 25, both identified as "private collection" on the cardboard mount.

120 *Paul Klee*. Kunsthalle Bern, February 23 to March 24, 1935. 273 works were on display.

121 *Paul Klee*. Kunsthalle Basel, October 27 to November 24, 1935. The exhibition featured 191 works.

122 Exhibition in Lucerne (see n. 75 above). With a total of 173 works, this was the smallest exhibition.

123 The following had been identified as not for sale in Bern: *The Celebration of the Asters*, 1921, 206; *Castle in the Air*, 1922, 42; *Southern Mountain Village*, 1923, 60; *Head (before Awakening)*, 1929, 9 (9); *Peasant Garden in Person*, 1933, 33 (L 13); *A Child Walks Home*, 1933, 50 (M 10); *Child in Armchair*, 1933, 64 (N 4); *The Invention*, 1934, 200 (T 20) – In Basle: *The Celebration of the Asters*, 1921, 206; *Castle in the Air*, 1922, 42; *Dispute*, 1929, 232 (X 2); *The Snake on the Ladder*, 1929, 340 (3 H 40); *The Woman with the Bundle*, 1930, 67 (P 7) – and in Lucerne: *Nocturnal Feast*, 1921, 176; *The Celebration of the Asters*, 1921, 206; *Castle in the Air*, 1922, 42; *Bird Pep*, 1925, 197 (T 7); *Girl Bedecked with Flags*, 1929, 19 (K 9); *Growth on Rock*, 1929, 258 (Z 8); *The Woman with the Bundle*, 1930, 67 (P 7); *Young Tree (Cloranthemum)*, 1932, 113 (P 13); *The Invention*, 1934, 200 (T 20); *Botanical Theatre*, 1934, 219 (U 19).

124 The behind glass painting was *Pregnancy*, 1907, 19, which formerly belonged to the artist's mother; the painting is: *Composition with Windows*, 1919, 156.

125 Of the 256 works which Klee assigned to the special category, only 19 were details of a larger original piece. In particular: *Untitled*, 1915, 253; *Untitled*, 1917, 40; *Head*, 1919, 5; *Southern Gardens*, 1919, 80; *Urban Scheme with Green Church Tower*, 1919, 191; *Autumnal Sound*, 1920, 86; *Stairway with 2 Figures*, 1920, 87; *Similar [to] 1920/136*, 1920, 137; *The House at the Rose Tree*, 1920, 218; *Rose Tree*, 1920, 219; *Physiognomy of a Blossom*, 1922, 88; *Puppet Theatre*, 1923, 21; *Still Life "with the Dice"*, 1923, 22; *Mural*, 1924, 128; *Côte de Provence 3*, 1927, 231 (X 1); *Côte de Provence 5*, 1927, 233 (X 3); *Côte de Provence 7*, 1927, 235 (X 5); *Glass Houses, Quartered*, 1927, 242 (Y 2); *Fear behind Window*, 1929, 328 (3 H 28).

126 Klee had classified only the following works as belonging into the special category: *Floating Grace (in the Style of Pompeii)*, 1901, 2; *In Ostermund Quarry, 2 Cranes*, 1907, 23; *Portrait of a Woman*, 1907, 30; *Seated Girl*, 1909, 71; *Nude*, 1910, 124.

ACKNOWLEDGMENTS

I would like to express my most sincere thanks to all the lenders of works for this volume and the exhibition and to everybody involved with *Paul Klee: Selected by Genius, 1917–1933*. First and foremost I would like to thank Angela Rosengart for her considerable personal commitment to this project, her much valued advice and the generous loan of works from her unique collection. In addition I am extremely grateful to Christian Rümelin from the Klee Foundation for the research and scholarship in his essay 'Klee's Interaction with his own Œuvre'—an invaluable contribution on the public reception of Paul Klee's work. My gratitude also goes to Stefan Frey from the Paul Klee-Nachlass-Sammlung who supported this project most generously. Prof. Heinz Berggruen made it possible for eminently important works to be included in the exhibition. A sincere thank-you goes to him and for his never-failing encouragement. Similarly I would like to extend my thanks to all other lenders of works who would prefer to remain anonymous. I am grateful to the Mayor of Balingen, Dr. Edmund Merkel, to Ulrich Klingler and all members of staff at the Stadthalle Balingen. My thanks also extend to all those at Prestel Publishing in Munich for their much valued and uncomplicated cooperation in compiling this exhibition catalogue.

LENDERS TO THE EXHIBITION

Bayerische Staatsgemäldesammlungen, Munich,
Dr. Joachim Kaack
Fondation Gianadda, Martigny, Léonard Gianadda
Galerie Kornfeld, Bern und Zurich, Christine Stauffer
Kunsthaus Zürich, Dr. Christoph Becker
Kunstmuseum Basel, Dr. Katharina Schmidt
Kunstmuseum Basel, Kupferstichkabinett,
Dr. Dieter Koepplin
Kunstmuseum Bern, Michael Baumgartner, Toni Stooss
Staatliche Museen zu Berlin, Preußischer Kulturbesitz,
Sammlung Berggruen, Prof. Dr. Peter-Klaus Schuster

Peter Allenbach
Prof. Dr. Heinz Berggruen
Manuela Beutler
Stefan Frey
Prof. Rudolf Hagemann
Dr. Adrian Hinderling
Alexander Klee
Livia Klee
Erika und Werner Krisp
Christiane Lange
Rolf Marti
Angela Rosengart
Lothar Strobel

PHOTOGRAHIC CREDITS